CALLIGRAPHY
IN 24 HOURS

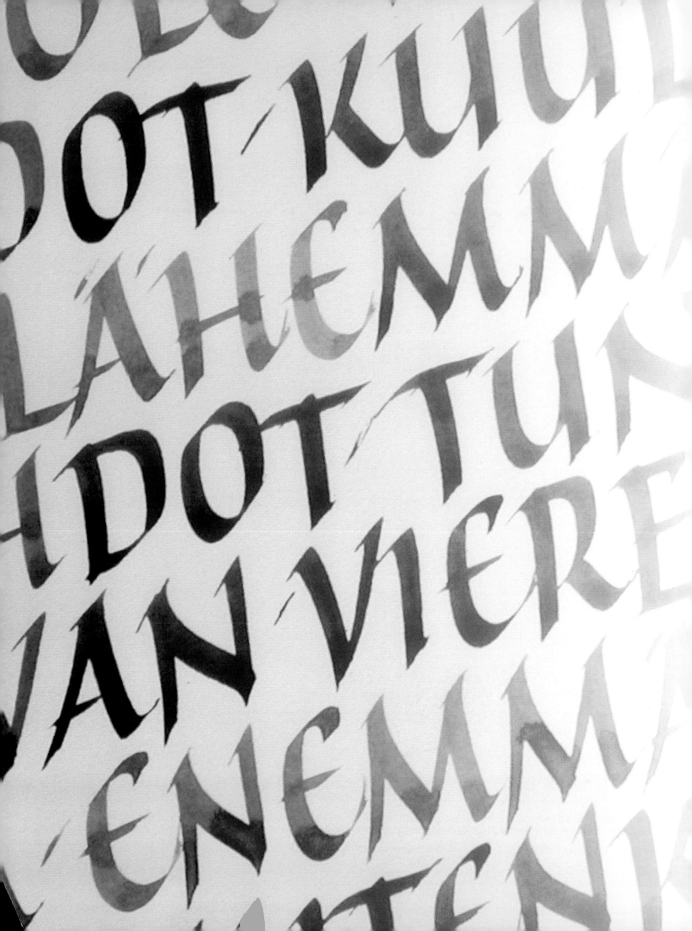

CALLIGRAPHY
IN 24 HOURS

VEIKO KESPERSAKS

BARRON'S

A QUARTO BOOK

First edition for North America
published in 2011 by
Barron's Educational Series, Inc.

All inquiries should be addressed to:
Barron's Educational Series, Inc.
250 Wireless Boulevard
Hauppauge, NY 11788
www.barronseduc.com

ISBN: 978-0-7641-4506-3
Library of Congress Control Number:
2010940557

QUAR.CATF

Conceived, designed, and
produced by
Quarto Publishing plc
The Old Brewery
6 Blundell Street
London N7 9BH

Project editor: Chloe Todd Fordham
Art editor: Emma Clayton
Designer: Karin Skånberg
Photographers: Simon Pask,
Phil Wilkins
Picture research: Sarah Bell
Additional text: Michael Alderton
Copyeditor: Liz Dalby
Art director: Caroline Guest
Creative director: Moira Clinch
Publisher: Paul Carslake

Color separation by Modern Age
Repro House Ltd, Hong Kong
Printed in China by 1010 Printing
International Limited

10 9 8 7 6 5 4 3 2 1

CONTENTS

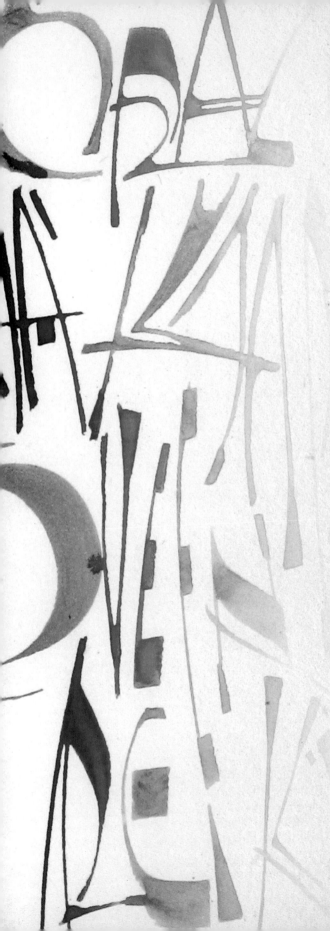

INTRODUCTION

The advent of digital technologies is making handwriting as a social skill largely redundant. The amount we write every day has decreased sharply, students type their notes on computers, application forms require printed writing or block capitals, and even signatures are increasingly being replaced by electronic signatures. Typing itself may soon be obsolete as speech recognition software becomes more advanced.

However, freed from the constraints of commerce and necessity, calligraphy has become an artform in its own right like printmaking or drawing. Contemporary calligraphers explore the limitless design capabilities of letterforms as well as their traditional use for creating documents and communicating ideas.

This book will teach you to appreciate, or rediscover, the beauty of the handwritten word. As you progress through the exercises in this book, the scripts will subtly adapt to your own handwriting and become truly your own.

Practicing calligraphy will change your way not only of writing, but also of seeing. You will become aware of the different styles of letterforms that surround us and become more discerning about which forms work and which don't. I have seen many students change the way they feel about words as a consequence of learning calligraphy, which has led them to a deeper appreciation of language and communication.

This is the beginning of a hugely rewarding journey that I hope will lead you to a better understanding of the art of writing, and of yourself.

Veiko Kespersaks

How to use this book

This book is organized around the different historical hands, their main features, and their variations. They are presented in four-page lessons that will inspire you to practice your writing.

"ABC" are blown up to illustrate the key features of each script.

Information on nibwidths, pen angle, x-height.

The deconstructed alphabet is shown in full. Arrows indicate direction of pen stroke.

Here, the letters are organized by family group to help you understand their structure and shape.

Letter spacing, common mistakes, joining letterforms, serif variations: one or all of these is covered in each lesson.

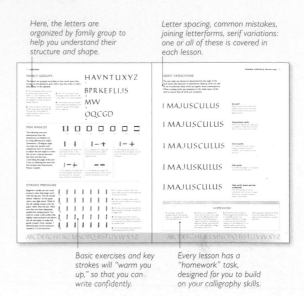

Full-color finished examples show the script in context.

Basic exercises and key strokes will "warm you up," so that you can write confidently.

Every lesson has a "homework" task, designed for you to build on your calligraphy skills.

Analyzing a script

Every calligrapher has different ideas about what a script should look like and how it should be written. Edward Johnson (1872–1944), considered the "father" of modern calligraphy, studied historical manuscripts and devised a system of analysis that enabled letterforms to be understood and replicated.

Before Johnson, it was mistakenly believed that scripts had been written with a pointed nib and then filled in afterward. Johnson made many discoveries in his research, including how to construct missing letters, following a method of analysis shown on the next page.

Since then, modern authors have devised their own version of scripts based on their own individual analysis. Additionally, contemporary scribes have constructed letters that are missing from modern alphabets (or other languages). There is nothing to stop you from conducting your own analysis and formulating your own conclusions; no one can be certain exactly how scripts written hundreds of years ago were constructed, and it is very rewarding to make your own discoveries.

The exercise starting on page 8 will give you invaluable insight into the process of handwriting. You may be surprised at how inconsistent historical scripts were before the creation of the printed word. Undertaking your own analysis is the only way to really understand calligraphy and go beyond merely copying examples of other people's work.

Remember, this is personal analysis. There are no right or wrong answers: You may change your mind about how a script is constructed. If you follow all the steps on the next two pages, you should find that your hand intuitively understands the shape of the letters.

"Eusebias History of the World" by Bartolomeo Sanvito
This beautifully written and illuminated page dating back to the fifteenth century is used for the basis of analysis in this book. The original can be found in the British Library Collection. The format of the original is 13x9in (330x215mm).

I Blow up the script to tabloid size using a photocopier. You will need at least four lines of text. Using double pencils (see page 12), check the width of the widest part of the letterform. The pencils may need to be adjusted (by shaving the side of one of the pencils). Using a sheet of tracing paper and the double pencils, slowly trace the letterforms as accurately as possible. Repeat six times. You will find that this becomes much easier with each attempt.

2 Using different colors for each stroke, color in the order of strokes.

ANALYSIS CHECKLIST

- **Pen angle:** What is the most constant pen angle?
- **X-height:** How many nib widths is the X?
- **Width of letters:** Measure in nibwidths.
- **Number and order of strokes:** What's the most likely order?
- **Serifs:** What type of serif is used, if any?
- **Speed of writing:** Note the slope of letterforms and the angle of branches.

3 Figure out how the serifs are constructed. It is best to use subtle colors so that areas where the strokes overlap and the different pen movements can be clearly indicated.

4 Count the height and the width of the letterforms with double pencils. Color the inside shape of the letters. Note the similarities and differences of the letters.

5 Using two colors, indicate each time the double pencils flatten or steepen their angle. The angles should be measured from the baseline with a protractor. This does not have to be too precise; it is more an indication of how the scribe built up the letterform. In practice you will use an average pen angle to make the letterforms consistent.

INTERPRET
BiI CAESAR
TA PER BEAT
NŸMVM ET

6 Using a dip pen and ink, trace over the original photocopy, noting the speed of writing.

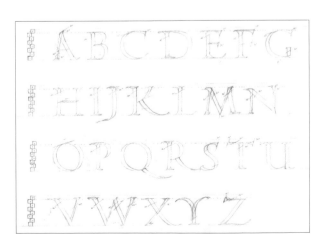

7 Finally, based on your analysis, construct the missing letters with double pencil. It is useful to compare the results of your analysis with other scribes' writing in the same hand. Note that there will inevitably be differences and similarities—all reflect the preferences of the individual scribe.

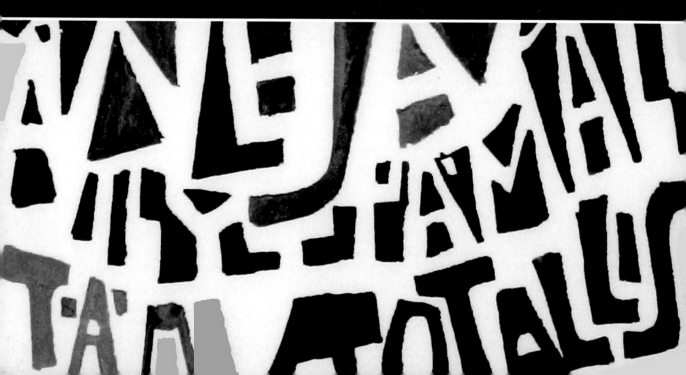

GETTING STARTED

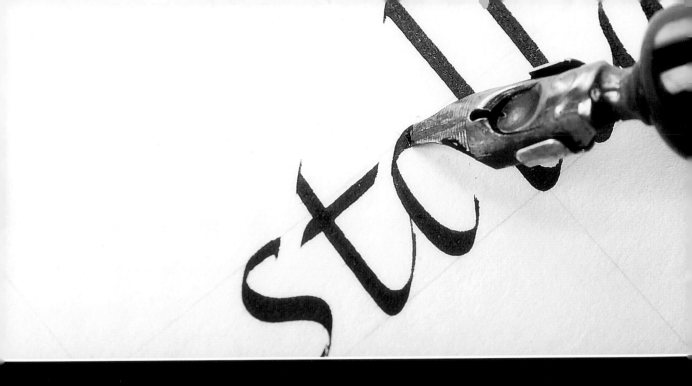

Understanding how to set up and create an effective working environment will improve the quality of your work and enhance your overall enjoyment of calligraphy practice.

TOOLS AND MATERIALS

The increasing popularity of calligraphy has brought with it a huge range of writing tools and materials. The variety may seem confusing at first, but these four pages will ensure you have everything you need, from basic equipment to specialized pens, nibs, and inks.

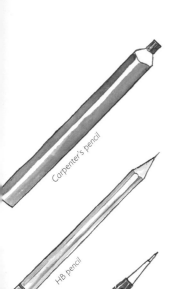

Carpenter's pencil

HB pencil

Automatic pencil

Double pencil

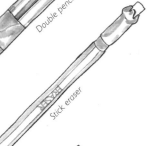

Stick eraser

Erasers and sharpener

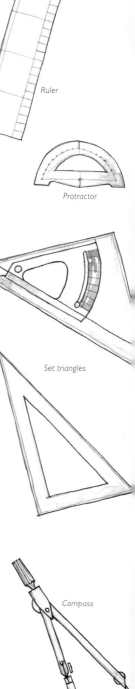

Ruler

Protractor

Set triangles

Compass

BASIC EQUIPMENT

H or harder **pencils** are the most useful and will not need to be sharpened as much as HB or softer B-grade pencils. **Automatic pencils** are very useful for ruling up, as they never need sharpening and the very narrow 0.3 leads can be used for drawing very thin, faint lines, which can be erased easily when the work is finished. If you choose to work with 0.3 leads, you will need to learn to use a light pressure when ruling up to avoid breaking them. A **carpenter's pencil** has a chisel-shaped point that mimics the effect of the broad-edge nib and is very useful for practicing weighted letterforms. Alternatively, use **double pencils**. These are made by fastening two pencils together with tape or elastic bands, sometimes with a portion of one pencil shaved away to alter the distance between the two points. This too mimics the effect of the broad-edge nib.

Any soft **eraser** will do, and an **erasing shield** is useful for masking out areas not to be erased.

Precision/stick erasers, similar in appearance to automatic pencils, are useful for erasing gaps between letters or words.

Make sure you have a **sharpener**, although a **craft scalpel** is excellent for sharpening double pencils and for trimming finished projects—as is a good pair of **scissors.** If you are using a craft scalpel, make sure you cut on a **self-healing cutting mat** to prevent damage to surfaces.

Use **Pritt Stick** or **Magic Tape** for sticking down paste-up text, and **masking tape** for holding paper in the correct position and holding loose nibs in place.

Gridded rulers allow you to line up very accurately. Most have a metal strip for use as a cutting edge. **T-square rulers** or **plastic set triangles** are also very useful, as they make it easier to draw straight lines and mean you only have to make x-height markings (see page 22) on one side of your paper. A **protractor** is advisable for measuring the angle of the pen or the slope of the letters, and a

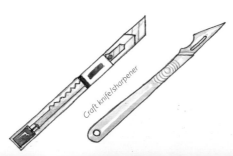

Craft knife/sharpener

Scissors

Magic Tape

Masking tape

Gum sandarac

Magnifying glass

Razor blade

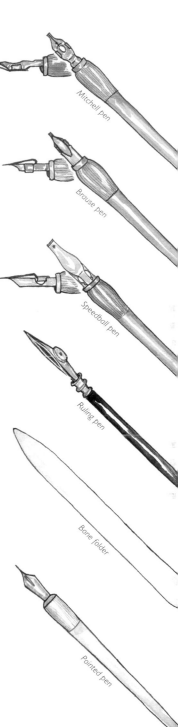
Mitchell pen
Brause pen
Speedball pen
Ruling pen
Bone folder
Pointed pen

compass for drawing accurate circles that make up the geometric skeleton forms of letterforms in scripts like Roman Capitals.

Most calligraphers use a wooden **writing board** with an easel that sits on top of a desk or table. If you don't have a desk, you can sit with the board on your lap propped up against a flat surface, or make your own portable writing desk (see pages 17–18).

PAPERS AND PAPER CARE

Choose thin white **layout paper** for practicing. For finished work, explore the range from machine-made to handmade papers. **Heavier-weight papers** will not wrinkle and are especially good if you're planning to wet the paper with a color wash. **Smooth-surfaced papers**—often called "hot-pressed"—suit fine pen work, whereas **textured paper** is better suited to large pens and edged brushes. Save strongly colored papers until you have developed the technique of writing with gouache paints.

Always test a sample on both sides of the paper first. Store your paper flat and handle it minimally to avoid "bruising" it. For more on paper, see page 16.

Gum sandarac is a powder applied to most writing surfaces to make them more receptive to the ink and is a useful purchase.

Safety **razor blades** are great for correcting mistakes (see pages 24–25), but take care! They're available in packets of five or ten and it's important that you use a fresh blade each time.

A **bone folder** is a small spatula-shaped tool with a rounded end. It's very useful for scoring folding paper and invaluable if you want to incorporate bookbinding into your calligraphy.

PEN NIBS

Nearly all nibs will fit onto a standard penholder. Keep them dry to prevent rusting. New nibs may need to be treated in a match flame to remove varnish from the underside.

Mitchell roundhand nibs are flexible broad-edge nibs that are the standard size used throughout this book. The reservoirs attach underneath. Orginally from Germany, **Brause nibs** have a chisel tip and are sold with the reservoir attached. **Speedball nibs** are made in the United States and have permanently attached reservoirs.

If you want to write in the Copperplate or Spencerian hand, you will need to use a **Gilot 505 nib.** These are flexible pointed nibs. For best results, use the Gilot 505 nib in conjunction with an oblique penholder.

A **magnifying glass** is handy for inspecting nibs for sharpening.

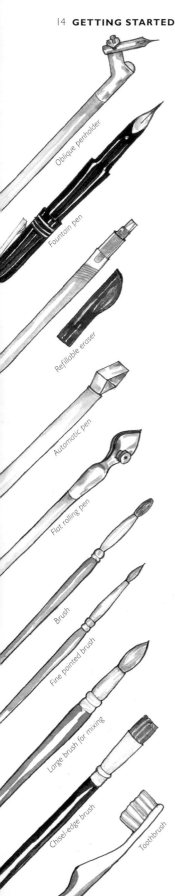

Oblique penholder

Fountain pen

Refillable eraser

Automatic pen

Flat rolling pen

Brush

Fine pointed brush

Large brush for mixing

Chisel-edge brush

Toothbrush

Bottled ink

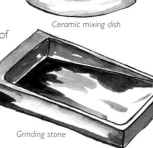

Wooden ink stick holder

Ink stick

Ceramic mixing dish

Grinding stone

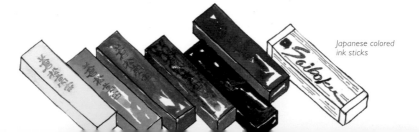

Japanese colored
ink sticks

A glass with 20x magnification is the most useful. Many are available in flea markets very cheaply.

Nibs need to be sharpened regularly so that they can produce sharp hairline strokes. For this, you'll need an **Arkansas stone** (see page 20). The stone needs to be of dentist or jewelry quality. Only a small stone is required. A cheap alternative to Arkansas stone is **sandpaper**. Use no. 4 wet and dry paper.

A **toothbrush** is perfect for cleaning your calligraphy nibs.

PENS AND BRUSHES

Calligraphy pens have broad edges, so you will need several widths to allow for large and small writing. When choosing pens, be aware that each manufacturer has a different system of measurement.

Dip pens allow the use of a wide variety of inks, paints, and nibwidths. Most contain a reservoir to hold more ink, but some rely on ink sticking to the underside.

Fountain pens are more for convenience and layout work than for serious calligraphy, as they are limited by a relatively small range of nibs. In order for the ink to be free flowing, it is processed with a number of chemicals that may not be of archival quality. Fountain pens can never achieve the density of

sumi ink and a dip pen. A **suede pen** is a broad-edge fountain pen made of metal and ultra suede. It's available in a wide range of sizes.

Use an **automatic pen** (or **coit pen**) for larger lettering. They consist of a diamond-shaped nib capable of holding a lot of ink or paint attached to a thick plastic penholder.

A **ruling pen** is very useful for drawing precise ink lines of a uniform width.

Penholders are available in a variety of patterns and colors. Cork-tipped holders cost a little more money, as do turned-wood holders, which will last a lifetime. If you have longer fingers (or dislike fat pens), then think about buying yourself a slimmer holder. **Oblique penholders** hold the nib at the correct angle for Copperplate and Spencerian scripts, which do not require a broad-edge nib.

Paintbrushes have a variety of uses: loading the ink onto the nib, filling in the details of illuminated letters, washes for colored backgrounds. It is good to have a selection on hand.

Palette

Water

Pipette

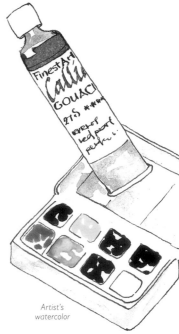

Artist's watercolor

Gouache

INKS AND PAINTS

Freshly ground ink is the best, especially the ink made from Japanese ink sticks. They are handmade using a traditional process and are of a very high quality. One stick can last a number of years. A brand called Yasutomo is especially useful when you need only a tiny quantity and don't want to mix fresh ink.

Grinding stones come in a variety of shapes, sizes, and qualities. The smallest size is the most useful—a lid can also be helpful to prevent the ink from drying out too quickly. You will need one grinding stone for each color and one for black ink. Test a stone by applying a small amount of liquid to it—the slower the liquid dries, the better the quality of the stone.

Bottled inks are generally not recommended, as they contain preservatives such as salt that can damage nibs. They are also much more expensive compared with freshly ground ink. If you do use them, however, **liquid acrylics** are widely available and they come in a large range of colors. The ink is waterproof when dry. Metallic inks are particularly useful. **Artist's watercolors**, such as Winsor and Newton, are useful for wash backgrounds.

If you wish to write with **gouache**, make sure you buy artist-quality gouache (rather than student quality), as it contains more pigment and produces more intense colors.

Use a **palette** for mixing ink—plastic or ceramic will do. A **pipette** is useful for dispensing water drop by drop onto a grinding stone or palette.

SPECIALTY ILLUMINATION MATERIALS

PAPERS
Vellum or parchment is made from specially prepared animal skins. It is beautiful and durable, and gives a subtle luminosity to painted color that paper does not.

BRUSHES
The finest brushes for creating illuminated letters are sable brushes (artist's quality or similar). Use sizes 000, 00, 0, and 1 for mixing paint and applying gum ammoniac, and a large soft brush for removing excess gold.

PAINTS
Gouache is generally the best all-around choice for beginners; it works well for both the painting and the accompanying calligraphy. Use watercolor for transparent glazes.

GOLD
Gold leaf comes in books of 25 leaves and should be at least 23¾ carat. Patent gold (known as transfer gold in the U.K.) is attached to a backing sheet, which makes it easier to handle. Transfer gold (known as loose-leaf gold in the U.K.) is not attached, but is supplied between sheets of soft paper coated with jeweler's rouge. You can also use shell gold (powdered gold), metallic gouache, and bronze powders for gilding, but they are less radiant.

ADHESIVES
Plaster gesso is the most effective, but the messiest. Gum ammoniac is a good alternative and can be bought ready-made in solution. If you're a beginner, however, PVA glue is affordable and easy to apply, like a modern version of gum ammoniac.

PAPER

Historically, books and documents would have been made from vellum, a material derived from cow skin, specially treated to make it suitable for writing on. Although vellum is still sometimes used in conservation and heritage work, it is now more usual to work on paper.

For practice work, layout paper—or even copy paper—is readily available and is lightweight and smooth enough for pen and ink. For finished work, it is important to use better-quality paper that is archival; it won't yellow with age and is ideal for ink and gouache application.

MAIN TYPES OF PAPER

Handmade paper: Cellulose fibers (typically cotton) are ground up and mixed with water to form a pulp. Paper is produced by dipping a mesh-covered wooden frame (a mold) into the pulp and lifting it out with a shaking action.

Mold-made paper: Pulp is prepared in the same way as for handmade paper. It is then poured into a vat that contains a rotating mesh-covered drum (a cylinder mold). As it rotates, fibers are formed on the outside of the cylinder, which are continuously removed and further processed.

Machine-made paper: Cellulose pulp is prepared (often from mixed or lower-quality materials than the other methods) and then passed through a fast-moving wire mesh, leaving the sheet formed on the wire.

MOST COMMON SURFACES

Hot Pressed (HP): The paper is pressed through hot plates or rollers during manufacture to create a smooth surface.

Not Hot Pressed (NOT): This finish creates a matte surface. Also known as Cold Pressed.

Rough: An uneven surface achieved by having specifically rough felts on the mold or cylinder-mold machine.

The weight of paper is referred to as grams per square meter (gsm). The lower the number of gsm, the lighter the paper.

CALLIGRAPHY PAPERS

Simili Japon (1): A beautiful, smooth paper made from acid-free, high-grade wood pulp. This paper was originally made in 1900 and was designed to resemble Japanese paper. It comes in two weights—130gsm and 225gsm—and is an excellent paper for beginners because it is inexpensive and is easy to write on.

Fabriano 4 and 5 (2): A very white, smooth, inexpensive paper with good resistance to erasers. This paper is a first step up from layout paper.

Saunders Waterford (3): A warm-white, watercolor paper made from high-quality cotton rag. It comes in a variety of weights suitable for making manuscript books or finished work.

Somerset Satin (5): A versatile, luxurious, printmaking paper available in many weights. The 300gsm is ideal for finished work.

Colored Ingres: These papers are generally machine made, but some are of a high quality and can add an extra dimension to finished pieces. They are not suitable for use with watercolors.

Zerkhall (4): Medium-quality papers made from part cotton and part wood pulp. There are a wide range of surfaces and weights to try—the smooth printmaking grades are particularly good.

SETTING UP

Before you begin your calligraphy, you'll need to create the ideal working conditions, find or build a flat surface clear from clutter, assemble your pen, and make some practice marks. The following pages show you how.

WORKING ENVIRONMENT

First and foremost it is vital to be organized. To progress as a calligrapher it is important to be able to practice regularly, and this entails creating a work environment that is easily accessible and organized. If you have to hunt around for your tools and materials before you begin your practice, it is unlikely that you will get much done! It is also important that you enjoy your calligraphy practice, so make a space for yourself that is pleasant to work in and that you will look forward to using. If you don't have the room to set aside a dedicated workspace, then at least keep your materials organized in one place so you can quickly set up when you need to.

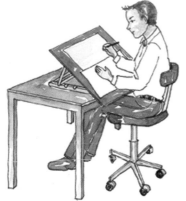

Correct sitting position
Work with both feet flat on the floor and make sure your board is positioned as close as possible to you so that you avoid leaning over. Adopt a relaxed posture and allow your arm to move freely or you will quickly tire and it will be harder to produce accurate letterforms.

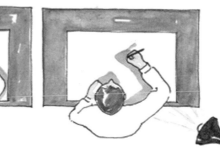

Correct lighting for right-handed calligrapher *Incorrect lighting for right-handed calligrapher*

Lighting your workspace
If you are right-handed, you should have your light source on your left-hand side; if you are left-handed, you should have your light source on your right-hand side to avoid casting shadows across your work. Work during the daytime, near a north-facing window, as the light is even throughout the day. This prevents you from straining your eyes and is the best light for accurate color work.

MAKE YOUR OWN WRITING DESK

Most calligraphers use a wooden board with an easel that sits on top of a desk or table. These come in a huge range of prices and designs, from simple pieces of masonite board to fully equipped architects' tables with parallel motion rulers. A plain piece of wood (such as the door from an old kitchen unit) can work as well as the more expensive boards. If you don't have a desk, you can sit with the board on your lap propped up against a table. The best angle for the board is about 30–45 degrees. Alternatively, you can make your own, as shown.

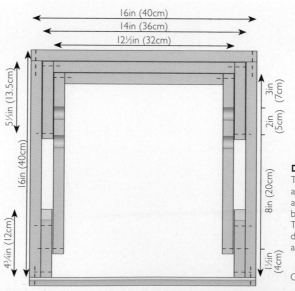

Drawing plan
The only materials required are timber, screws, a saw, and a thin sheet of masonite board to lay over the easel. This illustration shows the drawing board when flat and from a bird's-eye view.

Continued on next page ▶

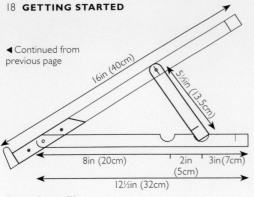

◀ Continued from
previous page

16in (40cm)

5¼in (13.5cm)

8in (20cm) 2in
(5cm) 3in (7cm)

12½in (32cm)

Board in profile
The drawing board in profile, set up at a
45-degree angle ready for writing.

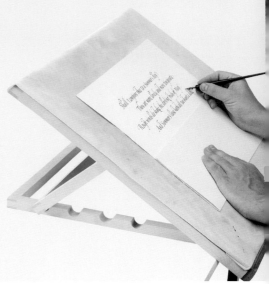

Completed board
The completed board
at a 45-degree angle—
the optimal position for
controlled ink flow, and
the most comfortable
for writing. Pad the
board with suede or
blotting paper to make
a soft yet resilient
surface for writing.

HOLDING THE PEN

A wide nib makes thick and thin
marks, depending on whether you
pull it downward or sideways. A
Copperplate pen is pointed rather
than chisel-edged; the thick strokes
are made by pressure alone. Before
you write any letters, it's important
to get to know how each pen feels
in your hand.

Holding the wide-nib pen
Hold the handle close to the nib with your
thumb and first two fingers. Twist the handle
a little between your fingers until you can feel
when the whole width of the nib is in contact
with the paper; try a thick stroke, then a
sideways thin stroke. Hold the nib firmly and
keep the full width of the nib pressed
constantly against the paper.

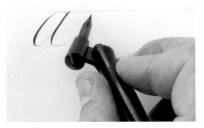

Holding the Copperplate pen
Holding a Copperplate pen is very different,
as the thick strokes are made by pressure
alone. Hold the nib directly in line with the
slope of writing. The "elbow" nib (shown)
is fashioned to assist the right-hander in
twisting farther to the right; hold the pen
with the handle pointing roughly toward
your chest.

LEFT-HANDERS

Left-handed calligraphers have
developed their own way of
working to accommodate the
movements of the dip pen. One
option is to turn the paper 90
degrees and to begin strokes at the
top of the letterform. A guard
sheet is essential for left-handers so
that your wrist does not smudge
the surface you have written on.

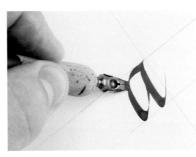

Twist your wrist a little so you can hold the
straight edge of the nib at the required angle;
a left oblique nib can help. You may find it
more comfortable to move the paper to
the left of your body, but make sure you
can still see what you're doing. If you write
"overarm," consider writing the letters in a
different stroke order, from bottom to top,
so you can still pull the ink. Take care not to
smudge the ink with your arm.

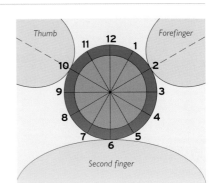

Holding the pen for best results
Imagine the pen as a clock face.
Hold the pen with balanced pressure
between the thumb and forefinger
(at 10 and 2 o' clock), the shaft resting
on the second finger for support (at 6
o' clock). Your fingers should be about
⅓in (1cm) from the neck of the nib.

ASSEMBLING A BROAD-EDGE CALLIGRAPHY PEN

One of the advantages of assembling a pen is that you can adjust it to suit your individual requirements. Dismantling, cleaning, and reassembling it regularly will also help you to become well acquainted with your writing instrument. The assembled pen here is the standard wide-nib pen used for teaching the scripts in this book.

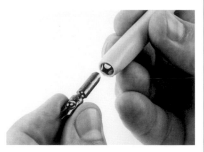

1 Ease the nib into the holder. Avoid putting pressure on the writing edge. Slide the nib in as far as possible. It should fit closely to the holder's neck.

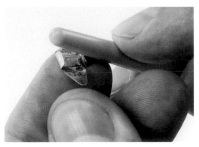

2 New reservoirs need to be adjusted to ensure they don't cause the nib to "split" and impede the flow of ink. Gently bend the reservoir around the tail of the penholder and loosen the side flaps with slight pressure from your finger and thumb so that it can slide easily onto the nib.

3 Fit the reservoir onto the nib, taking great care not to damage the end of the nib when the two are brought together.

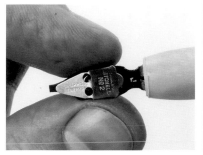

4 The reservoir should make just enough contact to prevent it from falling off. It must not grip the nib so tightly that it distorts the writing edge. Position the reservoir about ½in (3mm) from the writing edge, or farther back on smaller nib sizes.

5 If the reservoir is too far forward, it will catch the paper and drag ink across the surface; too far back, and it will not supply ink to the writing edge.

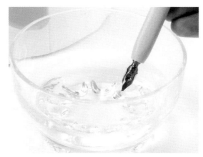

6 With a new nib, be sure to remove the protective lacquer coating—plunge it into hot water, or hold it briefly in a flame and then cool it in cold water.

CHECKING YOUR NIB SIZE

Throughout this book, the nib sizes quoted refer to Mitchell roundhand nibs, which are widely used by calligraphers. If you are using a different brand, you will need to convert these sizes to those of your nib. A simple way of doing this is to hold each of your nibs against the size checker here to determine which Mitchell size it most closely matches.

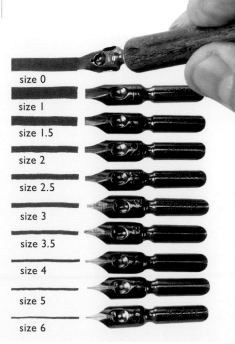

size 0
size 1
size 1.5
size 2
size 2.5
size 3
size 3.5
size 4
size 5
size 6

SHARPENING THE NIB

Nibs get tired with use and you will eventually need to sharpen them to ensure the best results. A nib is blunt when it is no longer capable of making sharp hairline strokes. A small Arkansas stone is used for sharpening nibs. These sharpening stones are smooth and good quality and will not damage nibs. A cheap alternative is grade no. 4 wet and dry paper. Sharpening pointed nibs is not recommended.

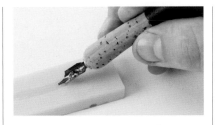

1 Place a sharpening stone on a flat surface and lubricate it with water. Place the nib at 30 degrees, with the top toward the stone and the underside of the nib facing you. Keeping the nib at 30 degrees, move it across the stone 10 to 12 times.

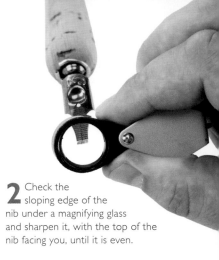

2 Check the sloping edge of the nib under a magnifying glass and sharpen it, with the top of the nib facing you, until it is even.

MAKING INK

The best calligraphy is written with ink made from Japanese ink sticks. They are handmade using a traditional process and are very high quality. The required amount of ink should be freshly prepared, as it deteriorates once exposed to air. Grinding stones come in a variety of shapes, sizes, and qualities. The smallest size is the most useful. A lid can also be helpful to prevent the ink from drying out too quickly, but is not essential.

1 Test a stone by applying a small amount of liquid to it—the slower the liquid dries, the better the quality of the stone.

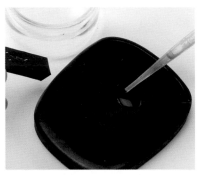

2 Add four drops of water to a grinding stone. If more ink is required, more water can be added later in increments of two drops. It is far easier to make ink too thick and dilute it than to thicken ink that is too thin.

3 Grind the stick against the stone. The ink stick should be ground slowly and rhythmically to enable the pigment to disperse as evenly as possible. Grinding for too long or with too much pressure can result in a grainy texture.

4 Stop when the ink has thickened. You will need to test the ink to assess when it is ready by dipping the nib into the ink and making a mark. It should flow smoothly and appear solid black on paper.

LOADING THE PEN

You can load your pen with ink by either dipping the pen in a full inkwell and wiping the excess ink on the edge of the pot, or by feeding the nib with a brush as shown.

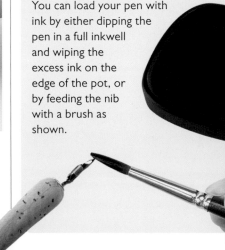

CLEANING THE BROAD-EDGE CALLIGRAPHY PEN

Taking care of your tools can become an enjoyable part of the whole craft, not a chore. A pen must be kept clean to perform well. Nibs left with ink or paint drying in their recesses will clog and rust. Rust will also develop on penholders left to soak in water with their nibs attached. When writing is finished, the penholder, nib, and reservoir need to be separated, washed, and dried.

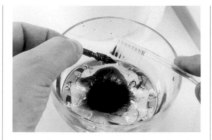

1 Ease the reservoir off the nib and soak it in a bowl of lukewarm soapy water. If it is stuck, do not force it. This may damage the nib. Soak it first to loosen any dried ink. Dip an old toothbrush in the lukewarm water, and gently scrub both sides of the nib and reservoir.

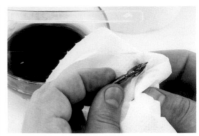

2 Immediately after washing, dry the nib and reservoir with a cotton rag. Do not use tissues, which leave fibers.

PEN ANGLE

The pen angle is the number of degrees up from the horizontal writing line that the broad edge of the pen must be held at in order to achieve thick and thin strokes in the desired places. The pen angle affects the thickness of stroke when writing, so copy the L-shapes in this exercise to train your hand to tell the difference.

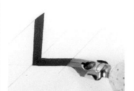

1 At 45 degrees, the upright and horizontal strokes will be equally thick.

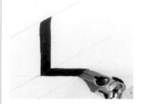

2 An angle of 30 degrees makes the upright strokes thicker than the horizontal strokes.

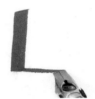

3 An angle of 10 degrees produces even more noticeably different thicknesses between uprights and horizontals.

PEN ANGLE AND LETTERFORMS

The effect of incrementally flattening the pen angle is as follows: When the pen angle is too steep, the letterform is too narrow; when the pen angle is too flat, the letters become too fat. Upright letters are written at a 30-degree angle, but as a script begins to slope, the pen angle steepens to balance thick and thin strokes.

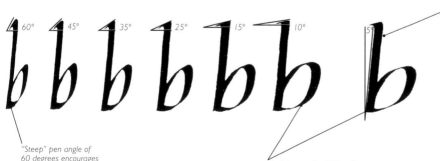

60° 45° 35° 25° 15° 10° 5°

Gothic Cursive (see page 50) is upright, but some alphabets have a forward slope, such as Italic (see page 58): it all depends on the hand.

"Steep" pen angle of 60 degrees encourages narrow letters and makes a vertical stroke.

"Flat" pen angle of 10 or 5 degrees encourages the making of wider letters, and the main, vertical strokes are much thicker.

MAKING A LADDER

A vertical ladder is needed to determine the correct x-height of the script. Construct the ladder with care, avoiding overlapping marks or gaps.

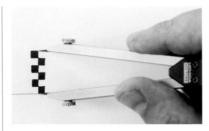

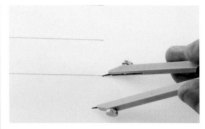

1 The full width of the nib must be used to accurately mark multiples of the nib's width. You may have to practice this several times to get precise marks. Do several ladders and measure them all to get an average. Check that you have not overlapped, or left gaps.

2 Measure carefully with a ruler the nibwidths you know you need for the style you are writing, or use a pair of dividers (as shown).

3 Rule tramlines that correspond exactly to the dividers' measurement in Step 2.

RULING LINES

It is important to take the time to rule accurately. Always use a 0.3 pencil and make light marks that are easy to erase. Rule using only the x-height lines. As you become more proficient, rule the baseline only.

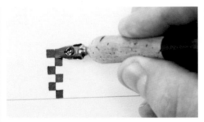

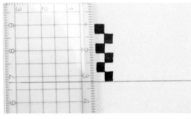

1 First find the letter height. Rule a baseline, hold the pen at 90 degrees to the line, and make square steps upward using the width of the nib. The number of squares needed varies between scripts. For example, Foundational is generally four nibwidths high, Italic is five, and Roman Capitals are six or seven.

2 Next, measure the letter height. When the ink is dry, measure accurately from the baseline to the top square.

3 Now, mark off the measurements. Use a sharp pencil to mark multiples of this measurement all down the page. Transfer the measurements to a strip of paper and mark them off down the page.

4 Now you'll need to mark some parallel lines. Lay the long side of a triangle along the first line, push the ruler against its side, and then slide the triangle down the ruler to mark parallel lines.

5 Mark points along the other edge of the paper and join up the marks, ruling carefully (and lightly) across.

UNDERSTANDING LETTERFORMS

All letters have an underlying skeleton form. By studying these forms you can become familiar with how the different elements of the alphabet relate to each other. Some relationships that are not immediately obvious when written with a broad-edge pen become apparent in the skeleton form of the alphabet. Understanding these relationships is the key to progressing quickly as a calligrapher. You should practice all the letterforms in this book in skeleton form first before progressing to the broad-edge nib.

ANATOMY OF A LETTERFORM

Keep a bookmark in this page until you become familiar with the terms that occur frequently when discussing calligraphic lettering.

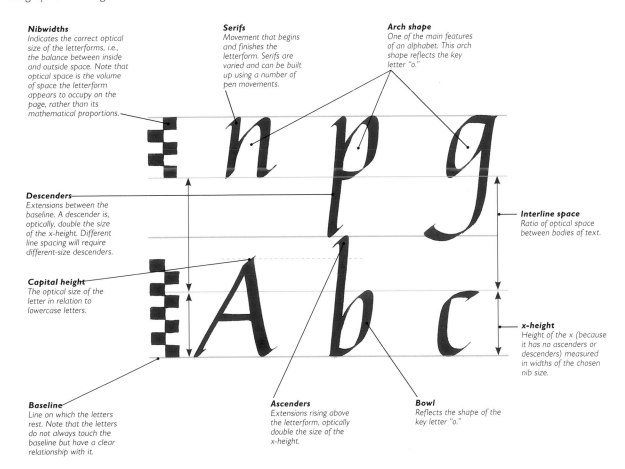

Nibwidths
Indicates the correct optical size of the letterforms, i.e., the balance between inside and outside space. Note that optical space is the volume of space the letterform appears to occupy on the page, rather than its mathematical proportions.

Serifs
Movement that begins and finishes the letterform. Serifs are varied and can be built up using a number of pen movements.

Arch shape
One of the main features of an alphabet. This arch shape reflects the key letter "o."

Descenders
Extensions between the baseline. A descender is, optically, double the size of the x-height. Different line spacing will require different-size descenders.

Interline space
Ratio of optical space between bodies of text.

Capital height
The optical size of the letter in relation to lowercase letters.

x-height
Height of the x (because it has no ascenders or descenders) measured in widths of the chosen nib size.

Baseline
Line on which the letters rest. Note that the letters do not always touch the baseline but have a clear relationship with it.

Ascenders
Extensions rising above the letterform, optically double the size of the x-height.

Bowl
Reflects the shape of the key letter "o."

CORRECTING MISTAKES

In the long term it is better to develop ways of working that reduce the likelihood of making errors than to spend time correcting mistakes. Always work letter-by-letter rather than word-by-word to avoid spelling errors. Work the piece out thoroughly in the rough so that you can take more care over areas where errors are more likely on the finished piece. Correcting errors takes time and skill; consider how many there are and where they occur—it may be less time-consuming and more satisfactory to write the piece out again. Remember that corrections are essentially damage limitation and will always be apparent close up.

SHAVING OUT THE ERROR

Shaving out the error is usually most successful on good-quality hot-pressed paper. Only shave what is absolutely necessary—i.e., the upper or lower part of the letter— and never scratch areas that do not have ink on them.

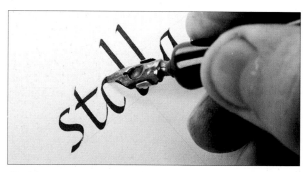

1 Assess the extent of the alteration—it may be necessary to remove part of the letter by scratching out.

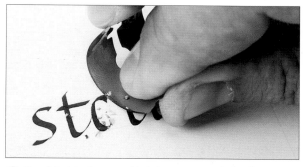

2 Carefully take the razor blade between your index finger and thumb and bend it slightly. Gently shave the mistake, 0.5mm at a time, until the ink is removed.

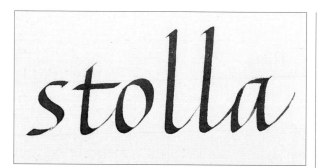

3 With your hand brush away the debris, and rewrite the letter.

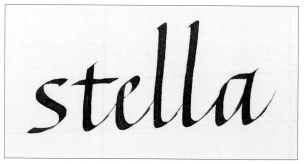

4 Make sure the ink is the same consistency as that used for the original text.

SCRATCHING OUT THE ERROR

Make sure the paper is suitable for this exercise before you attempt to scratch out the error. If the paper is not smooth, it will absorb the ink. To avoid this, lightly dust the corrected area with gum sandarac to make the surface suitable for writing. If the paper is colored, it may be possible to overpaint the mistake with colored pencil or gouache but the surface may not be suitable for writing.

1 Take the razor blade and, using the corner, scratch out the mistake.

2 The corrected word. The paper can be polished with a bone folder afterward to smooth the surface. If you need to write over the top of the correction, you may need to use gum sandarac to limit the spread of ink.

ADDING IN LETTERS

Sometimes it is possible to add in a missing letter. If you have enough space you may be able to fit in the missing letter by writing it with a smaller nib.

1 Here, because "r" creates a space, a missing "i" can be inserted without removing anything.

2 Ensure the ink consistency matches, and then fit the "i" with a hairline gap under the end of the "r."

QUICK FIXES

This method works best with letters that are from the same family groups such as "a"–"d," "o"–"e," "d"–"j," and "u"–"y."

To turn "a" into "d" (or a "g"), add a straight line to the stem.

If "l" needs to be "b," go back to the bottom corner and make a branching arch up and out, blending in at the bottom.

It is simple to turn "c" into "e" by adding a curved line, joining the stem halfway down the letterform.

If there is space to do it, an "n" changes easily into "m" by adding a repeat arched stroke. Be sure you have matched its width.

THE GUARD SHEET

The "guard sheet" is not really a specific piece of equipment. Any thin piece of paper will do, but it is very handy to have one taped over your drawing board so that you can slip your paper underneath it and your hand can lean on it when you are working. This prevents grease from rubbing off your hand onto the paper, which can keep the ink from lying evenly on the surface. If you are left-handed, it is especially important to have a guard sheet, as your hand could easily smudge your work.

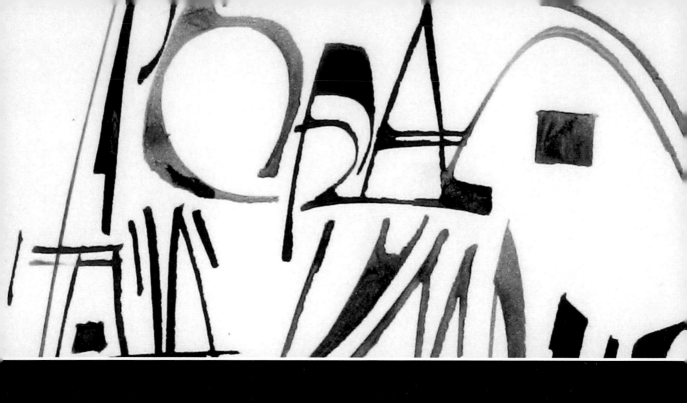

THE LESSONS

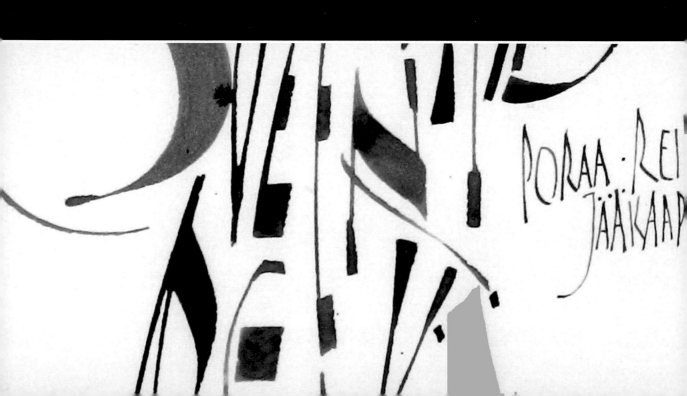

This chapter contains seventeen different alphabets arranged in chronological order, beginning with the first Western alphabet, Roman Capitals, to the most recent pen-made hand, Flourished Spencerian. All the lessons contain details of the alphabet's construction, spacing, and unique forms.

ROMAN CAPITALS:
Monoline

The Roman Capitals script is still used today for short texts, titles, and first lines of sentences, especially in written announcements. The alphabet lends itself to stylistic variations and can be illuminated or left unadorned in classical simplicity. This chapter teaches the monoline letterforms only, which illustrate the underlying proportions of the hand. Close study of the skeleton forms will make the next lesson easier, when you learn to write the hand with a broad-edge pen.

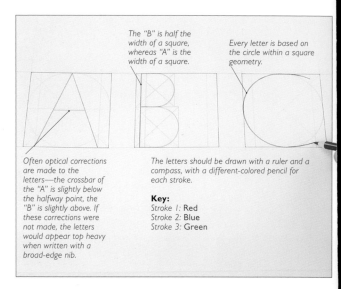

The "B" is half the width of a square, whereas "A" is the width of a square.

Every letter is based on the circle within a square geometry.

Often optical corrections are made to the letters—the crossbar of the "A" is slightly below the halfway point, the "B" is slightly above. If these corrections were not made, the letters would appear top heavy when written with a broad-edge nib.

The letters should be drawn with a ruler and a compass, with a different-colored pencil for each stroke.

Key:
Stroke 1: Red
Stroke 2: Blue
Stroke 3: Green

ABOUT THE LETTERING

The letterforms are based on geometric widths relative to the circle and the square diagrams to the right. Traditionally, there were only 22 letters in this alphabet (no "W," "U," "J," or "K"), so modern interpretations of the scripts have created these based on an understanding of the proportions that underpin the rest of the letterforms. Although the letters are based on geometrical forms, they are often "optically corrected" (that is, slight changes are made to their shape) to appear pleasing to the eye. Take care with spacing Roman Capitals to bring out their full beauty and elegance.

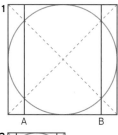

1

A B

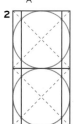

2

Constructing the letterforms

These two diagrams explain the basis of the alphabet. The first and fourth groups of letters in the family groups on page 30 are based on a circle within a square (1). In order for the letters to have different shapes but retain the same volume, one-eighth of the space is taken away for each letter. For example the "D" aligns with the left-hand grid mark (A), whereas the "C" aligns with the right-hand grid mark (B). "H" occupies the central space between the two grid marks. The narrow letters (see family group 2 on page 30) are based on a rectangle containing two circles (2).

Poem by Veiko Kespersaks

These letters are written with a no. 5 nib using bleed-proof white ink. The credit is written with a no. 6 nib at half the x-height using red ink mixed with a little white so that it stands out against the background.

" KÄRSIMYS VAIN ON /
EI KETÄÄN KÄRSIJÄÄ /
TEKO ON / VAAN EI TEKIJÄÄ /
VAPAUS ON / VAAN EI SEN ETSIJÄÄ /
POLKU ON / VAAN ANĀTMAN .
EI SEN KULKIJAA "

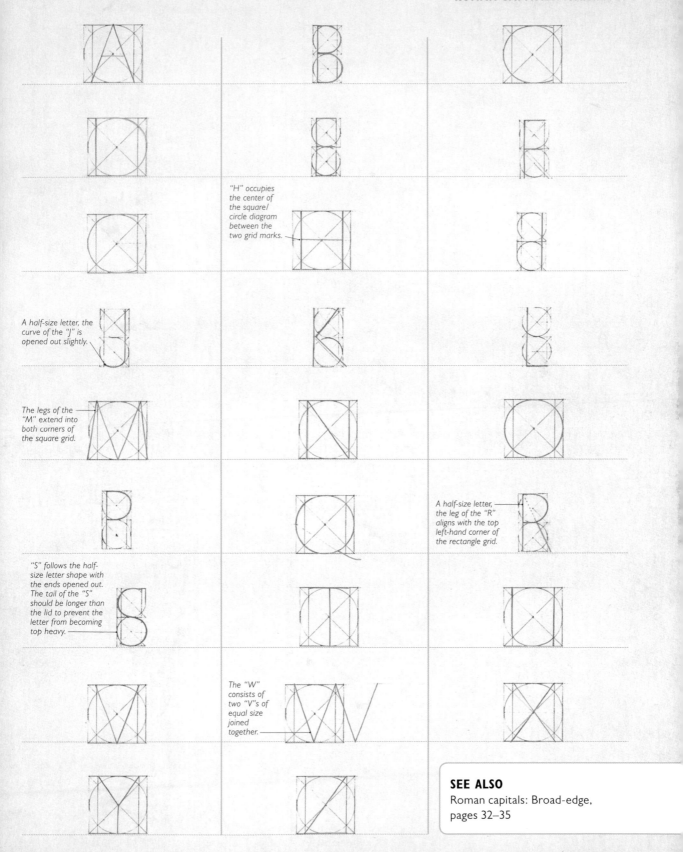

"H" occupies the center of the square/ circle diagram between the two grid marks.

A half-size letter, the curve of the "J" is opened out slightly.

The legs of the "M" extend into both corners of the square grid.

A half-size letter, the leg of the "R" aligns with the top left-hand corner of the rectangle grid.

"S" follows the half-size letter shape with the ends opened out. The tail of the "S" should be longer than the lid to prevent the letter from becoming top heavy.

The "W" consists of two "V"s of equal size joined together.

SEE ALSO
Roman capitals: Broad-edge, pages 32–35

FAMILY GROUPS

The letters are grouped according to how much space they occupy on the geometric grid (see page 28), rather than the order in which they appear in the alphabet.

HAVNTUXYZ

1

BPRKEFLIJS

2

MW

3

OQCGD

4

1. These rectangular letters occupy the same visual space as the letter "O." The crossbar of the "A" should be slightly lower than the midpoint so that the spaces visually balance.

2. These narrower letters are about half the size of the square. The top half of the letters are slightly smaller so they do not appear top heavy.

3. Much wider than the letters in group 1, the "M" is the size of two rectangles side by side; the "W" is two letter "V"s joined together.

4. The bottom and top strokes of these rounded letters are flattened to fit inside the space of the square.

SPACING LETTERS AND WORDS

The considerable variety of letter widths and shapes create particular problems in spacing Roman Capitals. It is often necessary to make optical adjustments for the text to appear even. Optical spacing is a unique characteristic of hand lettering and takes time to master. When assessing your work, it is useful to consider the spacing of just three letters at a time, as any imbalances between them will be so much more noticeable.

1. A sequence of pencil lines indicate the effect of varying degrees of pressure. The entrance and exit strokes have more pressure in the Roman Capitals script. Practicing these strokes will help you understand how gentle the pressure needs to be. This exercise is excellent preparation for working with the dip pen, which needs a very light pressure to make the ink flow smoothly.

2. Before attempting the coloring exercise, try writing out the text with the correct spacing in pencil. This will provide a guide to which letter combinations you should focus on during your practice.

3. Practice coloring in the space between letters and words. This will make the space "active" and increase awareness of how it affects the overall appearance of the piece. By practicing this coloring exercise, you will become more aware of the visual balance between letters and spaces in your work.

4. Color both letters and space between the letters to assess the balance. This exercise helps train the eye to understand even spacing.

| | | | | | | | | |

1

CARITAS PATIENS EST

2

BENIGNA EST CARITAS

3

NON AEMULATUR

4

ABCDEFGHIJKLMNOPQ RSTU VW XYZ

Optical spacing
Spacing varies depending on which letters follow or precede each other.

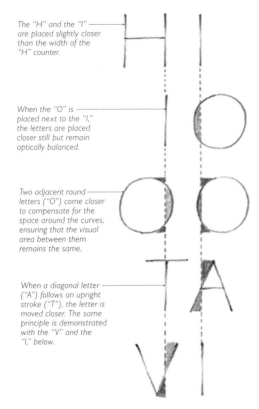

The "H" and the "I" are placed slightly closer than the width of the "H" counter.

When the "O" is placed next to the "I," the letters are placed closer still but remain optically balanced.

Two adjacent round letters ("O") come closer to compensate for the space around the curves, ensuring that the visual area between them remains the same.

When a diagonal letter ("A") follows an upright stroke ("T"), the letter is moved closer. The same principle is demonstrated with the "V" and the "I," below.

"HIOC" and optical spacing
The letters "HIOC" illustrate the principle of optical spacing. The "H" and the "I" are placed close together (slightly closer than the width of the "H"). The "O" should be placed close to the "I," as a curved letter can always be placed closer to a diagonal letter. The "C" is placed closer still, as two curved letters can be placed very close together in order to create the appearance of even spacing.

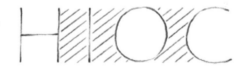

NUMBERS

The ancient Romans used a decimal system based on letters of the alphabet, combined to signify the total sum of their value. Since the fifteenth century, Arabic numerals have been the standard system in Europe. There is evidence to suggest that the original "Arabic" notation for numbers, which may have been invented in South Asia as early as the Bronze Age, contained the same number of angles that the number itself represented. So, as shown below, a number three would contain three angles, the number four would contain four angles, etc. Over time the angular forms of the letters became more rounded and it was forgotten that the number shapes had more than just a symbolic meaning.

0 1 2 3 4 5 6 7 8 9 0

ABCDEFGHIJKLMNOPQRSTUVWXYZ

I
2
3
4
5
6
7
8
9
10
11
12
13
14
15
16
17
18
19
20
21
22
23
24

ROMAN CAPITALS:
Broad-edge

Your main challenge in this lesson is to "flesh out" the Roman Capitals monoline letters using a wide-nib pen. You must maintain a consistent pen angle. Capitals are largely formed with a pen angle of 30 degrees. Practice maintaining this angle first with double pencils and then with a dip pen. This can take a lot of practice, as the bad habit of constantly changing the pen angle when you write normally can be hard to shake.

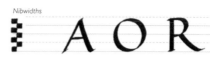

Nibwidths

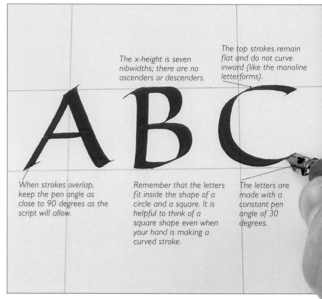

The x-height is seven nibwidths; there are no ascenders or descenders.

The top strokes remain flat and do not curve inward (like the monoline letterforms).

When strokes overlap, keep the pen angle as close to 90 degrees as the script will allow.

Remember that the letters fit inside the shape of a circle and a square. It is helpful to think of a square shape even when your hand is making a curved stroke.

The letters are made with a constant pen angle of 30 degrees.

ABOUT THE LETTERING

Roman Capitals need a lot of practice and dedication to write well, and you will find yourself returning to them many times to perfect them. Balancing thick and thin broad-edge strokes is essential to learning any calligraphic script. Learning Roman Capitals is the best introduction to understanding how the smallest changes to spacing, pen angle, and pressure can result in a huge effect on how a script appears. The most effective way to learn how broad-edge capitals work is to practice making them in different sizes. Begin with a no. 2 nib and go up to the widest nib you have—2cm if possible (see page 19). Working at this size clearly illustrates how the pen makes thick and thin lines.

"Alphabet" by Veiko Kespersaks
Capitals were written on white paper with a flat brush and diluted watercolors to form a decorative background. The red capitals in the foreground were created with a pen and red ink and were aligned with a left-hand margin. The attribution was written with a smaller nib and black ink. This was an experiment to see how capital letters work with different layout elements, rather than an actual text block. If you want to experiment with using lettering as a background design it is important to make the ink as light as possible so it does not compete with letterforms in the foreground.

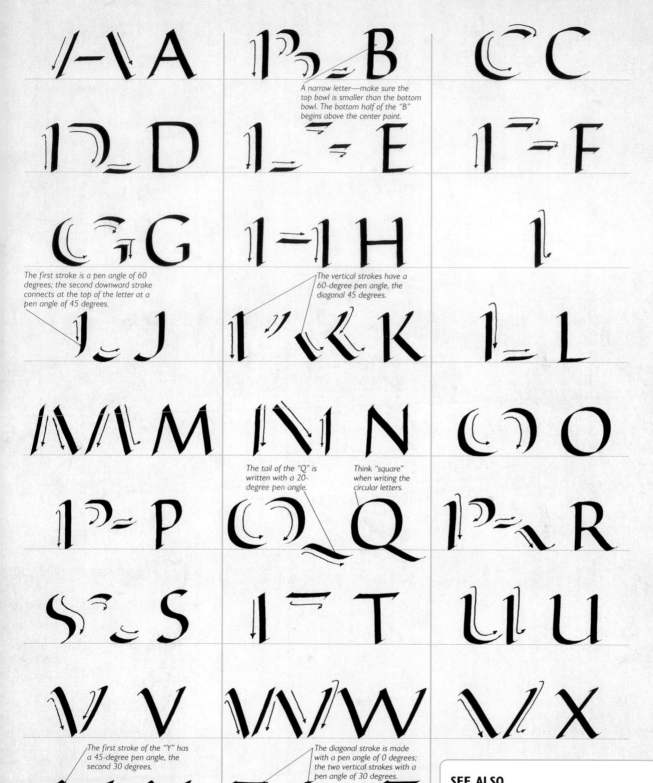

A narrow letter—make sure the top bowl is smaller than the bottom bowl. The bottom half of the "B" begins above the center point.

The first stroke is a pen angle of 60 degrees; the second downward stroke connects at the top of the letter at a pen angle of 45 degrees.

The vertical strokes have a 60-degree pen angle, the diagonal 45 degrees.

The tail of the "Q" is written with a 20-degree pen angle.

Think "square" when writing the circular letters.

The first stroke of the "Y" has a 45-degree pen angle, the second 30 degrees.

The diagonal stroke is made with a pen angle of 0 degrees; the two vertical strokes with a pen angle of 30 degrees.

SEE ALSO
Roman capitals: Monoline
pages 28–31

FAMILY GROUPS

The letters are grouped according to how much space they occupy on the geometric grid, rather than the order in which they appear in the alphabet.

1. The rectangular letters occupy the same visual space as the letter "O." The crossbar of the "A" should be slightly lower than the midpoint so that the spaces visually balance.

2. These are about half the size of the square grid (see page 28). The top half of the letters is slightly smaller so they do not appear top heavy.

3. The "M" is the size of two rectangles side by side; the "W" is two letter "V"'s joined together.

4. The bottom and top strokes of the letters are flattened to fit inside the space of the square grid on page 28.

HAVNTUXYZ
1

BPRKEFLIJS
2

MW
3

OQCGD
4

PEN ANGLES

The following exercises demonstrate how the letterforms are fleshed out by using different pen angles. Sometimes a 30-degree angle can make the strokes look unbalanced and it is necessary to adjust the pen angle to create the correct contrast between the thick and thin lines. Controlling the angle of the pen is key to achieving the thick and thin strokes that characterize Roman Capitals.

0° angle 20° angle 35° angle 45° angle 55° angle 65° angle 90° angle

In a 0-degree pen angle, the downward stroke is very thick, and horizontal stroke very thin.

In a 35-degree pen angle, the downward stroke is slightly thinner, the horizontal line slightly thicker.

In a 45-degree pen angle, the horizontal line will appear thicker, but in fact they are the same thickness.

In a 55-degree pen angle, the two lines appear very similar but they are not—the eye sees a thicker horizontal line.

In a 90-degree pen angle, the downward stroke is much thinner and the horizontal line is thick.

STROKE PRESSURE

Beginners usually use too much pressure when they begin work with the dip pen. The nib should almost "balance" on the paper with a very light touch. Think of the ink making contact with the paper rather than the pen. Make sure that you have adequately padded the writing board: You need to create a soft surface that slightly resists pressure and allows the nib and paper to make full, gentle contact. Here, number 1 demonstrates correct pressure; numbers 2–5 are incorrect.

1. To create a correct, clean line, apply slight pressure at the beginning and end of the line.

2. The nib is making contact with just one corner of the nib, causing an uneven line.

3. The nib is not connecting with the paper along its full length, resulting in a ragged line.

4. The beginning of the stroke is correct but the pressure is too light or is executed too quickly, resulting in an uneven mark.

5. Too much pressure and speed too slow, causing the ink to flood.

ABCDEFGHIJKLMNOPQRSTUVWXYZ

SERIF VARIATIONS

The pen angle can always be determined by the angle of the serif. Serifs add character to letterforms. Built-up serifs can add an air of authority; sharp serifs can appear more contemporary. When creating serifs, pay attention to the inside space of the serif to ensure that all serifs are consistent.

I MAJUSCULUS

No serif
Begin and end the stroke with gentle pressure; the main body of the stroke should have very light pressure.

I MAJUSCULUS

Sharp/Hook serifs
With a 30-degree pen angle push up slightly to make the serif and then continue down the stroke.

I MAJUSCULUS

Curve serifs
To create the correct shape, imagine tracing around an invisible circle contained inside the serif.

I MAJUSKULUS

Flat serifs
Turn the pen angle to 50 degrees and add a short flat serif.

I MAJUSCULUS

Slab serifs (hook and flat combined)
Any serif variations can be combined, but it is best to keep the choice of serifs consistent within a text block.

HOMEWORK

1. Look again at the serif variations above. The exercise helps you understand how serifs work with letterforms.

2. Using a no. 2 calligraphy nib, write a word of your choice using each of the different serifs in the example. Practice flattening the angle of the pen to create flat and slab serifs. Notice how using each serif or serif combination changes the impact of the word.

3. Remember when working on finished pieces that the serifs used in a text block need to be consistent. Write the word again but this time use only one serif variation for the letterforms. Try to make the serifs as even and as consistent as possible, especially when spacing the letterforms. Write the word at least three times, or until you have achieved a consistent text block.

ABCDEFGHIJKLMNOPQRSTUVWXYZ

1
2
3
4
5
6
7
8
9
10
11
12
13
14
14
16
17
18
19
20
21
22
23
24

UNCIALS

Uncial letters are rounded, with all arches following the shape of the "O." It is a majuscule alphabet only, with no minuscule forms ("I" and "J" are never dotted). The script shows the first signs of ascenders and descenders that would become the defining features of minuscule scripts. The letters are upright with no slant. Students who have learned compressed scripts such as Italic might have to overcome the tendency to create oval rather than circular letterforms.

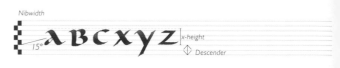

Nibwidth

ABCXYZ x-height

15° Descender

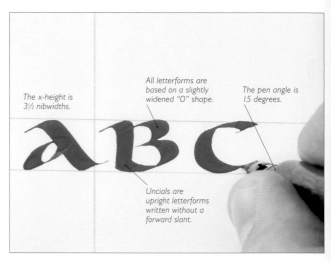

The x-height is 3½ nibwidths.

All letterforms are based on a slightly widened "O" shape.

The pen angle is 15 degrees.

Uncials are upright letterforms written without a forward slant.

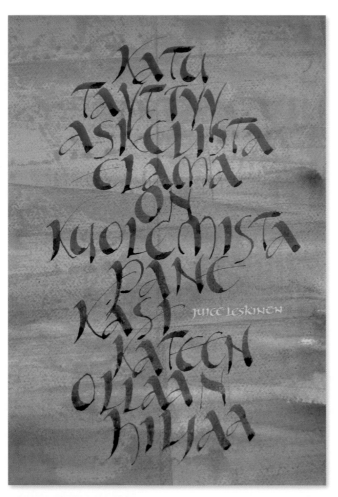

"Katu (a street)" by Tarja Luhta
This piece uses a wash of muted greens and blue-browns as a background for the stretched Uncial text. The text was written using an automatic pen to achieve the thick and thin lines. The background is acrylic paint; the credit is shell gold.

ABOUT THE LETTERING

Uncial letterforms are very legible and easily adaptable for contemporary use. The hand has no capital letters, so when a capital letter is required, it should be written larger or in a different color. Uncial hand evolved from Roman Capitals. It was the most widely used hand between the fourth and eighth century and existed in many variations throughout Europe and the rest of the world. Uncial has become associated with Christianity, as its use coincided with the spread of the religion. It is thought that the word "uncial," literally meaning "inch-high," derives from the use of 1in (2.5cm) guides that were used to assist the writing of the hand. Early manuscripts also feature symbols from the Christian faith such as the cross and the fish; this was the beginning of the process of integrating text and images, which would evolve into "illuminated" letters. The spacing should be generous to balance the interior spaces of the letters with the surrounding space on the page.

The diagonal should be straight like the side of a capital "A."

ɑ a

ʙ B

ᴄ C

The form of the "E" has become rounded, relating to the other circular letterforms.

ᴅᴅ ᴅ

ᴇ e

ꜰ F

ɢ ɢ

ʜʜ ʜ ʜ

The "I" is not dotted, as all Uncials are capital letters. Neither is the Uncial "J."

ɪ

ᴊ

ᴋ ᴋ

ʟ L

Both curves of the "M" need to be the same distance from the stem in order to look balanced.

The first stroke is longer, finishing just below the baseline. There is a variation of this letter, which is made like "h."

ᴍ ᴍ

ɴ N

ᴏ O

p p

q q

R R

s s

ᴛ T

u u

v v

ᴡ W

x X

The first stroke is diagonal; the second begins with a curved serif and curves down to form the tail.

y y

z Z

FAMILY GROUPS

Uncial is a transitional script, existing in the period before the split between majuscules and minuscules. It therefore has characteristics of both scripts. The descenders and ascenders are still very short and have yet to adopt the extended forms that we know from later scripts. Uncial later evolved into Foundational script.

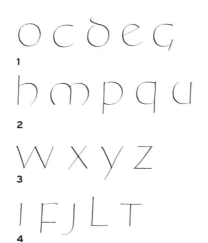

1. All Uncial letters are rounded in shape but the "O" is slightly wider than a circle, and the "C," "D," "E," and "G" all follow this lead.

2. These letters have one curved side and one straight side.

3. These letters also maintain the width of the "O." When written with a broad-edge pen the diagonals should be the same thickness as an upright stroke. The right to left diagonals should be thinner than the left to right strokes.

4. These letters are constructed from straight lines crossing or joining.

BASIC STROKES

Making the smooth circular strokes that form the Uncial hand requires practice. If you are already familiar with Italic, then you will need to overcome the tendency to compress the letters and make the "O" into an oval shape.

1. Write the half-moon curve from top left to bottom right. Remember that the "O" is slightly wider than a circle.

2. Practice writing the corresponding curve in a clockwise direction. It is helpful to trace the shape of the "O" before writing it to fix the shape clearly in your mind.

3. Write both the curves practicing smooth joins. The "O" should join at 11 and 5 o'clock.

Warm-up exercises

With the addition of the "O" exercise you have just practiced, the exercises that follow make up all the component strokes of the letterforms. Remember to write slowly and rhythmically. Uncial is a hand that is not meant to be rushed.

OOOOOO

Think of a circle as you make the "O"s in two strokes, and space them evenly.

IIIIII

Keep these upright and evenly spaced, making small sharp entry and exit serifs.

Keep the round form, flat top, and thin exit stroke.

CCCCCC

Make each "U" shape touch; keep the interior spaces identical.

UUUUUU

uuuuuu

These are straight, not curved, strokes on a consistent slope, with minimal serifs at each end.

HOMEWORK

1. Using a fairly large nib (Mitchell 3.5 or a 3) rule up the paper to four nibwidths for the letterforms and three nibwidths between the lines.

2. Practice writing out the letters in family groups.

3. As soon as you can confidently reproduce all (or nearly all) the letterforms, progress to writing out your choice of words. You may need to practice the same word a number of times before you feel confident.

abcdefghijklmnopqrstuvwxyz

LETTER SPACING

Uncial letter spacing is visually balanced to maintain the overall feeling of round forms. Be generous with space between straight letters; don't crowd them, so that the texture of a page of writing is airy. Write slowly and evenly, considering the placing of each letter.

minimum

A good word to practice as it has both straight and curved lines.

minuo

Note the connection between the curves of the "m," the base of the "u," and the "o." Try to keep them the same shape or the word will appear unbalanced.

una

"a" is written with a pen angle between 10 and 15 degrees. Avoid flattening the angle any further or the letter will appear too fat.

unber

Note the top curve of the "b," "r," and "e." Maintain the same slight curve when writing all three letters.

successio

All letters use either the top or bottom curve of the "o." Ensure they are balanced.

thymum

The "y" has a slight curve to harmonize with the curves of the other letters. It is also written with a very short x-height (two nibwidths).

quadrum

The "a" has been rounded, as it occurs between a curved line and a straight line. This creates the appearance of even spacing.

abcdefghijklmnopqrstuvwxyz

1
2
3
4
5
6
7
8
9
10
11
12
13
14
15
16
17
18
19
20
21
22
23
24

FOUNDATIONAL:
Minuscules

This hand is usually taught to beginners because it has many features that are relatively straightforward to learn. As the pen angle is an almost constant 30 degrees, there are fewer manipulations to master than with the broad-edge pen. All the strokes are "pulled" rather than "pushed" (as in Italic), and the letters are based around the circular "o" shape. The clarity of the circular forms makes the connections between the different families of letters much easier to see.

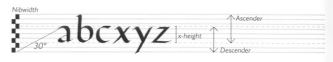

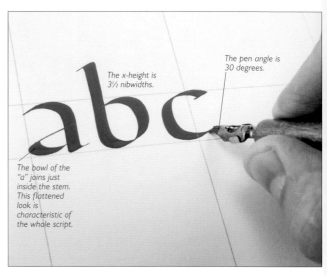

The x-height is 3½ nibwidths.

The pen angle is 30 degrees.

The bowl of the "a" joins just inside the stem. This flattened look is characteristic of the whole script.

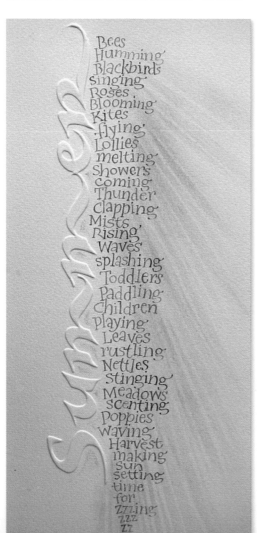

ABOUT THE LETTERING

At the beginning of the twentieth century, Edward Johnson researched medieval manuscripts in the British Library to find a script that could be standardized for teaching the foundations of calligraphy. The Ramsey Psalter, a tenth century Carolingian alphabet, became the model for what would later be known as Foundational hand. Johnson produced many beautiful manuscript books and samplers using the hand, often using black and red ink and clean, minimal layouts. His version of the hand used pointed serifs, but any serif can be effectively used with the letterforms. The script is ideal for contemporary use and is equally suited to use as a "book hand" as well as for producing artwork for quotations and poetry.

"Summer" by Jan Pickett
Arranging a stack of single words lined up against a single vertical title makes a striking design. The contrast of white embossed "Summer" against the colorful text is enhanced by the "sunshine rays" effect.

a a b b *Form the arc of the "c" with a curved stroke; complete the lid of the "c" with a slightly arching stroke.*

c c

d d e e *Make the lid of "f" as in letter "c"; line up the crossbar with the top end.*

f f

Note that the top bowl is smaller than the bottom.

g g h h i i

j j k k l l

Ensure that the arches are not too curved and are related to the top of the letter "o."

m m n n o o

Make a downward stroke beginning and ending with equally sized serifs. Begin the curved stroke just below the top of the letter.

p p q q r r

The base and top of the "s" should relate to the lid of the "c."

The crossbar should be just below the top of the x-height of the letter.

s s t t u u

v v w w x x

y y y y z z

FAMILY GROUPS

Understanding the skeleton letterforms in their family groups will greatly enhance your progress when writing with a broad-edge pen. It's helpful to note the similarities of construction of letters within the same group.

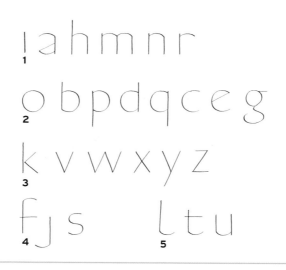

1. Note how the arches share the same characteristics in this group.

2. For these letters, keep as much of the circular "o" as possible.

3. This group is constructed of predominantly diagonal lines.

4. Note that the arch of "f," the bowl of "j," and the top and bottom of "s" are the same curve.

5. These bottom curves match each other.

BASIC STROKES AND PRESSURE

When starting with the broad-edge pen, it is important to maintain a consistent pen angle, to allow the pen to do the work in creating thick and thin strokes naturally. Practicing strokes of similar shape is the best way to begin.

1. Make a half-moon curve with the pen at a 30-degree angle.

2. Make a clockwise curve, starting and ending with a fine point.

Warm-up exercises

It is best to do these warm-up exercises as often as possible to familiarize yourself with the script. Produce two pages of these exercises before going on to write the hand itself.

mmm

Start the curve high up, make a semicircle, and then go straight down.

uuuu

This is a reverse of the first exercise; allow joining at the base of the letterform.

ooooo

Space these "o" shapes evenly, and keep them very round.

llllll

Keep these strokes vertical with minimal entry and exit serifs.

HOMEWORK

1. Rule up a page of four nibwidths with two x-heights between.

2. Mark 1in (2.5cm) margins all around.

3. Write a piece of continuous prose to fill the page.

4. Check for consistency.

abcdefghijklmnopqrstuvwxyz

MOVING FROM MONOLINE TO WIDE-NIB

Working with double pencils forms a valuable introduction to working with the shape of a broad-edge nib, as the underlying construction of the letterforms, especially the branches, can be clearly seen. Remember to keep the pencils at a 30-degree angle except on the "k," "v," and "w" to compensate for the thick and the thin lines.

The illustrations here show how different letters relate to the circular letter "o."

Note that the arch of the "n" originates from inside the stem at exactly the point of the "o" axis.

Slightly flatten the downstroke of the "e." Make sure the right-hand points of the letter are aligned and that the crossbar finishes at exactly halfway.

Make sure the left-hand points of the letter are aligned. The first stroke of the "a" is like the branch of the "n."

Crossbar is the same height as the top arch of the other letters.

Flatten top and bottom stroke to increase the inside space of the letter.

Grouping the letters
Practice letters in family groups to understand the location of the branches and other structural points.

JOINING LETTERS AND WORDS

In most cases, all the letters are kept separate, but where awkward combinations occur, with an exit stroke taking up too much space, it is convention to join it to the next letter.

minimum
The simplest spacing, with all straight-sided letters, needs no joining.

imagio minuo que
It may be convenient to join the "g" tail to the "i."

successio tabellae
Join the two "c"s if necessary, for overall texture.

Join "l" to "a" as close as possible for spacing.

thymum una

abcdefghijklmnopqrstuvwxyz

1
2
3
4
5
6
7
8
9
10
11
12
13
14
15
16
17
18
19
20
21
22
23
24

COMPOSITION AND LAYOUT

Regular practice of letterforms develops a sense of how text works on the page. These experiences are invaluable in learning how the layout, or design, affects the work. It can be tempting to discard your practice sheets as "failures." However, keeping them for reference not only provides a record of your progress but also allows you to analyze why some layouts work and others do not. Practicing layout skills is just as important for your progress as a calligrapher as practicing letterforms; it also makes your practice much more interesting.

PORTRAIT OR LANDSCAPE?

Portrait can feel formal and dignified; landscape can feel more open and calming. Squares are best suited to alphabet panels and abstract work rather than text blocks.

MARGINS

When you use your writing for a finished piece of work, the margins that you choose will make an important contribution to the overall effect. To show your writing to best advantage, you need to balance the text against the space around and within it. The amount of space between the lines, between areas of text, and between heading and text helps to determine the proportions of the outer margins. Too much space weakens a design; insufficient space makes it look cramped. Generous margins are generally preferable to narrow ones, because the surrounding space gives the text unity.

Many designs use the traditionally proportioned margins found in printing and picture framing, and these are easy to calculate (see right). Others may flout convention to achieve a particular effect. Each piece of work has its own requirements. Your ability to assess margins will gradually become second nature.

Side margins should be equal, but the bottom margin should be larger than the top, so that the work does not appear to be "slipping off" the page. If a title or author's name is used, this should be considered as part of the text area when measuring margins. As well as the more traditional margin proportions shown here, there are many other possibilities where less conventional margins would be appropriate to the mood and layout of the text. These include placing the text high or low on the page with exaggerated space above or below, or placing it to one side of the page. Such margins are assessed more intuitively than "traditional" margins.

Calculating margins for vertical layout
For a vertical panel of text, the top margin is gauged by eye and doubled for the bottom margin. A measurement between these two is used for the sides.

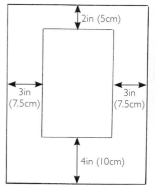

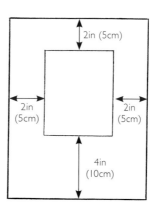

An equal measurement for the top and sides, with a deeper margin at the bottom, is sometimes appropriate.

Calculating margins for horizontal layout
For a horizontal panel of text, the widest spaces need to be at the sides. Side margins should be equal.

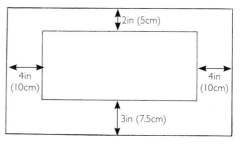

LAYOUT BASICS

Layout is the arrangement of text (as well as images) on the page. The aim is to bring together the visual and textual content of the work in a way that is attractive, harmonious, and legible. To some extent, layout will be dictated by the purpose of the work, the degree of formality or freedom involved, and the mood that is sought. No single format will suit every case. Creative decisions always depend upon individual judgment. This is an exciting area for discovery, but there are guidelines that can help you.

Layouts can have a vertical or horizontal shape, and text may be aligned left, aligned right, justified, centered, or asymmetrical (see below). Deciding which arrangement to choose means considering the overall "texture" of a piece of work in terms of positive and negative shapes—marks on the page and the spaces between them. Accustom your eye to looking for weak features when planning your layout, and aim for positive rather than understated contrasts, such as large and small, dark and light, strong and weak.

The choice of layout also depends on the sense and mood of the text, and the way it divides into lines. For a poem, line endings need to be kept as the poet wrote them. In interpreting prose, line breaks can be planned to enhance the meaning of the text. It is usual to have lines of five to nine words in a relatively lengthy text. In short texts, just one or two words per line can provide an interesting layout. Line spacing and the style of script—tall or laterally spreading letters—will also affect the shape of the text area. It is useful to begin by making thumbnail sketches.

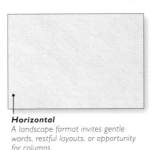

Portrait
Choose this format for short lines, formal quotations, or dynamic compositions.

Horizontal
A landscape format invites gentle words, restful layouts, or opportunity for columns.

Square
A square invites geometric arrangements radiating from the center or perhaps a circle or spiral.

TYPES OF LAYOUT

The main types of layout are shown here. Most important of all, when deciding on layout, is to consider the meaning and the purpose of your work: Are you seeking an overall effect or something that will need close study to be appreciated?

For example, Roman Capitals have huge effect but are slower to read than minuscules (although this might be the effect you are aiming for). Long lines can be tiring on the eye, as are text blocks that are too dense.

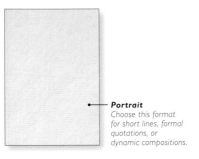

Centered
The writing lines are balanced equally on either side of a central line (drawn faintly in pencil for guidance and erased when writing is complete). This symmetrical layout is often useful when balancing long and short lines. A centered layout is most suitable for poetry or short prose pieces.

Aligned left
All writing lines begin from a straight vertical left margin. This gives a strong left-hand edge and a softer effect on the right-hand side. Avoid marked variations in line length and split words. This is a versatile layout, used for both poetry and prose.

Aligned right
The lines are aligned vertically on the right. This layout can be effective in giving a degree of tension to a design, although it takes practice to achieve the necessary accuracy of letter widths and spacing. This layout is often seen in short texts such as letterheads.

Justified
Both right and left edges are vertically aligned. Skill is needed to calculate word spacing to achieve this effect. Justified layouts produce a formal effect that is useful for prose work.

HEADINGS

Roman Capitals are useful as headings because they are dominant letterforms, but the choice of lettering is yours. Here are some effective layout variations for marrying main text with the title and credit.

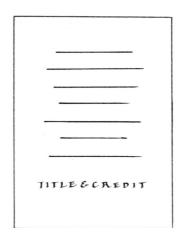

Traditional layout gives a formal feel. Keep the credit small and evenly spaced, arranged to balance the title.

If your words stand up for themselves give the title a lower profile, particularly if the main text is powerful language.

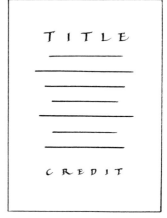

Here the title is spread wider, with credit to match, giving the design a broader shape, keeping it formal.

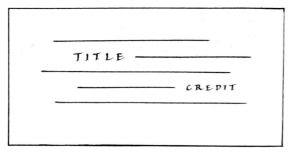

Here the title and credit are placed inside the text.

Here the title and credit have wide spacing between letters—landscape format.

DROP CAPS

Drop caps (capitals) originate from illuminated manuscripts and are an easy way of adding visual interest to a text block. If the drop capital is placed inside the margin (see variation one), make sure there is enough space to accommodate it.

Capital inside text

Capital halfway between text and margin

Capital outside the margin

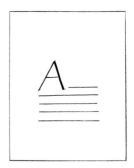

Very large capital

PLACING FLOURISHES

Ensure there is enough space around the flourish and that it does not collide with other letterforms. Generally flourishes should be used to extend an ascender or descender or lead in to the top left-hand corner of a letter.

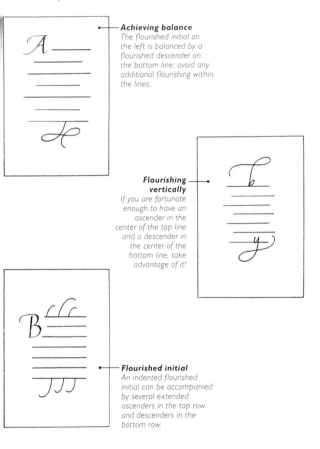

Achieving balance
The flourished initial on the left is balanced by a flourished descender on the bottom line; avoid any additional flourishing within the lines.

Flourishing vertically
If you are fortunate enough to have an ascender in the center of the top line and a descender in the center of the bottom line, take advantage of it!

Flourished initial
An indented flourished initial can be accompanied by several extended ascenders in the top row and descenders in the bottom row.

HOMEWORK

Choose a short piece of text and write it a couple of times to decide what format would work best. It is useful to try different formats and pen sizes. When you have assessed your rough drafts, write out the text on good-quality paper. Avoid breaking words and try to make sure the heading/credit/text balance each other.

Either find your own text, or use the following Latin phrase:

Vitae summa brevis spem nos vetat incohare longam.

(Life is short. We cannot entertain ambitious hopes.)

EXPLORING LAYOUTS USING A COMPUTER

Planning a draft version of your work allows you to try different ideas and anticipate any problems. Contemporary calligraphers use computers, as they are a quick and accurate way of generating layouts. Use InDesign, Illustrator, or a basic word-processing program for this exercise.

1. Choose a font that is the closest match to your calligraphic handwriting.

2. Try different text alignments, such as right aligned, centered, justified, etc., to get a feel for the best way to use your text on the page.

3. Add some illustrations or different backgrounds. If you have experimented with different ideas, choose the one you like the most and print it out at the size you would like it to be in the finished work.

4. You will need to match approximately the size of your font to the size of your nib. Rule-up your paper for the size of your chosen nib.

5. Write your text, using your computer printout as a guide. Computers have different spacing than the written word, so you may need to write the text out twice to find the correct spacing.

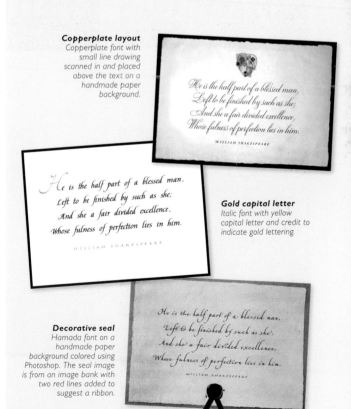

Copperplate layout
Copperplate font with small line drawing scanned in and placed above the text on a handmade paper background.

Gold capital letter
Italic font with yellow capital letter and credit to indicate gold lettering.

Decorative seal
Hamada font on a handmade paper background colored using Photoshop. The seal image is from an image bank with two red lines added to suggest a ribbon.

I
2
3
4
5
6
7
8
9
10
11
12
13
14
15
16
17
18
19
20
21
22
23
24

DECORATIVE BORDERS

Borders can be used to "frame" the text or to add a special finishing touch. You need to use them with care so they don't dominate the text or create an imbalance in the overall design. Think about the text and what border it suggests to you—if you are working on a text block about flowers, for instance, use a border with a different design element, such as leaves.

TYPES OF BORDERS

Although good calligraphy should be able to stand alone, there are situations in formal or creative work where decoration can enhance the written text. Decorative borders from Eastern and Western historical manuscripts are an infinitely varied source of reference. These borders may influence your own designs, but try to use them in new and creative ways. The wealth of designs in Western manuscripts includes simple linear borders, consisting of different-colored bands of varying widths. These may be plain, divided into decorated rectangles, or feature repeating patterns of geometric or intertwined plant elements. Sometimes the border is an extension of a decorated initial letter. A myriad of plant designs, including complex floral designs, are found in Flemish, French, and Italian manuscripts from the late medieval period onward.

As with any other form of decoration, the border must be appropriate to the subject and script, and should be an integral part of the work as a whole.

Floral border
A floral border all around would be appropriate for a framed panel or formal certificate.

Floral motif
A more restrained use of a floral motif makes a quiet design.

Balanced
When balancing a border top and bottom, ensure that the top is a little stronger.

Alternating motifs
This pattern of alternating motifs gives movement to a static design.

Border on left
A border along the left is more interesting if it is wavy rather than straight.

Border on right
A border along the right can be manipulated to fill any short lines in a piece of vertical text.

Along two sides
A border along two sides gives a spacious feel.

Along the bottom
A border along the bottom acts as a decisive ending to the composition.

Interspersed motifs
Interspersed floral motifs allow up-and-down placing of blocks of text.

Formal
One focal decoration flanked by smaller motifs creates a formal design.

DESIGNING THE BORDER

These simple borders can be used as the basis for your designs.
Try using different designs with a text block to get a feel for how
they work with the writing.

Straight stem
All decoration is added to branches coming from the main stem. This border is most effective on one side of a text block and when it is not too long.

Curvy
This is a very flexible border that is effective at any length. It can also be extended or further embellished at a later date if required.

Branched
This is a good choice when a narrow border is required. It is most effective when used at a longer length.

Crossing
This is a good choice for shorter pieces of text. Avoid adding too much decoration to the inside space of the border.

Spirals
A very attractive, versatile, and easy border. The spirals can be made bigger or smaller, depending on the length of the border.

INCORPORATING BORDERS INTO YOUR LAYOUT

Computers are an invaluable tool for the contemporary calligrapher because they make adding and removing design elements quick and easy. Using a computer will speed up your learning as you improve your design skills. Favorite design ideas can be saved as templates, to allow you to model subsequent work on the same design.

1. Make some line drawings of borders you like.
2. Scan and import to your computer.
3. Experiment using your borders and text together; remember that this does not have to be perfect—you are simply trying out different design ideas for your final work. If you don't like your hand-drawn borders, there are many designs you can download free of charge from the Internet.
4. Select and print out the design that appeals to you the most. In pencil, draw (or trace) your border and add color with watercolor pencil or gouache and a brush.

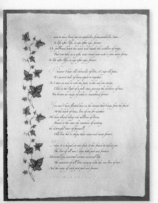

Ivy border
Zapfino font on a handmade paper background, with text aligned to the left.

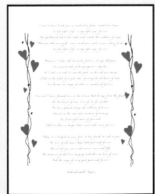

Love hearts
Hamada Lt Pro font with centered alignment. The hearts were drawn with the computer mouse.

Flower border
Lucida font on handmade paper background. The border was drawn by hand then scanned in.

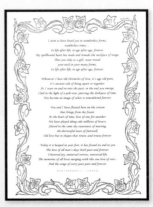

Frame border
Corsiva font with yellow capitals to suggest gold lettering. The border is from an image bank.

1
2
3
4
5
6
7
8
9
10
11
12
13
14
15
16
17
18
19
20
21
22
23
24

GOTHIC CURSIVE:
Minuscules

Also known as Bastarda, the Gothic cursive lowercase script is characterized by compressed, angular letterforms based around an "o" pointed at the top and the bottom, and the pointed arch of the "n." Another feature of the hand is the long and heavy "f" or "s." The hand is written in an even, regular style, much like a picket fence. For this reason, it is important that the dots of the "j" and "i" be well executed to ensure legibility. The script has a romantic "antique" feel that lends itself to proclamations or historical quotations.

Nibwidth

35ª abcxyz

Ascender

x-height

Descender

The x-height is four nibwidths.

The letterforms are compressed, with pointed arches at the top and bottom.

The hairline strokes that form the branches of the "a" and "b," the lead-out stroke of the "c," and many other letters in the alphabet are made using the corner of the nib.

All letters have the same inside space, which is about as narrow as the upright strokes.

The pen angle is 35 degrees.

ABOUT THE LETTERING

Many different writing styles developed throughout Europe in the period following the use of Carolingian hand. These included various sharply pointed Gothic or blackletter styles, which were often richly ornate and decorative. The more legible Gothic cursive (or Bastarda) became popular in England and Holland during the fifteenth century. As the materials for the manufacture of books were still very expensive during this period, these hands used sharper quills (to enable the script to be written smaller). Letterforms were compressed to fit more words onto a page, and books themselves became smaller. The hand could also be written much faster, meeting the increase in demand for books as the rate of literacy throughout Europe increased.

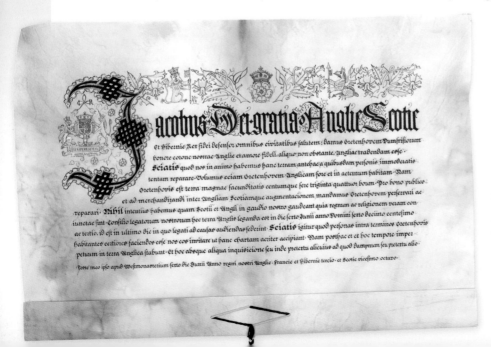

Fake document by Veiko Kespersaks

This document, created to imitate a Royal Proclamation from James I, featured in a television program. It was written on vellum with shell gold drawings and gall ink, which are historically accurate materials. The document is written in Gothic cursive style with capital letters.

The branch of the "a" is halfway up the letterform (like Italic), but with the addition of a flat serif.

a

b

c

The second stroke of the "d" has the same inside line as the "s."

d

e

The letter that dominates the alphabet is "f" (historical Latin texts had many). The descender is longer than that of other letters.

f

The tail of the "g" is formed first using the pen corner, followed by the thick line of the descender using the full nib. This is the only letter formed this way.

g

h

i

j

k

l

m

n

o

The descender of the "p" is formed with a straight downward stroke, but with a change in the angle to create the sharpened tail.

p

q

r

The branch is halfway up the letterform (like Italic), with the addition of a small square serif before the downward stroke.

s

t

u

v

w

x

y

z

SEE ALSO

Gothic Cursive: Majuscules, pages 54–57

FAMILY GROUPS

Writing out the family groups in pencil is a good way to understand the structure of the letterforms and will ease the progression to using a broad-edge pen when writing in Gothic cursive.

1. These letters are rounded, with a sharp point at the bottom or top.

2. These are rounded letters with the branch ending in a flat line. Letters in this group have a sharp point at the bottom. They are usually formed in one stroke.

3. The letters in this group end with a flat serif. They are formed with the branch halfway up the x-height and end with a flat serif. Note how the top right-hand corner of each letter ends with a sharp point.

4. Diagonal lines form these letters. The "w" is made from two joining "v"s, and the "y" is essentially a "v" with a descender.

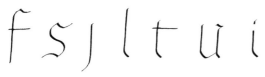

5. The letters in this group have a flattened curve on the top or a slightly bent line on the bottom. The bend on the base of the "l" and "t" relates to the base of the "u."

Warm-up exercises

Do a line of each exercise to make sure the ink is flowing and to familiarize yourself with the component strokes of the hand. It is not necessary to spend more than a couple of minutes on these exercises. If one exercise is hard, return to it later in the session.

Maintaining a 40-degree pen angle, make strong downstrokes, and then end in fine hairlines.

Make the "diamond" top before pulling down and across as before.

This is a down-and-up motion; ensure the upward curve is a fine hairline stroke.

Make these "c" strokes in two movements and practice regular spacing.

HOMEWORK

1. Rule up to an x-height of four nibwidths using a Mitchell no. 2 nib (see page 19).

2. Begin by writing out the alphabet, inserting an "m" between each letter. This will help with the flow and rhythm of writing.

3. Note any letters that you find particularly difficult, and write out words that include them. Practice inserting a "u" or "m" between every second letter until you can write them confidently.

abcdefghijklmnopqrstuvwxyz

BASIC STROKES

The script is written with an x-height of four nibwidths; the ascenders and descenders with three nibwidths. At a 40-degree pen angle, many of the letters are formed by pushing up, or have a hairline stroke as a descender, which is done with the left edge of the nib. These exercises will help you to apply just the right amount of pressure to achieve this script.

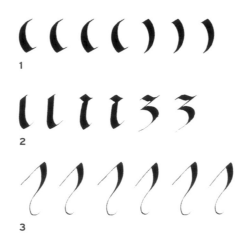

1. Make a compressed half-moon stroke, applying pressure on the upstroke. End in a sharp point, not a full curve. Repeat the shape, starting from the top this time and applying pressure on the downstroke.

2. Most letterforms have a point at the bottom and a flat shape at the top. Practice these shapes to familiarize yourself with this characteristic stroke.

3. This stroke forms the tapering tails of letters like "f" and "s," but may also be used for "m," "n," "r," "h," or "y." The hairline stroke of the descender is formed by turning the nib on its point.

LETTER SPACING

Spacing the Gothic Cursive minuscule script is similar to spacing Italics (see pages 58–65). The letters should be parallel to each other and appear uniform like a picket fence.

minimum

"Minimum" is a good word to practice to understand spacing and rhythm. The space inside and between the letterforms needs to appear even.

imagio

The descenders do not join the letterforms in this script.

Small ligatures (joins) can help keep the spacing of the letters even.

quadrum

minuo

The two "c"s are placed closer together to make the space equal to two parallel lines.

succesio

The word has the same space inside and between the letters.

The tail of the "s" has been executed with a manipulated hairline stroke like "h" or "y." This balances the word.

tabellae

The "e" is placed closer to the "l" and the "a" is placed closer to the "t." This visually compensates for the space inside these rounded letters. No matter what the combination of letterforms, the space must be adjusted to appear even.

thymum *una* *vita*

When two letters with descenders are placed together, the first one is always slightly shorter than the second.

Like the letters, the words should be as even as possible; think of placing an "o" or an "n" between words.

abcdefghijklmnopqrstuvwxyz

GOTHIC CURSIVE:
Majuscules

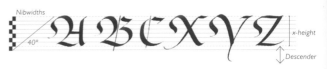

Nibwidths · 40° · x-height · Descender

Used sparingly and with consideration the richness and weight of these majuscules can add a lot of visual interest to a text block. They require more space around them than other majuscules so that they do not appear crowded. They are always used with minuscules, as they are too illegible to be used on their own. When planning a text block using these majuscules, it is also useful to bear in mind that if the letterforms are grouped together, they can be too dense and "black spots" can appear in the text. It is best to attempt these letterforms after progressing through the rest of the book, as they are quite challenging for beginners.

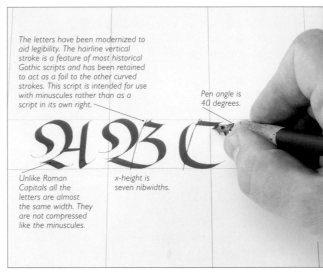

The letters have been modernized to aid legibility. The hairline vertical stroke is a feature of most historical Gothic scripts and has been retained to act as a foil to the other curved strokes. This script is intended for use with minuscules rather than as a script in its own right.

Pen angle is 40 degrees.

Unlike Roman Capitals all the letters are almost the same width. They are not compressed like the minuscules.

x-height is seven nibwidths.

ABOUT THE LETTERING

Gothic scripts were used extensively in the Middle Ages across Europe, and many different styles emerged. As a consequence there is no definitive version of the script. The letterforms featured in this book are based on analysis of different historical scripts and have been refined to be more legible, easier to write, and more contemporary but still retain the Bastarda "look."

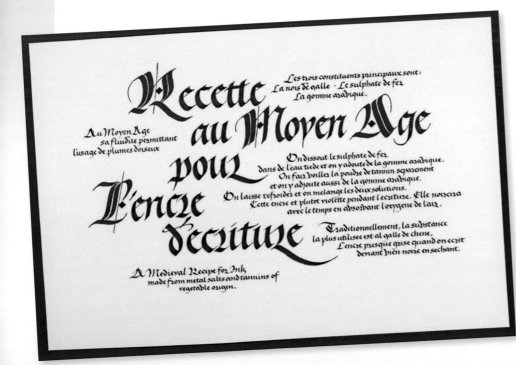

"Batarde French Medieval recipe" by Maureen Sullivan
This contemporary example of Gothic cursive references French historical forms of the script—for instance, the half "r" used throughout the text. This is an alternative to the more legible "r" used in this book. To create the decorative capitals, the scribe has used red ink and, using the same nib, has created some double-thickness lines with a white gap in between. The capitals are further embellished with black vertical lines and triangular dots. Note the use of the pen corner to add hairline decorations to the capitals (for instance either side of the "A") and to create the tails of letters such as "v" and "g."

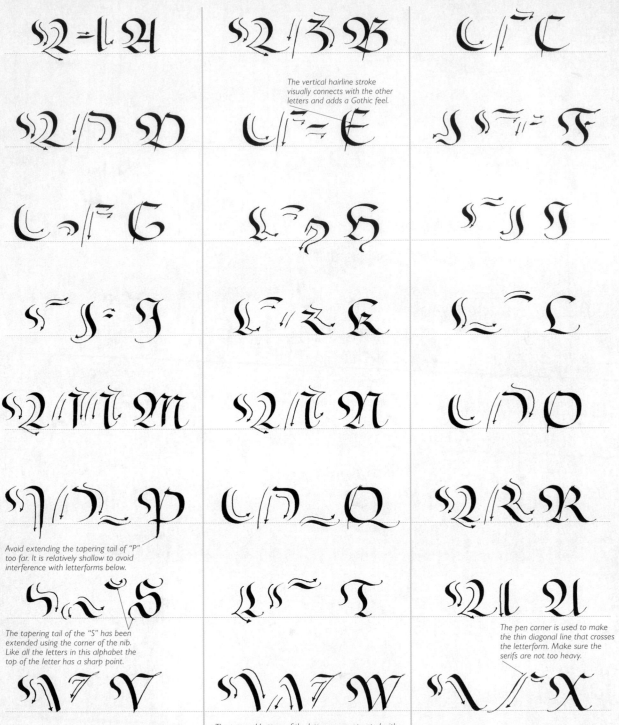

The vertical hairline stroke visually connects with the other letters and adds a Gothic feel.

Avoid extending the tapering tail of "P" too far. It is relatively shallow to avoid interference with letterforms below.

The tapering tail of the "S" has been extended using the corner of the nib. Like all the letters in this alphabet the top of the letter has a sharp point.

The pen corner is used to make the thin diagonal line that crosses the letterform. Make sure the serifs are not too heavy.

The top and bottom of the letter are constructed with a pen angle of 35 degrees, which tapers to the pen corner at the end of the stroke. The central diagonal line is made with a flat pen angle.

SEE ALSO

Gothic Cursive: Minuscules, pages 50–53

FAMILY GROUPS

These majuscules are not a historically accurate hand. They are a modern interpretation of manuscripts from different historical periods and geographic locations. However, they are constructed in the same way as the other scripts, and letters that share the same characteristics are organized into family groups.

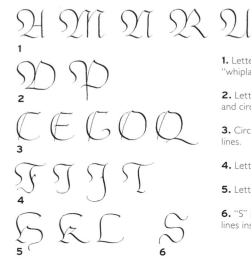

1. Letters that begin with a curved "whiplash" line.

2. Letters containing a curved whiplash line and circle.

3. Circular letters broken with diagonal lines.

4. Letters with flat tops and straight lines.

5. Letters with circular tops.

6. "S" is in its own group, as it has curved lines inside.

BASIC STROKES

These strokes are the building blocks of the alphabet; practice making these marks before progressing to writing out words. They can be written in different ways, many without pen lifts.

1. "Whiplash curve"— best achieved in two downstrokes.

2. Push up with pen corner and then curve down in a confident sweep, as in "D" and "P."

3. Straight line with curved flat serif and curved lid.

4. Straight line with a curve at base; release pressure on the exit stroke.

5. Half-moon made from top down, releasing pressure.

6. Half-moon ending in a curved serif.

Warm-up exercises

It is best to do these warm-up exercises as often as possible to familiarize yourself with the script. Ideally you'll want to produce two pages of these exercises before going on to write the hand itself.

Start and end with light pressure and make a sweeping curve.

Make this "s" shape as if enclosing two circles.

This shape is like an "s," but the middle is a straight stroke.

Make a light cross stroke before pulling down and out.

A two-part stroke; preserve a good internal shape.

Push up with the pen corner to create a thin line and then curve down. Try to complete without pen lifts.

LETTER SPACING

Gothic Cursive is spaced much like Italic—the upright compressed letterforms appearing regular like a picket fence. If the x-height varies, the letter spacing will remain the same. Gothic Cursive can be tightly spaced with some letters joined together. Practice words with and without joins to develop a feel for how the script can be connected. Do not force joins.

Minimum

This is written with a very small x-height, which gives a denser effect and contrasts with the capital.

Imagio

The "g" does not have a natural connection line so the serif of the "i" has been extended.

Minuo

The top of the "M" and "u" are curved, but they are not given any additional space. The spacing is even, much like Italic spacing.

Note that the "Q" is attached twice to the following "u."

Quadrum

Succesio

To help preserve even spacing, "c" and "e" are joined.

The historical "U" is very similar to the letter "A." There is more space inside the "U" to distinguish it from the letter "A."

Una

Vita

The "t" and the "a" join top and bottom to assist spacing.

LETTER VARIATIONS

There are many variations for Gothic Cursive majuscules, as the script was written differently in different historical periods and geographical locations. The minuscules, too, have many variations—not just in the letterforms, but in the ascenders, descenders, and flourishes.

Minuo

The horizontal line decreases the inside space of the letter. The tail of the "M" is finished with the pen corner.

The space is balanced by adding a dot, which decreases the inside space of the letter.

A thin line cuts the shape in half. The tail of the "S" has been extended.

Quadrum

Succesio

The flag shape of the ascender has been extended into a flourish.

The ascenders have drooping, curved extensions.

Tabellae

Tabellae

Thymum

ABCDEFGHIJKLMNOPQRSTUVWXY

1
2
3
4
5
6
7
8
9
10
11
12
13
14
15
16
17
18
19
20
21
22
23
24

ITALIC:
Minuscules

Italic is currently the most widely used and taught of all the hands, and it crops up in a number of variations. Its characteristic thick and thin strokes, springing arches, and gentle forward slope are instantly recognizable in contemporary signage and illustration as well as calligraphic work.

ABOUT THE LETTERING

Italic grew out of the "humanist" hands of Renaissance Florence. The Humanists were a group of scholar scribes who produced and published their own editions of classical texts. It is thought that the change in writing style was a reaction against the medieval period and an attempt to reflect the new spirit of learning embodied in the Renaissance. One of the most celebrated scribes of this era is Bartolomeo Sanvito, whose richly colored and often beautifully illuminated manuscripts survive in museums around the world.

By the mid-fifteenth century the invention of the printing press by Johannes Gutenberg had an

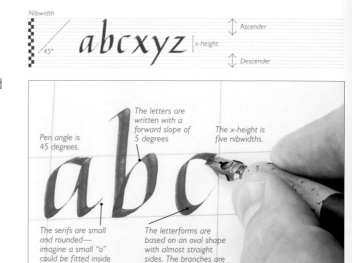

Nibwidth

45°

abcxyz

Ascender
x-height
Descender

Pen angle is 45 degrees.

The letters are written with a forward slope of 5 degrees

The x-height is five nibwidths.

The serifs are small and rounded— imagine a small "o" could be fitted inside them. Avoid making the serifs too angular.

The letterforms are based on an oval shape with almost straight sides. The branches are halfway up the stems. It is vital to pay attention to the structure of the branches to ensure that the inside space of the letters is equal.

influence on the writing of Italic as scribes tried to emulate the uniform appearance of the printed letter. Although the printing press had an enormous impact on the written word (Bibles could now be mass-produced), there was still a demand for handwriting skills for letters and formal correspondence. Italic became the handwriting of literate Europeans. Its popularity spread by the proliferation of printed instructional manuals produced from the sixteenth century onward. This golden era lasted until the rise of Copperplate during the eighteenth century.

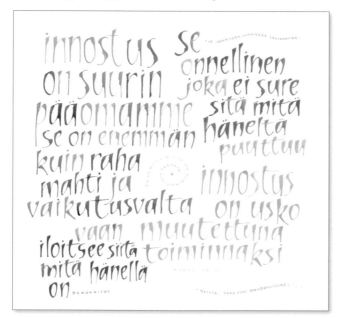

"Onnellinem" (Euphoria)
by Merja Koivumiemi
These lively Italic-based letterforms were written with an automatic pen to create a sense of dynamism and movement. The artist has manipulated the angle of the pen nib to vary the thickness of the line, and complementary colors add a sense of excitement.

Push upward in a curve all the way to the line.

uıa

b The line enclosing the top space must be above halfway, to keep the inside space small.

Flatten the curve to match "s."

*c*c

uıd

e

ff

uıg

h

i

j

k

The base of the "l" relates to the oval arch shape. Don't make it too flat.

l

mmm

nn

oo

The two halves are of equal width. The branches spring from halfway up the letterform.

Push up from the baseline and then hook out.

p

q

r

The top half of the letter is slightly smaller than the bottom half. Make sure the "s" does not lean forward.

ss

t

uıu

First line is written with a 45-degree pen angle; second line with a 30-degree pen angle. This balances the letter.

vv

www

x

Alternative "y"

yy y

z

SEE ALSO

Italic: Majuscules, pages 62–65

FAMILY GROUPS

These skeleton letters have been made more angular so that the relationships between the letters are more apparent. Writing out the family groups in pencil is a good way to understand the structure of the letterforms and will ease the progression to using a broad-edge pen.

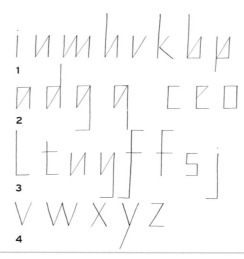

1. The branches spring from halfway to two-thirds up the height of the letters in this group.

2. Note that "a–q" shapes are triangular (although softened when written out with a pen) and "c–o" are more oval.

3. Note the base curves of this letter group and relate to the branching arches of group "i–p."

4. These letters are made from predominantly diagonal strokes.

BASIC STROKES AND PRESSURE

Italic minuscules are written at a 45-degree pen angle and a slope of 5 degrees. The branching characteristic of this hand makes it necessary to adjust pen pressure to lighten up on the upward strokes to allow the pen to flow unrestricted.

1. At a 45-degree pen angle, make a small serif, straight downstroke at a 5-degree slope, and exit right, still at 45 degrees.

2. The asymmetrical arch of "n" emerges halfway up the stem.

3. Arch formations emerge progressively from the base of the stem.

4. Emerging very high up is a nonstandard option.

Warm-up exercises

It is best to do these warm-up exercises as often as possible to familiarize yourself with the script. Ideally you'll want to produce two pages of these exercises before going on to write the hand itself.

Arched letter practice
Develop a rhythm of writing, aiming for asymmetric arch forms and evenly spaced letters.

Arched and diagonal letters
Practice arched letters with diagonals, keeping the axis of "v" sloping, and paying attention to even spacing.

HOMEWORK

1. Rule double lines for five nibwidths of your pen.

2. Write the letters in their family groups using a pencil. Repeat each group as often as necessary, checking your work against the examples on this page.

3. Using an edged pen, write out the alphabet, softening the arches.

abcdefghijklmnopqrstuvwxyz

SPACING LETTERS

Aim to keep an overall appearance of equal distance between uprights. Some diagonal or open-sided letterforms require optical spacing.

hioc

1

minim

2

nvivniv

3

1. Space "oc" closer than "hi" to compensate for curves.

2. All uprights should be the same distance apart.

3. Awkward spacing generated by "v" against uprights will need to be adjusted.

JOINING LETTERS

Although standard form does not join letters, some combinations benefit from joining in order to preserve good spacing. Difficulties such as two descenders in "f" (or "y") are resolved by making them different.

1. Join the crossbar in one stroke.

2. Save space by joining "f" and "t" with the crossbar.

tt ft ff rv st

1 2 3 4 5

ce ti ul mo

6 7 8 9

3. Shorten the first "f" to allow the second descender more space.

4. Join "r" and "v" to reduce the gap.

5. An ornamental join for "s" to "t."

6. Join "c" to "e" to close the gap.

7. Ensure that the crossbar of "t" is narrow.

8. Join "u" to "l" to gain rhythm.

9. An optional join for "m" to "o."

JOINING DIFFERENT STYLES OF LETTERFORMS

The standard form of Italic keeps all letters separate. Joining letters creates a less formal, more fluid appearance. Join them with hairline upstrokes. Begin with easy combinations of letters to join and repeat the same words, ensuring that even pressure, rhythm, and spacing is maintained.

non ducor

1

non ducor

2

non ducor

3

1. Letters kept separate, with an "o" width between words.

2. Letters joined; exit stroke intrudes into word space so there is a wider gap.

3. Joining pointed forms.

abcdefghijklmnopqrstuvwxyz

1
2
3
4
5
6
7
8
9
10
11
12
13
14
15
16
17
18
19
20
21
22
23
24

ITALIC:
Majuscules

Italic capitals are easier and faster to write than Roman Capitals. Like their minuscule counterparts they lend themselves to more variations in letterforms, serifs, and spacing. They are often used for whole blocks of text rather than just for the beginning of lines. It is important to understand the structure of Roman Capitals before attempting Italic capitals, as they share the same characteristics.

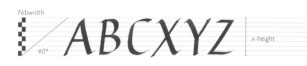

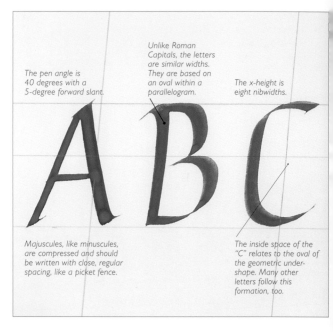

Nibwidth

40°

x-height

The pen angle is 40 degrees with a 5-degree forward slant.

Unlike Roman Capitals, the letters are similar widths. They are based on an oval within a parallelogram.

The x-height is eight nibwidths.

Majuscules, like minuscules, are compressed and should be written with close, regular spacing, like a picket fence.

The inside space of the "C" relates to the oval of the geometric under-shape. Many other letters follow this formation, too.

ABOUT THE LETTERING

Early manuscripts used traditional Roman Capitals. Italic capitals were an innovation of printers rather than scribes. The first printed font was based on Italic scripts, the Italic capitals were developed to match this printed font, and, as they were compressed and sloping, printers were able to fit more letters onto a page (and consequently save money). Italic capitals have a more contemporary and informal feel than Roman Capitals. With experience, further variations can be introduced such as the letters "dancing" on the baseline, or horizontal lines such as the crossbars of "A" or "E" being inclined slightly. These touches can make the letters appear lively and more approachable.

Poem in red and white by Veiko Kespersaks
This delicate panel is written in two different-size pens, in two colors on black paper. The white lettering is Estonian; the red is the English translation.

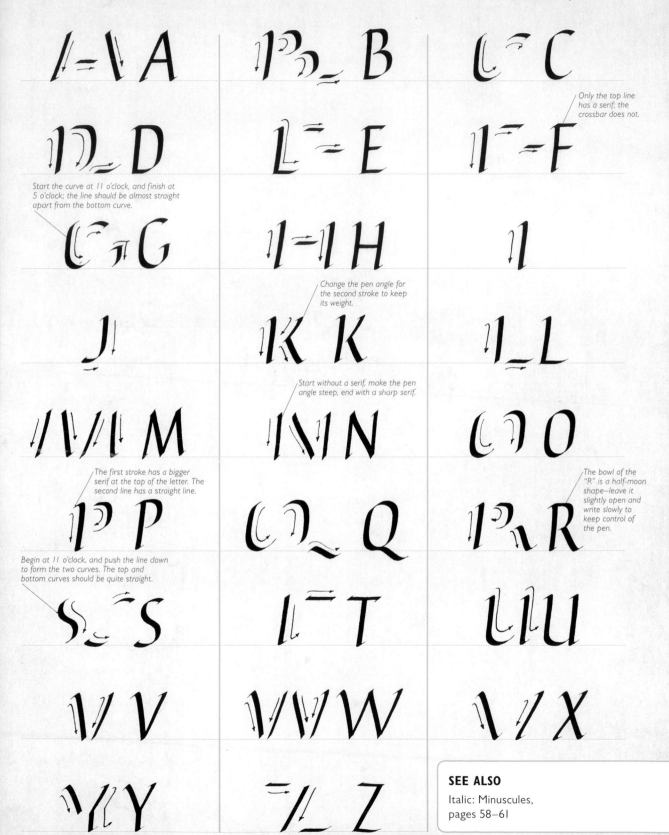

Only the top line
has a serif; the
crossbar does not.

Start the curve at 11 o'clock, and finish at
5 o'clock; the line should be almost straight
apart from the bottom curve.

Change the pen angle for
the second stroke to keep
its weight.

Start without a serif, make the pen
angle steep, end with a sharp serif.

The first stroke has a bigger
serif at the top of the letter. The
second line has a straight line.

The bowl of the
"R" is a half-moon
shape—leave it
slightly open and
write slowly to
keep control of
the pen.

Begin at 11 o'clock, and push the line down
to form the two curves. The top and
bottom curves should be quite straight.

SEE ALSO
Italic: Minuscules,
pages 58–61

FAMILY GROUPS

Although the letterforms are based on Roman Capitals, so can be grouped according to their width, these differences are less marked because of the compression and slant of the letters. The letters have a 5-degree forward slant.

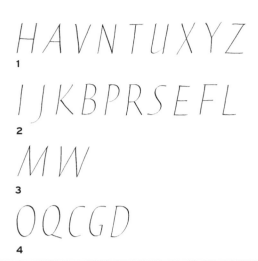

1. "H" and "U" should be three-quarters the width of the "O." All these letters should be as wide as the "H."

2. These are half the width of the parallelogram, apart from the "I" and "J," which are single-stroke letters.

3. The "M" should be the same width as the "H"; the "W" should be the width of two "V"s.

4. The bowl of "D" echoes the right-hand curves of "O" and "Q."

SERIF VARIATIONS

The pen angle can always be determined by the angle of the serif. Serifs add character to letterforms; built-up serifs can add an air of authority, and sharp serifs can appear more contemporary. Pieces that are rendered entirely in Italic capitals are often written without serifs or with a basic hook form.

1. Hook serifs (top and bottom).

2. Hook serif (top) and slab serif (bottom).

3. Sharp serifs (top and bottom).

4. Hook serif (top) and sharp serif (bottom).

5. Flat serif (bottom) and sharp serif (top).

6. Flat serifs (top and bottom).

1 2 3 4 5 6

Warm-up exercises

It is best to do these warm-up exercises as often as possible to familiarize yourself with the script. Ideally you'll want to produce two pages of these exercises before going on to write the hand itself.

Make vertical strokes, keeping the pen in contact with the paper at all times, practicing even spacing and maintaining the 30-degree pen angle.

Steepen the pen angle (for "N" uprights) and practice getting this thinner vertical for other letters.

Maintain a 30-degree pen angle and make horizontal right-to-left strokes; they should be thinner than vertical strokes.

Maintain a 30-degree pen angle and make diagonal left-to-right strokes; resist the temptation to change the angle of the pen.

Practice "pulling" the pen from right to left, making diagonal strokes and maintaining a 30-degree pen angle.

This stroke forms the "lid" of "C" and "G." Practice making a short, only slightly curved stroke.

HOMEWORK

1. Rule double lines with a height of eight nibwidths 1in (2.5 cm) apart.

2. Write the letters in their family groups using a pencil. Repeat each group as often as necessary, checking your work against the examples printed on this page.

3. Using an edged pen, write out the alphabet.

ABCDEFGHIJKLMNOPQRSTUVWXYZ

SPACING LETTERS

Spacing Italic capitals is similar to Roman Capitals, but, as they are based on an oval form rather than a circle, they are more compressed. Consequently there is less space between letters and words. However, the spacing must appear even, so refer to the guidelines on spacing Roman Capitals (see pages 30–31). There are fewer pen manipulations than for Roman Capitals. However, it is important to keep a similar pressure throughout the strokes—it is easy to vary the pressure without realizing it when writing diagonal lines, for example.

MINIMUM

This is a good word to practice because the "M" requires wider spacing than the other letters.

The inside space of the two halves of the "M" must be equal.

GLORIA

Check that the "A" is not wider than the "O."

The spacing between narrow letters and oval letters is similar.

IMAGIO

The spacing of the "G" and the "I" is too big compared with the "M" and the "A."

UNA VITA QUADRUM

Don't press too hard on the diagonal strokes.

Make sure "Q" and "D" are wider than the rest of the letters.

LETTERFORM VARIATIONS

Capitals are more flexible than their Roman counterparts. Because of their slant, and their more regular width, it is easier to generate a greater number of variations. These include variations in pen size, letter size, and spacing. The examples below are suitable for unflourished letterforms only.

ABCDEFFGHIJKLMNOPQRSTUVWXYZ

A smaller x-height results in thicker lines. Angle the pen at 30 degrees on the vertical strokes to add more weight to the letterforms.

ABCDEFGHIJKLMNOPQRSTUVWXYZ

A thinner nib and bigger x-height results in thinner letterforms.

ABCDEFGHIJKLMNOPQRSTUVWXYZ

Double-size x-height results in compressed letterforms. You may need to balance thick and thin lines by changing the pen angle.

ABCDEFGHIJKLMNOPQRSTUVWXYZ

SPACING LETTERS AND WORDS

Calligraphy is spaced optically rather than by precise measurements. The spaces between words are judged by how the eye perceives spatial balance and harmony rather than by mathematical formulas. To the twenty-first-century scribe accustomed to the uniformity of the printed word, this can be challenging. Balancing the inner and outer spaces of letters, especially taking into account the effects created by using a broad-edge pen, can be learned only through experience.

SPACING BASICS

Use the width of an "n" to judge how far apart vertical strokes should be. A curve next to a vertical is a little nearer, and two curves back-to-back are the closest.

The aim of spacing in most calligraphic scripts is to make the areas of space within and between letters appear equal. If all letters were straight-sided, this would be easy—you could simply measure the same amount of space between each of them. As letterforms vary, however, you need to be aware of the spacing needs of different combinations of letters.

This means thinking about the area inside each letter—the counter space—as well as the white area created around the letter itself. In practical terms, to achieve even spacing, a curved letter should be placed closer to a straight-sided letter than another straight-sided form

SPACING LETTERS

It is important to understand negative spaces between letters. Train your eye to the effect of close and wide spacing. There is a magnetic relationship between the letterforms—too close and they stick together; too far apart and the relationship between them is lost. When spacing is correct, letters and spaces will appear harmonious.

Closed up	Spaced out	Closed up	Spaced out
abc	*a b c*	*abc*	*a b c*
Closed up	Spaced out	Closed up	Spaced out
ABC	*A B C*	*ABC*	*A B C*
Closed up	Spaced out	Closed up	Spaced out
Abc	*A b c*	*Abc*	*Abc*
Closed up	Spaced out	Closed up	Spaced out
Abc	*A b c*	*Abc*	*Abc*

would be, and two adjacent curved letters should be placed closest of all. Spacing patterns of each script can be established with the aid of the diagram below. Using this diagram, you can verify the amount of space needed to achieve balance.

THE RULE OF THREE

Look at the first three letters in your writing and see whether the space on either side of the middle letter appears equal. Then, looking at the last two letters of that trio and the following letter, verify the spacing on either side of the new middle letter. Continue in the same fashion until you have checked the entire word, rewriting if necessary. Follow the instructions below.

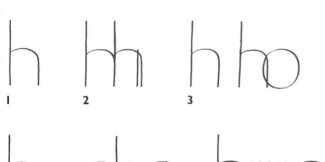

Rule lines in pencil ½in (13mm) apart. Copy the "h i o c" diagram in pencil, using the following guidelines:

1. Write the "h," ensuring that it is the correct width, because it will determine the spacing pattern.

2. Place an "i" next to it, slightly closer than the width of the "h" counter (in blue).

3. Write an "o" slightly closer to the "i." To maintain the appearance of equal space, adjacent straight-sided and curved letters need to be closer than a pair of straight-sided letters.

4. Place the "c" even nearer to the "o," because adjacent curved letters let in additional space between them at top and bottom.

5. The completed exercise.

SPACING WORDS

Each of the hands has its own unique characteristics and spacing requirements. As a beginner you may find Copperplate easier to work with, as it is written monoline and so is closer to normal handwriting; the most difficult is Roman Capitals. Words written too close together will appear cramped and from a distance will appear as dense black areas. If words are written too far apart, then "rivers" will appear in the text, and the eye will travel down the text rather than reading it from side to side. Most hands look best when they appear evenly spaced and rhythmical; for optimal spacing it is useful to imagine an "o" or "n" between each word.

Correct spacing

Ars longa, vita brevis

When words are close enough, the eye travels with ease across the page; the gap should be just enough to distinguish separate words.

Incorrect spacing

Ars longa, vita brevis

When the gap between words is generous, each word floats separately. Here you can see uneven spacing within the words; compare "longa," which is tight, with "brevis."

Correct spacing

Ars longa, vita brevis

Keeping control of word spacing holds the line together and helps you maintain a writing rhythm.

Incorrect spacing

Ars longa, vita brevis

In Copperplate particularly, as this is delicate, lightweight writing, generous space between words can reduce legibility considerably.

INTERLINE SPACING

Keep the text as clean and uncluttered as possible—three to four x-heights between lines should be enough. The more words in a line and the wider the letterforms, the more interline spacing will be needed. Tighter spacing means that shorter lines can be used. The ideal is to produce writing with an even "texture," which is easily legible and comfortable for the eye to read.

Generous spacing
With four x-heights between lines, there is plenty of space for the eye to read across, and it may even allow for some flourishing. This gap is particularly appropriate when writing long lines— more than eight words per line—as it helps the eye to travel across.

Karrisima, noli tardare
studeamus nos nunc amare
sine te non potero vivere
iam decet amorem perficere

4 x-heights

Three x-heights
With Copperplate writing, with its potential for long ascenders and descenders, sufficient clearance to keep them from clashing is important, so three x-heights should provide the minimum. Use this gap for anything shorter than eight words per line.

Karrisima, noli tardare
studeamus nos nunc amare
sine te non potero vivere
iam decet amorem perficere

3 x-heights

Italic spacing
Generally, two and a half times the x-height is good interline spacing for a formal Italic. There is no danger of ascenders and descenders clashing, and the weight of the writing, being heavier than Copperplate, carries the eye across the page.

Karrisima, noli tardare
studeamus nos nunc amare
sine te non potero vivere
iam decet amorem perficere

2½ x-heights

Closer spacing
If ascenders and descenders are not too long, then it is possible to work with narrower interline spacing. Check always that the spaces between words are still narrower than the interline space, to avoid having white "rivers" running down the page of text.

Karrisima, noli tardare
studeamus nos nunc amare
sine te non potero vivere
iam decet amorem perficere

2 x-heights

SPACING FLOURISHES

Flourishes must have enough space around them; otherwise they will look cramped. Beginners often underestimate the amount of space that is needed, so add flourishes to letters at the beginnings or ends of lines only where there is enough space to accommodate them. Flourishes must appear balanced, so when there is a lot of space, it does not always make sense to expand the flourish to fill it. Like letterforms, they must have balance between inside and outside space.

The right-hand side of a letter is always less flourished, as it usually needs to join onto the following letters in a word. Flourishes can originate from the beginnings or endings of lines, or where two lines connect on the top line. Flourishes should never be added to the parts of letters that connect on the bottom line, for example "N," "M," or "V."

Written without flourishes; x-height is correct and spacing is regular.

Breaks out of the rhythm; asymmetric "m" and "n."

More interlinear spacing; descenders and ascenders are written faster.

Size of writing changing; the letterforms are jumped and written in different sizes.

Sharp and curve lines and pen manipulation; tail of "y" is sharpened

Written faster with more joined forms and large loops.

HOMEWORK

1. Write four short lines of text (three to four words per line) at two and a half x-heights interline space.

2. Write three long lines of text (eight-plus words per line) at four x-heights interline space.

1
2
3
4
5
6
7
8
9
10
11
12
13
14
15
16
17
18
19
20
21
22
23
24

FLOURISHED ITALIC:
Minuscules

Cursive Italic is written much faster than traditional Italic. Rather than lifting the pen after each letter, the letters are joined by thin ligatures, which may be diagonal or horizontal. This affects the letterforms themselves, which subtly alter depending on how they are joined. In addition, the decorative flourishes allow much scope for individual expression.

ABOUT THE LETTERING

A more slanted, cursive version, which closely resembles the Italic script we know today, began to appear during the Renaissance and has been attributed to Niccolò de' Niccoli in around 1420. It is thought that this new style of writing inspired the early Italic typeface. This new cursive style of Italic was much faster to write, as it had fewer pen lifts, simple serifs (usually just simple entry and exit strokes), and a constant pen angle. It was during this era that the stroke began to be pushed up from the bottom line, against the resistance of the pen. This innovation enabled the creation of the springing asymmetrical arches that characterize the script. Originally, the script would have been written with sharp quills, which make pushed-up strokes easier to execute than the modern metal nib.

Retirement card by Veiko Kespersaks
This retirement postcard is written very quickly and spontaneously. The letterforms have a lightness and informality that brings the text alive. It was written with a quill and sumi ink stick on handmade paper.

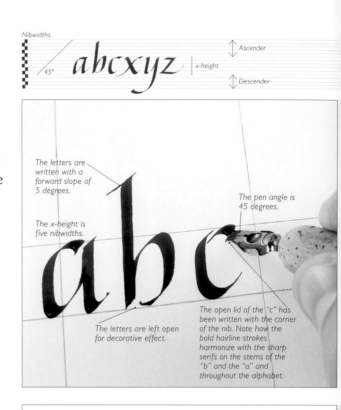

Nibwidths

45° abcxyz x-height Ascender Descender

The letters are written with a forward slope of 5 degrees.

The x-height is five nibwidths.

The pen angle is 45 degrees.

The letters are left open for decorative effect.

The open lid of the "c" has been written with the corner of the nib. Note how the bold hairline strokes harmonize with the sharp serifs on the stems of the "b" and the "a" and throughout the alphabet.

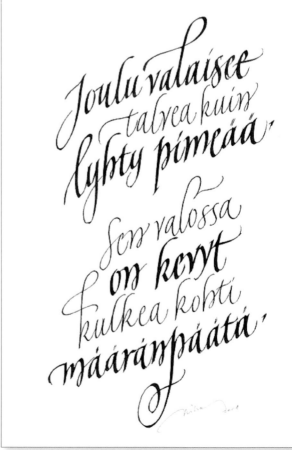

vv a

bb b b

c c

For the variation, extend the stem of the "b" using the left-hand pen corner or end with a long sharp serif.

d d d

c e e

f f

This variation can be done without loops; just push out with the left-hand pen corner.

g g

bh bh

i i

J j

k k k

l l ll

The second stroke begins inside the first stroke. Use the left-hand pen corner to push up and the whole of the pen to sweep down. Then make a small loop and lead out using the left pen corner. This stroke needs to be executed very quickly.

Start at 12 o'clock with a counterclockwise stroke to the bottom of the x-height. Using the pen corner push up to the top of the letter, leaving a small gap, and lift the pen. Using the right-hand pen corner push up and to the right to create the small flourished line.

m m m

n n n

o o

The first stroke is a 45-degree angle; make sure it has a sharp tail. Put the left-hand pen corner into the stem and push out. To finish, use either the left-hand corner and pull down or the right-hand corner and push up and end with a curve.

p p p

q q

r r r

s s

t t

u u u

Use the right-hand pen corner for the final upward curved stroke. The end flourish is like the letter "o."

v v

v v w w

x x x

Use the left-hand pen corner for the pushed upward stroke and the tail of the "y."

y y y

z z z

SEE ALSO

Flourished Italic: Majuscules, pages 74–77

FAMILY GROUPS

Writing out the family groups in pencil is a good way to understand the structure of the letterforms and will ease the progression to using a broad-edge pen. Note the branches spring from halfway to two-thirds up the height of the letters.

inmhrkbp
1

adgq
2

ltyu *ce*
3 4

ffsj *vwxyz*
5 6

1. Note the curved exit stroke of the "r," and the looped exit strokes of "n," "m," and "h." They evidently belong in one family.

2. The "lids" of the letters do not join the stems in this group.

3. Note the bowls of the letterforms.

4. The "c" and "e" are the only oval letterforms in this group.

5. Note the different forms of "f"—they share the same serif top as the "s" and the same serif tail as the "j."

6. Diagonal letters; note the curve in the base of "z."

BASIC STROKES

These strokes are the building blocks of the alphabet; practice making these marks before progressing to writing out words. The diagonal ligature is a "think uphill" push stroke produced by moving the thin edge of the nib uphill diagonally to the right at an angle of 45 degrees.

1 2

3 4

1. The "c" shape leads out with a thin ligature.

2. This ligature is used with letters that are "closed" but need to be joined onto the following letter.

3. This "c" shape leads out with a thin ligature that can connect to the top of the following letter.

4. A descender with a ligature leads up to the baseline to connect with the following letter.

Warm-up exercises

It is a good idea to warm up before beginning a writing session. This will prepare your mind for practice and eliminate any shakiness in your hand.

Lighten the pressure on the upward stroke and exit on the nib corner for a hairline finish.

Make light, diagonal, upward strokes, steady down, and finish with a delicate loop.

Ensure your pen angle secures a thin up-stroke and use the pen corner for the loops.

Pull downward, then curve upward with a generous sweep using the pen corner.

Make these joined "n"s with asymmetric arches and delicate exit loops.

Practice perfect serifs, even slopes, and even spacing.

HOMEWORK

1. Rule up to an x-height of five nibwidths using a Mitchell no. 4 nib.

2. Practice letters in family groups, paying particular attention to the pen corners. Try using alternate pen corners.

3. Write a short (three or four lines) text block. Try to be as spontaneous as possible to capture the freedom of the writing.

4. Practice writing the text block with different-size pens.

abcdefghijklmnopqrstuvwxyz

KEY FLOURISHES

The following flourishes can be used in isolation or in combination, although minimal designs are usually more successful.

1

2

1. Lines with curves: Practice horizontal and vertical.

2. Spirals: Left-to-right comes more naturally but try right-to-left also.

3. Clouds: Copy these and develop your own styles.

4. Knots: These lines should cross at a 90-degree angle to balance the loops.

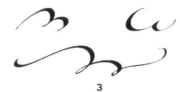

3

4

LETTER SPACING

Flourishing takes time to master, and in the initial stages of practice it is better to keep the scripts as minimal as possible. In the following examples, the letters are connected with a loop, rather than a simple leading-in-and-out stroke, to add a decorative touch. The ligatures need to be made as delicate hairline strokes; it may be necessary to use the corner of the nib to create the required effect.

minimum

Note the diagonal joins; the lead-out strokes of the "m" and "n" have slight loops, and the letters finish with an upward sweeping ligature.

imagio

The descender of the "g" is connected to an elegant looped ligature that sweeps back to the top of the "i."

minuo

que

The "e" is very open—it is finished with the pen corner.

successio

Slow down as you come around the bottom corner, and push up with the right-hand pen corner.

tabellae

The bowl of "b" is pushed up with the right-hand pen corner, so slow down as you lift off.

thymum una

The "m" is pushed up with the pen corner (like "h") to make hairline upward strokes.

abcdefghijklmnopqrstuvwxyz

I
2
3
4
5
6
7
8
9
10
11
12
13
14
15
16
17
18
19
20
21
22
23
24

FLOURISHED ITALIC:
Majuscules

These are extremely useful letterforms that can be used with Italic or any handwriting-based script. They are ideally suited to the line beginnings of poetry or for any wedding or party invitations. They are relatively easy to master and form a logical progression from learning Roman Capitals.

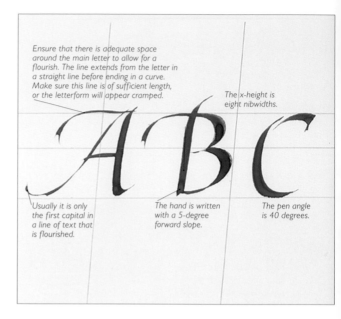

Ensure that there is adequate space around the main letter to allow for a flourish. The line extends from the letter in a straight line before ending in a curve. Make sure this line is of sufficient length, or the letterform will appear cramped.

The x-height is eight nibwidths.

Usually it is only the first capital in a line of text that is flourished.

The hand is written with a 5-degree forward slope.

The pen angle is 40 degrees.

ABOUT THE LETTERING

Historically, flourished Italic capitals exist in countless variations, the degree of complexity of the flourishes decided by the individual scribe. This script is a modern invention based on historical forms but simplified and refined to make it more consistent and useful to contemporary scribes. It is constructed of simple extensions to the lines with a small "swash" or "flag." The letterforms embody the fundamental rule for all flourishes—that flourishes can originate from the beginning or ending of lines, or where two lines connect on the top line. Flourishes should never be added to the parts of letters that connect on the bottom line, such as "N," "M," or "V."

Flourished Alphabets in Red and Black by Veiko Kespersaks
This freely written alphabet panel shows different options for writing Flourished Italic—tight spacing, wide spacing, two colors, and two different nibs. It is useful to play with letterforms to explore different ideas for finished pieces.

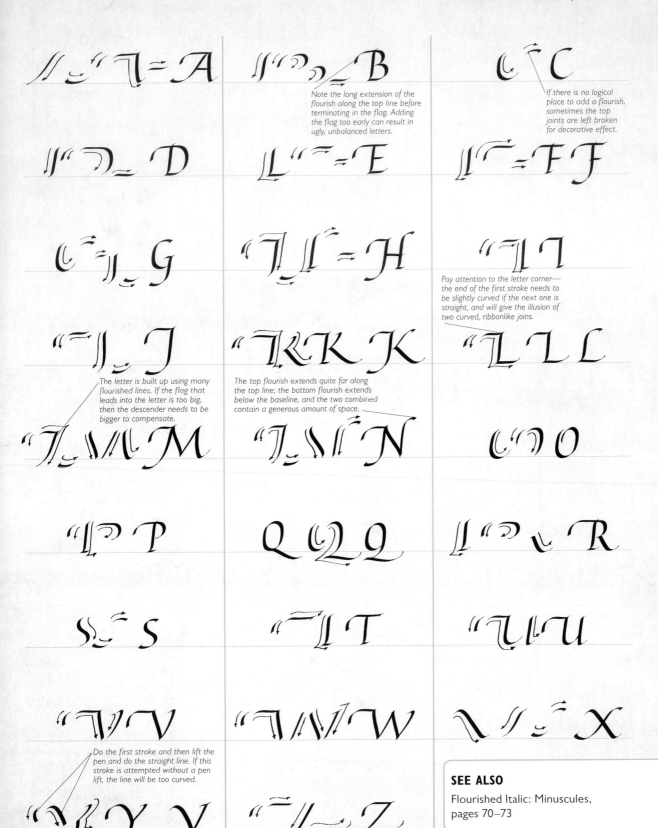

Note the long extension of the flourish along the top line before terminating in the flag. Adding the flag too early can result in ugly, unbalanced letters.

If there is no logical place to add a flourish, sometimes the top joints are left broken for decorative effect.

Pay attention to the letter corner— the end of the first stroke needs to be slightly curved if the next one is straight, and will give the illusion of two curved, ribbonlike joins.

The letter is built up using many flourished lines. If the flag that leads into the letter is too big, then the descender needs to be bigger to compensate.

The top flourish extends quite far along the top line; the bottom flourish extends below the baseline, and the two combined contain a generous amount of space.

Do the first stroke and then lift the pen and do the straight line. If this stroke is attempted without a pen lift, the line will be too curved.

SEE ALSO

Flourished Italic: Minuscules, pages 70–73

FAMILY GROUPS

All letters are combinations of different flags and flourished lines, grouped as follows. Pen angles are 30 degrees, sometimes steepening to 45 degrees. When you have learned a basic flourished line, you can add fewer or more lines. Always leave enough space around the letters and make sure the flourishes are in keeping with the text.

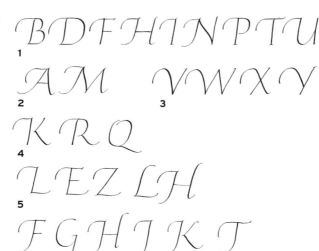

1. A flag or lead-in flourish can be used when a letterform has a top left-hand corner, as they do in this group.

2. In this group, the flourish is added to a diagonal line.

3. These letters lead in with a curved flag.

4. These letters have flourished diagonal tails.

5. These letters are anomalies and can be adorned with different flourishes.

BASIC STROKES

These exercises will help you progress to using the pen corner, which allows more elegant and lighter flourishes to be added. With practice you will be able to gain confidence in manipulating the pen and your calligraphy will appear free and spontaneous.

1. The first pair of flags are flat with a 30-degree angle and no pen corner. The second pair has the flag extended with a small serif. The third uses the right-hand pen corner to extend the flag and tapers out.

2. The first example uses just the pen to add a small flourished line. The other examples show the use of the pen corner to extend the flourish. The final example is written at speed using the pen corner.

Warm-up exercises

It is important to get to know your pen and what it can do. Sometimes it may be better to use your pen without a reservoir (although you may need to increase the slope of your table). Larger nibs can be scratchy as well as new nibs. The following exercises help you to start using your pen in different ways.

Half-moon curve with pen corner pushing up.

Using the pen corner to end the curve.

Leading in with pen corner and then straight line with full nib.

Adding curve with pen lift, so two separate lines.

Adding curve with pen lift (looks like "J").

HOMEWORK

1. Choose a short piece of text and experiment with designing flourishes. It is easier to plan different options in pencil before deciding what to write in pen.

2. Try writing the text and the flourishes at different speeds, and practice using the pen corner.

3. When you are satisfied with the layout, write out the final piece.

ABCDEFGHIJKLMNOPQRSTUVWXYZ

LETTER SPACING

This hand uses the same spacing as Italic. It is very unusual to write a whole work using just flourished capitals. If you want to try this, then reduce the number of flourishes to aid legibility.

Minimum

Flourishing the initial capital but keeping the word in minuscules allows maximum legibility.

MINIMUM

Flourished capitals in a whole word slows down the readability, so minimize the extensions and use with care.

If you have a curved line followed by a straight line try to make the curved line straighter to achieve even spacing.

Imagio

Minuo

The looped "n" helps keep your pen in contact with the paper so that almost the whole word can be written in one line.

Quadrum

Succesio

If there are double letters such as "cc" the spacing needs to be brought closer together to appear even.

"Q" leading out with long flourished line. The left-hand nib corner is used for the tapering end of the line.

Lead in with the bar of the "T" and continue with a loop into the "h."

Tabellae

Thymum

The pen corner is used for the line leading out of the "e." The "l" has been extended using the pen corner.

The "m" leads out with a line, using the pen corner.

Try to keep the lettering even after the slightly widened capital letter.

Una

Vita

Do not extend the crossbar of the "t" too far, otherwise the spacing will appear uneven.

LETTER VARIATIONS

When you can write flourished capitals with reasonable skill, explore using different nib sizes and letter variations. A flourish does not necessarily necessitate extra lines; it can mean simply that the letterforms have a particular variation, that they are sharpened or curved or have a particular x-height or spacing feature. The spacing must be consistent whatever variation/x-height is used.

AURORA

Correct x-height with correct spacing.

AURORA

Smaller x-height and slightly compressed.

AURORA

Larger x-height makes the letters appear more lightweight.

AURORA

Every second letter is "jumped" one and a half nib widths.

AURORA

The joined points have been lowered.

AURORA

Freer flourished lines.

AURORA

Free flourished lines with wider spacing and using letter variations.

AURORA

Slightly jumping letterforms, letters made in one line where possible.

AURORA

Sharpened letters with the crossbar constructed with a double line.

ABCDEFGHIJKLMNOPQRSTUVWXYZ

I
2
3
4
5
6
7
8
9
10
11
12
13
14
15
16
17
18
19
20
21
22
23
24

CHANCERY CURSIVE:
Minuscules

This script is a useful transitional hand to learn after mastering Italic and before attempting Copperplate. The letterforms are based on Italic, but the hand is written much more freely and marks the move from formal writing to a more relaxed handwriting style. The letters join naturally and easily, and there is an underlying rhythm to the hand. As the letters are simple, distinct, and well proportioned, the script is legible even when written at speed. Most of the letters can be made in one stroke and are joined both horizontally and diagonally.

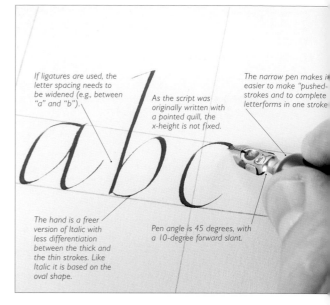

If ligatures are used, the letter spacing needs to be widened (e.g., between "a" and "b").

As the script was originally written with a pointed quill, the x-height is not fixed.

The narrow pen makes it easier to make "pushed-strokes and to complete letterforms in one stroke.

The hand is a freer version of Italic with less differentiation between the thick and the thin strokes. Like Italic it is based on the oval shape.

Pen angle is 45 degrees, with a 10-degree forward slant.

ABOUT THE LETTERING

The script was originally written with a pointed quill, so the thick and thin lines, although still a feature of the hand, are less evident. The script is more cursive with longer ligatures (resulting in wider spacing) and a wide variety of extensions and loops. The narrow nature of the pen made push strokes easier to master; consequently descenders begin to be pushed up from the baseline to join to the next letter. Many of the letters can be made in one stroke because of the narrow pen.

With practice this hand can be absorbed into your own handwriting and, perhaps more than the other scripts, can become an expression of your personality. The initial reduction in speed as the letterforms are mastered also helps to improve your use of language, as there is more time to choose the appropriate words.

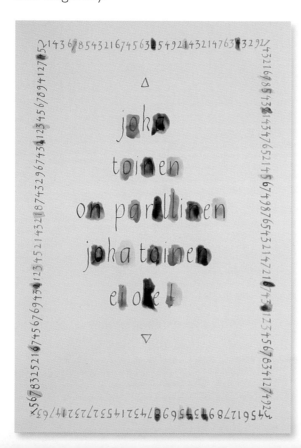

"Red and blue" by Timo Pontinen
This was an early experiment by the calligrapher using handwriting-based Chancery Cursive. A no. 6 nib, ink stick, and watercolor paper are used.

a

b

Done in one stroke, from the middle, out and around, as in handwriting.

e

c

Note the longer descenders executed in one stroke; needs speed to avoid a wobble.

d

f

The dot can be pushed or pulled, higher or lower, but needs to be aligned with the stem.

g

h

i

j

k

The top and bottom curves need to be very similar. It is easy to make the top curve too big or too small; practice to find the correct balance.

m

n

Letter "o" can be done without pen lifts—start at 1 o'clock, make the curved stroke, then push back up to the starting point.

o

Can be done without pen lifts if the second stroke is pushed up. The top line is almost straight, ending with a tiny curve. Don't flourish too much; otherwise the balance will be lost.

p

q

r

Don't make a very long tail, and keep the crossbar quite short unless it is at the end of the word. It should be tilted very slightly upward.

s

t

u

v

w

x

SEE ALSO

Chancery Cursive: Majuscules, pages 82–85

y

z

FAMILY GROUPS

As this script is based on Italic, it shares the same family groups and the same 5-degree forward slant. Also, the letterforms are compressed, although the ascenders and the descenders have softer curves.

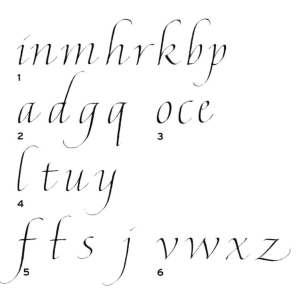

1. Letters that begin with a downstroke and then branch halfway into an arch.

2. Letters with a halfway branch that lead into an arch.

3. Oval-shaped letters.

4. Letters that begin with a downstroke and lead into a bowl.

5. Letters that begin with a downstroke.

6. Diagonal letters.

BASIC STROKES

These strokes are the building blocks of the alphabet. Practicing these basic movements will fix the shapes in your mind and help you to write the final script. If you have difficulty with any particular letterform, practice the basic stroke from which it is made until you are confident.

1. Open "a" shape/connecting "a" shape.

2. Vertical lines with alternate long and short entry and exit strokes.

3. Descenders and ascenders.

Warm-up exercises

Do these exercises at different speeds (slowly and quickly), aiming to produce the same consistent results.

Practice pushing and pulling your pen in one stroke.

Aim for the arch to branch halfway up the stem. Keep as even as possible.

Aim for the branch halfway up the stem. Keep as even as possible.

Aim for even spacing.

Joining letters
Write different letter combinations aiming to produce even spacing and a regular rhythm.

HOMEWORK

1. Practice writing out the minuscules in their family groups. Try not to copy the examples but to use them as a basis for free writing.

2. Attempt every letter a number of times, until you produce elegant, flowing lines.

abcdefghijklmnopqrstuvwxyz

LETTER VARIATIONS

Whatever spacing and size you eventually feel comfortable with, it is important to make your writing consistent in size and evenly spaced. Attempt to write a word (for example, your name) with wider or closer spacing and with as many variations as you can.

abcdefghijklmnopqrstuvwxyz

Unjoined
Write out the alphabet keeping the letterforms as simple as possible.

abcdefghijklmnopqrstuvwxyz

Joined
Practice joining all letterforms together. Experiment with different joins.

abcdefghijklmnopqrstuvwxyz

Joined and vertically stretched
Vertically stretched letterforms appear sharper and narrower. Try to keep spacing even.

abcdefghijklmnopqrstuvwxyz

Joined and horizontally stretched
Horizontally stretched letterforms appear rounder. The joins will need to be stretched as well.

SPACING LETTERS

This script requires care to appear evenly spaced. The examples show the different spacing adjustment required with different letter combinations. It is not necessary to join the letters. Aim to keep the letterforms upright and to match the shape of the serifs and joins with the shapes of the letterforms. Developing a rhythmical, even speed of writing will help achieve even spacing.

The "m" is an excellent letter to practice to help you learn rhythm and even spacing. Think of repeating the space of the "o" between each letter.

minuo

Double letters require special consideration. The two "c"s have been placed closer together and are joined at the bottom.

succesio

When double "l"s appear in a word, the spacing is even but the height of the first "l" is slightly shortened so that both "l"s appear balanced.

tabellae

All the spaces and inside curves need to look similar. Keeping the serifs the same size will help with spacing.

Balance the curves of "y" with "h."

thymum

Note the inside curves of the "u," "n," and "a." These need to be the same proportions.

una

abcdefghijklmnopqrstuvwxyz

1
2
3
4
5
6
7
8
9
10
11
12
13
14
15
16
17
18
19
20
21
22
23
24

CHANCERY CURSIVE:
Majuscules

These letterforms are extremely useful for the contemporary scribe, as they lend themselves to everyday use as well as to planned calligraphic work and can be written with a conventional fountain pen. In a certain sense they are more modern in their appearance than their Copperplate counterparts, as they have few flourishes and no pressure and release strokes. The pen does not need a reservoir, which can impede the flow of ink to the nib. It is also easier to write with a nib that has been used a few times than a brand new one.

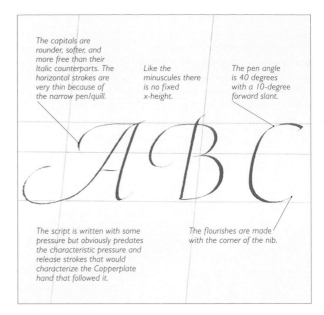

The capitals are rounder, softer, and more free than their Italic counterparts. The horizontal strokes are very thin because of the narrow pen/quill.

Like the minuscules there is no fixed x-height.

The pen angle is 40 degrees with a 10-degree forward slant.

The script is written with some pressure but obviously predates the characteristic pressure and release strokes that would characterize the Copperplate hand that followed it.

The flourishes are made with the corner of the nib.

ABOUT THE LETTERING

Like their minuscule counterparts, these letters were originally written with a quill, which allowed the letterforms to be pushed and pulled with few pen lifts. Consequently the letters have an elongated, almost classical appearance, as many of them are completed in one or two strokes. Unlike Copperplate they are usually quite minimal with few flourishes. The letters have an open, flowing quality that derives from their economy of movement. Beginners should avoid using more curvature than is required, and attempt to keep the exit strokes of the letters flat and sweeping rather than curly and obtrusive. This hand can be practiced quite easily with a pencil or ballpoint pen.

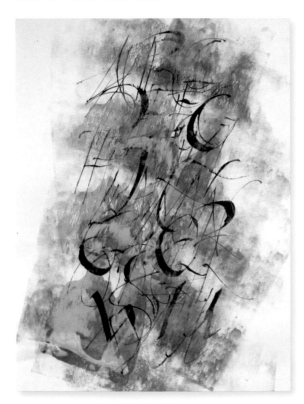

Capital variations by Veiko Kespersaks
These freely written Chancery Cursive capitals are made using a ruling pen and sumi ink between layers of rolled acrylic colors on Fabriano 5. Playing with different weights and sizes of letterforms is a good way to practice calligraphy.

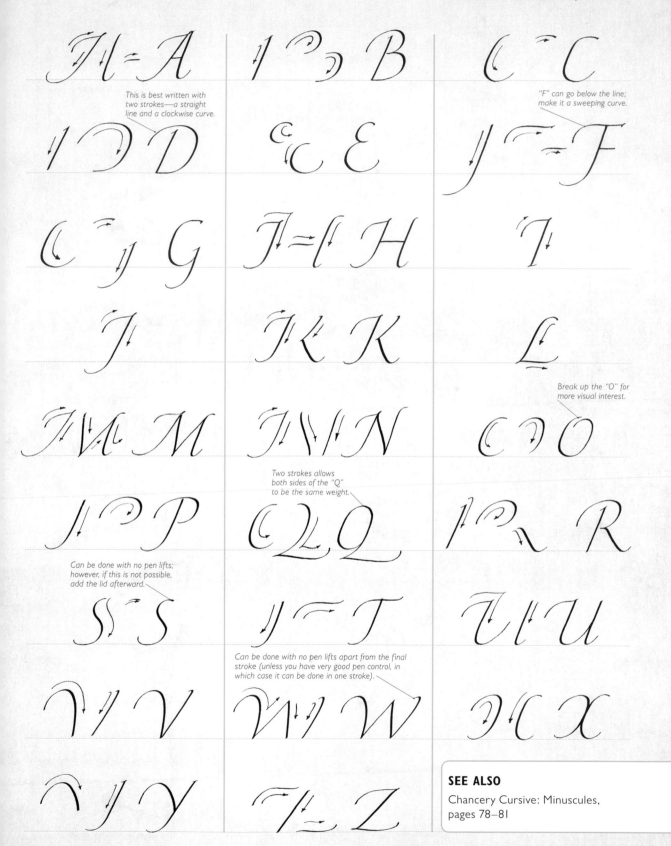

This is best written with two strokes—a straight line and a clockwise curve.

"F" can go below the line; make it a sweeping curve.

Break up the "O" for more visual interest.

Two strokes allows both sides of the "Q" to be the same weight.

Can be done with no pen lifts; however, if this is not possible, add the lid afterward.

Can be done with no pen lifts apart from the final stroke (unless you have very good pen control, in which case it can be done in one stroke).

SEE ALSO

Chancery Cursive: Minuscules, pages 78–81

FAMILY GROUPS

As these are a variation of Italic capitals, they slope forward by 5 degrees and the flourishes are simple, elegant, and low-key. They are shown here in groups of similar strokes or similar flourish formation. Keep the flourish to the left, to allow room for the minuscules to follow.

1. Letters that start with a flourish on the left.

2. Flourishes added to a sloping line.

3. Letters leading in with a curved flag.

4. Letters with flourished diagonal tails.

5. Letters with no flourish.

6. Letters with a flourish at each end.

7. Letters that flourish below the baseline.

BASIC STROKES

These exercises will help you practice the most common curves used in the letterforms. Try to develop a light touch with the pen, so that the strokes begin and end delicately.

1. All these strokes pull up from the left at a pen angle of 45 degrees; make sure they all have a horizontal part.

2. Pull around from the left, making a horizontal oval.

3. Curve around from the left, and pull down from the top.

Warm-up exercises

These exercises develop your writing speed and rhythm. Try to keep the inside space of the arches and bowls as regular as possible. Repeat the exercises with at least three different writing speeds.

Push and pull strokes: practice making the strokes as evenly as possible.

Wide spacing: branch is very low.

Regular spacing: branch at halfway point.

Tightly spaced arcades. Branch is very high.

HOMEWORK

1. Practice all the capitals in their family groups until you are familiar with them.

2. Write words in minuscules with the initial capital in alphabetical order (Alicia, Bernardo, Carla, for example).

LETTER SPACING

It is important to practice the letterforms and words many times to achieve consistency of style and even spacing. It is a good idea to practice first with a pencil, relaxing the wrist and writing the letterforms as freely as possible, almost as doodles, to get the hand warmed up and the eye accustomed to seeing the space between and inside the letters.

Minimum

An excellent letter to practice to learn rhythm and even spacing.

Imagio

The top of the "T" has been slightly shortened to lessen the distance to the "h."

Quadrum

Thymum

Succesio

Double letters require special consideration. The two "c"s have been placed closer together and are joined both at the bottoms and tops of the letters.

Tabellae

The "a" has been brought closer to the "T" to compensate for the empty space of the curve.

LETTER VARIATIONS

Whatever spacing and size you eventually feel comfortable with, it is important to make your writing consistent in size and evenly spaced. Attempt to write a word (for example, your name) with wider or closer spacing and with as many variations as you can. This script can help you understand your hand and develop your own personal style of handwriting.

Minuo

Standard form

Minuo

Compressed letterforms. The capital is only slightly compressed. The branch of the "n" and "u" is still halfway.

Minuo

Sharpened

Minuo

Rounded letterforms

Minuo

Stretched

Imagio

Compressed

Imagio

Rounded letterforms

ABCDEFGHIJKLMNOPQRSTUVWXYZ

1
2
3
4
5
6
7
8
9
10
11
12
13
14
15
16
17
18
19
20
21
22
23
24

COPPERPLATE:
Minuscules

Also known as English Round Hand or the English Hand, Copperplate was widely used from the sixteenth century and reached the peak of its popularity in the nineteenth. Copperplate derives its name from the Copperplate printing process. Unlike letterpress, which used individual letters in different combinations, Copperplate was engraved on one single sheet. The engravers copied English handwriting styles and added flourishes and decorations. It was used in the printing of legal documents, bonds, and insurance policies, because it is hard to forge.

ABOUT THE LETTERING
Although this hand originates from Italic script, in execution it is closer to "normal"

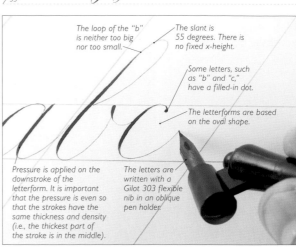

The loop of the "b" is neither too big nor too small.

The slant is 55 degrees. There is no fixed x-height.

Some letters, such as "b" and "c," have a filled-in dot.

The letterforms are based on the oval shape.

Pressure is applied on the downstroke of the letterform. It is important that the pressure is even so that the strokes have the same thickness and density (i.e., the thickest part of the stroke is in the middle).

The letters are written with a Gilot 303 flexible nib in an oblique pen holder.

handwriting. The letters are small and evenly spaced and formed without any pen lifts. Each letter has a lead-in from the previous letter and leads out to join the following letter. It is important to choose a pen nib that is neither too stiff nor too flexible so that the pressure can be applied gently and rhythmically. The balance of pressure and release is key to this hand, as is maintaining branches at a consistent halfway point of the stroke. As the nib is monoline, there is no fixed x-height for this hand. Simply rule the lines to the width required and adjust the downstrokes to create the desired weight. The ideal proportions are ascender 3; x-height 2; descender 3. In practice this means the ascenders and descenders are one and a half times the x-height. The pen angle is a constant 55 degrees. Copperplate takes time to master and is not the best hand for beginners. It is best to become proficient in Italic hand (on which Copperplate letterforms are based) before attempting it.

Letter by Veiko Kespersaks
This beautiful example of Copperplate is written with a very small x-height (2mm). In addition to black ink, Rose Madder is used for the writing and the illustration; the green of the leaf details was made by mixing Rose Madder and black ink. The same nib was used for both the writing and the illustration.

My Dearest Rosa

I have always known that all of this would have happened since our eyes locked for the very first time and finally, here I am, giving you these sweet words, knowing that you are someone that will appreciate them regardless of your feelings for me.

I have decided to write this heartfelt letter where words are chose to stay forever written on paper and not only preserved in your memory.

I want you to know that my feelings for you have never changed, but instead they have grown stronger than I ever they could.

To me; no other woman or anyone will mean as much as you do Ever; Rosa, I love You with all that I am. Carlo

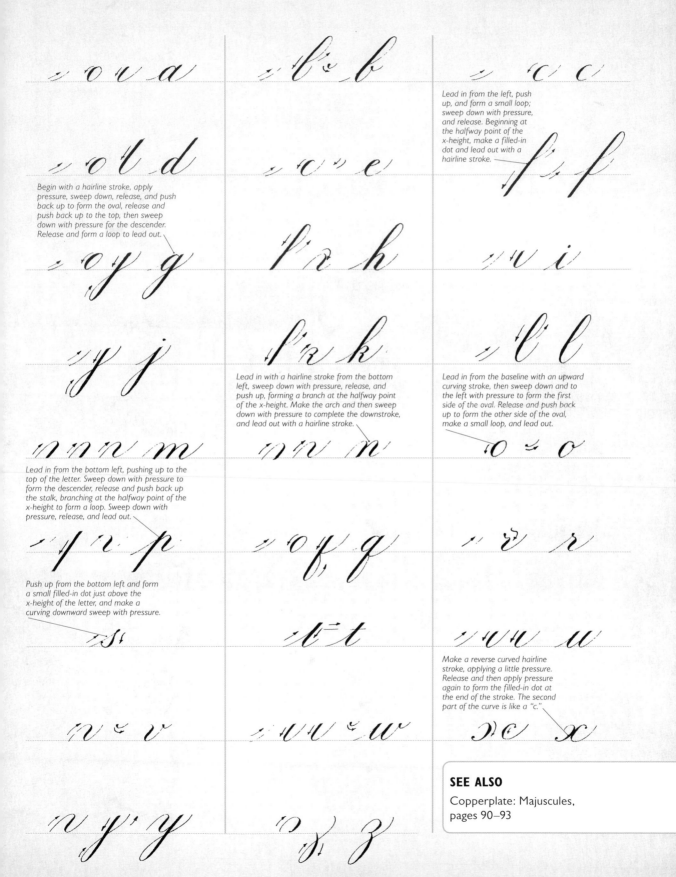

Lead in from the left, push up, and form a small loop; sweep down with pressure, and release. Beginning at the halfway point of the x-height, make a filled-in dot and lead out with a hairline stroke.

Begin with a hairline stroke, apply pressure, sweep down, release, and push back up to form the oval, release and push back up to the top, then sweep down with pressure for the descender. Release and form a loop to lead out.

Lead in with a hairline stroke from the bottom left, sweep down with pressure, release, and push up, forming a branch at the halfway point of the x-height. Make the arch and then sweep down with pressure to complete the downstroke, and lead out with a hairline stroke.

Lead in from the baseline with an upward curving stroke, then sweep down and to the left with pressure to form the first side of the oval. Release and push back up to form the other side of the oval, make a small loop, and lead out.

Lead in from the bottom left, pushing up to the top of the letter. Sweep down with pressure to form the descender, release and push back up the stalk, branching at the halfway point of the x-height to form a loop. Sweep down with pressure, release, and lead out.

Push up from the bottom left and form a small filled-in dot just above the x-height of the letter, and make a curving downward sweep with pressure.

Make a reverse curved hairline stroke, applying a little pressure. Release and then apply pressure again to form the filled-in dot at the end of the stroke. The second part of the curve is like a "c."

SEE ALSO

Copperplate: Majuscules, pages 90–93

FAMILY GROUPS

Practice the family groups with a sharp pencil to get a feel for how they are constructed; then practice with a pen. Note that the letters that have a sharp, flat top (e.g., "w" and "t") may need to be filled in with the pen.

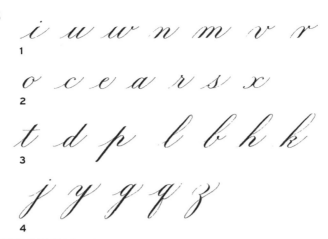

1. Letters with straight parallel lines. The tops of the letters have very sharp, flat tops.

2. All letters relate to the letter "o." One side of the curve has pressure, the other does not.

3. Letters with descenders and ascenders that have one heavy line. Good pen control is needed to ensure even pressure.

4. Both descenders and ascenders are looped. Ensure that the loops of the descenders and ascenders are the same size.

BASIC STROKES AND PRESSURE

Strokes 5–11 are the building blocks of the script. All letters are formed with these eight basic movements. Exerting more pressure means the nib will splay, enabling thicker downward strokes. Avoid applying pressure and pushing upward with the nib, as this will damage the pen. Different nibs and penholders require different amounts of pressure, so practice using a range of nibs.

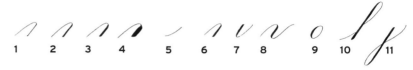

Pressure pointers (1-4)
1. No pressure.

2. Light pressure on the downstroke.

3. Moderate pressure on the downstroke.

4. Heavy pressure on the downstroke.

Basic strokes (5-11)
5. Light upstroke/joining stroke.

6. Upstroke, with pressure on downstroke.

7. Downstroke with pressure, upstroke without.

8. Pressure on downward stroke, pushing up without pressure.

9. One side with pressure, one without.

10. Loop stroke with pressure on ascender.

11. Looped letter with pressure on descender.

Warm-up exercises

It is particularly important to warm up thoroughly before writing Copperplate to eliminate any shakiness in the hand. These exercises help develop rhythmn and even spacing. Complete a couple of pages of these exercises before going on to write the hand itself.

Maintain a 55-degree angle; apply pressure on the downstroke and push up without pressure.

Push up without pressure and apply pressure on the downstroke.

Apply pressure on the downstroke, pushing up without pressure.

One side with pressure, one side without.

HOMEWORK

1. Rule up at least three pages of text at the correct x-height (see page 22).

2. Use a Gilot 303 nib in an oblique penholder. Beginners may find it easier to use a Gilot 404 for practice, as it is less flexible and easier to control. Complete all the warm-up exercises, paying attention to rhythm and pen angle.

3. After warming up, practice family groups and words of your choice.

abcdefghijklmnopqrstuvwxyz

COMMON ERRORS

The ability to control the application and release of pressure is key to success with this script. Practice will enable greater sensitivity and better pen control, and you will soon learn to avoid these common mistakes.

Correct **Incorrect**

Full pressure stroke at 55-degree angle
Try to maintain even pressure on both sides of the nib throughout the stroke to ensure lines are even and the tops of strokes are square.

Ascender loop
The ascender loop requires a slight inward curve to join the stem in the correct place and to allow the same inside space as the descender loop.

Downstroke loop
Make sure your loop is neither too wide nor too narrow. Ensure that it crosses the stem at the baseline. Practice both top and baseline loops.

Balance of pressure and release
Uneven pressure and release within the x-height is a common error. Maintain a 55-degree slope for both lines, and consistent interletter spacing.

JOINING LETTERS AND WORDS

All letters are joined with hairline upstrokes. Remember to maintain a slow, even rhythm. The space between the letters should be roughly equal to the space inside letters; space between words should be equal to the size of one letter (such as "o"). Begin with words that join together easily. Repeat lines of the same words ensuring that even pressure, rhythm, and spacing is maintained.

minuo

m + i = mi

i + n = in

una que

imagio succesio

error

o + r = or

When a letter begins or ends with a hairline, it is joined with a single stroke without lifting the pen. The same rule applies regardless of descenders. The "g" and "i" in "imagio" are linked in exactly the same way as the "m" and "i" in "minuo."

vita arber gloria tabellae

Lead-out strokes of letters always join the lead-in strokes of the following letters at any logical point. It is not always necessary to join letters together; it is more important to maintain a consistent spacing.

Note that the connecting line between the "t" and the "h" is within the stem of the "h."

thymum quadrum tantummodo

Die dulci freur

Note the pen lift after the capital letters "D" and "A."

Ars longa, vita brevis

abcdefghijklmnopqrstuvwxyz

1
2
3
4
5
6
7
8
9
10
11
12
13
14
15
16
17
18
19
20
21
22
23
24

COPPERPLATE:
Majuscules

It is advisable to become proficient at controlling the flexible pen nib before attempting Copperplate capitals, as they require more skill in their execution. It is important to write at a slow, rhythmical pace, paying attention to the weight and direction of the strokes and the beginnings and endings of each letter. Writing too quickly results in letters with inconsistent pressure. The height of the capital letters is equal to the x-height plus the ascender; this is higher than standard capital letterforms.

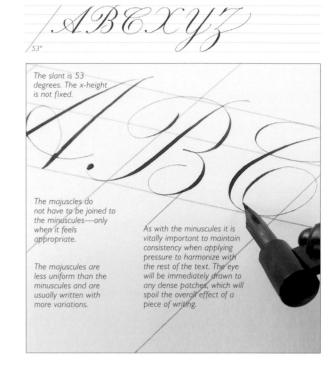

53°

The slant is 53 degrees. The x-height is not fixed.

The majuscles do not have to be joined to the minuscules—only when it feels appropriate.

The majuscules are less uniform than the minuscules and are usually written with more variations.

As with the minuscules it is vitally important to maintain consistency when applying pressure to harmonize with the rest of the text. The eye will be immediately drawn to any dense patches, which will spoil the overall effect of a piece of writing.

ABOUT THE LETTERING

Copperplate Capitals are used to indicate the first letter of a sentence only; they are not suitable for use as a stand-alone script like Roman Capitals. They also look best when given generous spacing around as well as between the letters. They can often be made in one line without any pen lifts. There are many different variations, all of which will work with Copperplate text, but it is best to stick to one type within a single text block.

Civil partnership invitation by Rosella Garavaglia
The invitation is written using sumi ink and smooth, hot-pressed paper. Copperplate is a very useful script for this kind of work. The initial "J" and "A" have been made into a monogram, and the artist has allowed space for a decorative flourish, which adds a unique touch. The flourished capitals and the extended crossbar of the "t"s are variation lettering and are the invention of the artist.

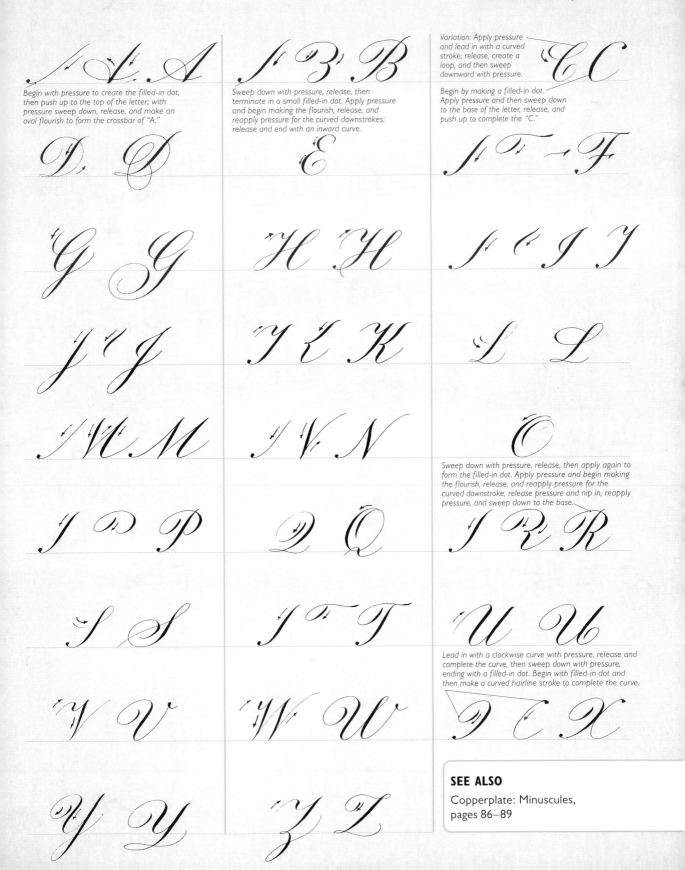

Begin with pressure to create the filled-in dot, then push up to the top of the letter; with pressure sweep down, release, and make an oval flourish to form the crossbar of "A."

Sweep down with pressure, release, then terminate in a small filled-in dot. Apply pressure and begin making the flourish, release, and reapply pressure for the curved downstrokes; release and end with an inward curve.

Variation: Apply pressure and lead in with a curved stroke, release, create a loop, and then sweep downward with pressure.

Begin by making a filled-in dot. Apply pressure and then sweep down to the base of the letter, release, and push up to complete the "C."

Sweep down with pressure, release, then apply again to form the filled-in dot. Apply pressure and begin making the flourish, release, and reapply pressure for the curved downstroke, release pressure and nip in, reapply pressure, and sweep down to the base.

Lead in with a clockwise curve with pressure, release and complete the curve, then sweep down with pressure, ending with a filled-in dot. Begin with filled-in dot and then make a curved hairline stroke to complete the curve.

SEE ALSO

Copperplate: Minuscules, pages 86–89

FAMILY GROUPS

Unlike the other family groups in this book, which are based on an underlying structure, these letters are grouped according to how the letterforms begin. This is not a comprehensive list of all the letterforms, but a selection of different ideas of how the letterforms can be constructed.

1

2

3 4

5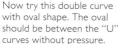

1. All letters begin with a dot and follow with an upstroke without pressure.

2. Letters have a curved topline.

3. Letters begin with a curved flag and finish with a dot.

4. The loop that begins the letter must be oval-shaped and without pressure.

5. Letters lead in with a circular flourish. Pressure is added at the beginning of the stroke.

COMMON MISTAKES

These mistakes tend to occur if you have not warmed up properly, if letters have been done in the incorrect order, or if you are losing concentration and not maintaining the same pressure on all the letterforms.

1

2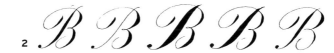

3 4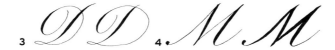

1. First correct, second incorrect. Both upstrokes have been pulled rather than pushed.

2. First letter is correct. Others have the wrong pressure (either too much or too little), or the wrong slope.

3. The first "D" is correct; the second is too wide.

4. First correct, second incorrect. Like the "A"s, both upstrokes have been pulled rather than pushed.

Warm-up exercises

It is best to do these warm-up exercises as often as possible to familiarize yourself with the script. Ideally, you'll want to produce a few pages of these exercises before going on to write the hand.

This double curve movement is key to coordinating pressure and release.

Now try this double curve with oval shape. The oval should be between the "U" curves without pressure.

This exercise will get you practicing sharp release and pressure. Ensure even distance between the strokes and controlled pressure and release.

Write the shape and keep writing over the original as many times as necessary.

HOMEWORK

1. Rule a tabloid sheet of paper.

2. Write an alphabet of majuscule letters. Repeat the letterforms that need more practice.

3. When you feel confident, write out words starting with a majuscule letter from "A" to "Z." This will help you understand how the minuscule and majuscules relate to each other in a block of text.

JOINING LETTERS

This script is very difficult for beginners, as the letterforms are constructed from a variety of pen movements, it is written with an unfamiliar pen angle, and it requires the mastering of pressure and release strokes, especially when joining majuscule and minuscule letterforms. However, by warming up thoroughly and with regular practice, progress can be made quite quickly. Different pointed pens will affect the appearance of the writing, especially the width of the thick and thin strokes.

Aer *Bestia*

The letters are similar distances apart. Make sure that the "t" is not too high.

Canto *Duo*

Ego *Ficus*

The gap between the "F" and the "i" is quite large to allow for the crossbar. However, the "i" has a slightly longer lead-in line to balance the space.

The dot of the "v" is very important here. The "v" does not have a connecting line so the dot and small join help to keep the spacing even.

Galea *Hora* *Ideo* *Juvenis*

Koffie *Laus* *Mane* *Natio*

The two "f"s need to be farther apart in order to accommodate the loops and prevent a "dark spot" in the word.

Make sure that the "s" is close enough to the other letters to feel connected.

This is a good word to practice, as it does not have descenders and ascenders. There needs to be more space between the "M" and the rest of the letters.

Ops *Poeta* *Que* *Regina*

The "S" loop and the "I" loop need to be similar sizes.

The gap between the "P" and the "o" is quite large to accommodate the bowl of the "P." The example does not have a lead-in line, but this could be added.

Sal *Talus* *Urbs* *Veritas*

Add a connection line to the "a" to prevent the space between the "a" and the "T" from seeming too wide. The line does not need to connect with the "T."

Wasser *Xiphias* *Yacht* *Zeit*

The two "s"s need to have the same slope and gentle pressure so they don't become too heavy.

The "X" can be written with a connecting line but here it has been finished with a flourish, which requires more space between the majuscule and the rest of the word.

ABCDEFGHIJKLMNOPQRSTUVWXYZ

I
2
3
4
5
6
7
8
9
10
11
12
13
14
15
16
17
18
19
20
21
22
23
24

DESIGNING WITH COLOR

Handwritten books with their rich colors were once a source of reverence and wonder, available only to the privileged few. There is a huge range of colors available to the modern scribe, but color choices must be made carefully to maximize their effect. You do not need to understand complex color theory to use color in your calligraphy; a basic knowledge of how colors work together will enable you to achieve the results you want. It is important to consider what colors are suggested by the text and, if you have a particular color in mind, how that will work with other design elements on the page. The most successful work creates a harmony between the colors and the paper. Clashing colors can be dramatic, but it is much harder to make them work successfully.

COLOR WHEEL

This color wheel shows two versions of each primary color and the secondary colors that are made from them. Each primary has a warm and a cool version, enabling a wider range of colors to be mixed from them. This is known as a "split primary color palette."

The lines running through the center of the color wheel illustrate the effects of mixing incompatible pigments together. The mixes that result from these will be dull and unpredictable.

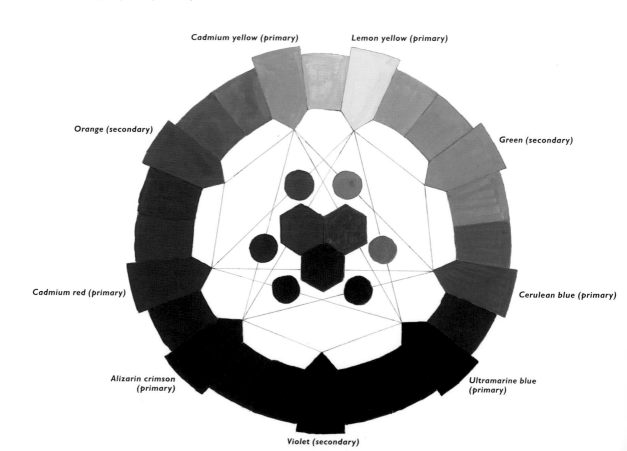

Cadmium yellow (primary)

Lemon yellow (primary)

Orange (secondary)

Green (secondary)

Cadmium red (primary)

Cerulean blue (primary)

Alizarin crimson (primary)

Ultramarine blue (primary)

Violet (secondary)

Primary colors
The three primary colors from which (theoretically) all other colors are mixed. Very often used in calligraphy because they produce a vibrant effect when used together.

Secondary colors
The colors made by mixing equal intensities of two primary colors. Less vibrant than primary colors and more harmonious, these colors are often used in longer pieces of text.

Complementary colors (yellow and purple)
Colors that are opposite each other on the color wheel. These can make vibrant contrasts—one color will appear to be in the foreground (purple), the other pushed back (yellow).

Complementary colors (green and red)
Green and red are also opposite each other on the color wheel. They seem to "vibrate" when placed next to each other and can create a dynamic effect.

Complementary colors (orange and blue)
Orange and blue is the last example of complementary color in its purest state. Notice how bold the contrasts are.

Analogous colors (cool range)
Colors adjacent to each other on the color wheel harmonize when they are used together. A cool color recedes. Adding white or thinning the paint can make it recede even more.

Analogous colors (warm range)
A warm color advances even when pale; compare this red with the blue above; which color seems nearer?

COLOR MIXING

Using the split primary color palette is the easiest way to obtain the widest range of bright, vibrant colors. Warm colors cannot be produced by cool primaries, and the opposite is also true. By using two versions of the primary—a warm and a cool version—it is possible to match a huge range of colors and to avoid muddy or grayish mixes. They can be mixed together to create a strong primary color, or mixed adjacently to produce secondary colors.

The illustration shows the different effects of mixing warm and cool primaries. Note the different intensity of the colors resulting from these mixes.

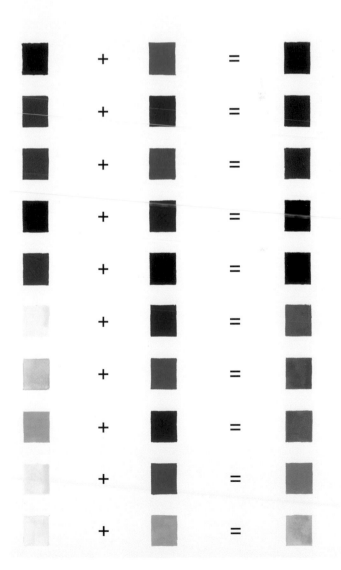

LEGIBILITY AND COLORED BACKGROUNDS

The background color of the paper will affect the appearance of the text, so certain factors need to be considered when planning the design. Brighter colors work best with white paper; pastel colors with cream. If you are writing on a dark paper, then you will need to add some white to your chosen color to make it brighter. White ink is very hard to use on colored backgrounds, except gray, which can work very well. Different writing mediums also have an effect on the look of the finished piece; gouache is opaque, ink less so unless it is mixed to quite a thick consistency, and watercolor produces a more transparent effect. It is also worth remembering that color contains water, which can cause the paper to wrinkle as it dries—thicker paper is usually the best choice. The most important consideration of all is legibility—no one will want to look at your work if it is too hard to read.

Colored background
The background color affects any color that is applied on top of it. In this example the yellow gouache appears brighter than the other colors when used on the green background.

White background
White is the most versatile background for use with colored ink. It is only paler colors (like the yellow in the example) that will not work as well.

COLORED LETTERING

Choose the color in your pen carefully with reference to the background color. Single-hue monochrome choices are a safe beginning. When color combinations are more complex, the color wheel is a helpful reference. Opposites—a primary color on a secondary background, for instance—can produce vivid results, as can contrasting two primaries. For more subtle effects, however, a series of mixes of more neutral secondaries will produce more restful results.

Green on green
This monochromatic scheme is a good example of single-hue harmony. The darker lettering stands out against the lighter background.

Blue on orange
The use of primary blue and secondary orange produces stunning effects. Such a combination uses the attraction of color opposites.

Red on black
Red is the warmest color and therefore the most advancing on the color wheel. It is particularly effective here against the strong matte black background.

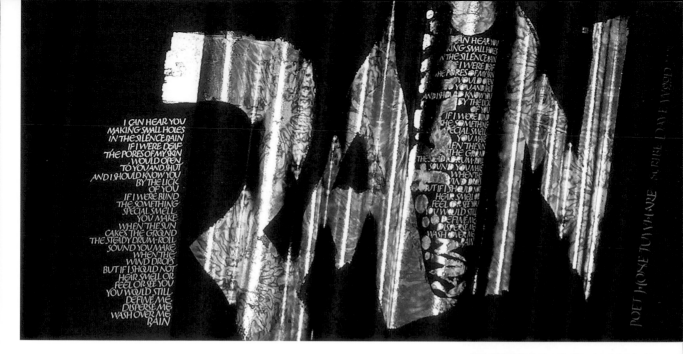

"Rain" by Dave Wood
Brightly colored lettering stands out dramatically against the black background, making the words feel three-dimensional.

Collage by various artists
This collage was created by a group of students working individually using different-colored papers and gouache. Each individual work was then carefully ripped and reassembled to make this composition. Although the torn lines of the paper and the contrasting colored inks are visually dramatic, there is an overall harmony to the piece, as the different elements have been carefully balanced together.

"Colorful E" by Mary Noble
Painted with water using a wide brush, different watercolors have been dropped on top of the letter and allowed to mix together.

1
2
3
4
5
6
7
8
9
10
11
12
13
14
15
16
17
18
19
20
21
22
23
24

FLOURISHED COPPERPLATE:
Minuscules and majuscules

It is important to remember that the Copperplate style developed through the skills of writing instructors and Copperplate engravers. Although the original design was written by hand with pen or quill and paper, the printed versions were created with the slow and precise skills of the engraver. The extravagant flourishes that survive in copybooks of the period would have been almost impossible to make by hand, and in some cases the mark made by the engraver's tool is very different to that made by pen and ink.

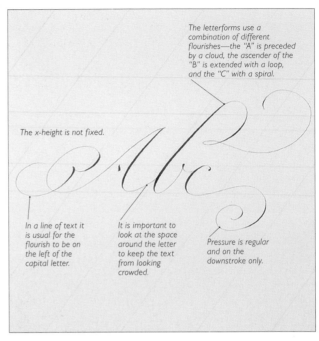

The letterforms use a combination of different flourishes—the "A" is preceded by a cloud, the ascender of the "B" is extended with a loop, and the "C" with a spiral.

The x-height is not fixed.

In a line of text it is usual for the flourish to be on the left of the capital letter.

It is important to look at the space around the letter to keep the text from looking crowded.

Pressure is regular and on the downstroke only.

ABOUT THE LETTERING

In their most basic form, flourishes are ornamental strokes that extend the ascenders or descenders of letterforms. Although they did once have a practical use of making official documents hard to forge, they are primarily for decoration and to express the calligrapher's skill. Despite their often extravagant appearance, flourishes have an underlying structure made of thick and thin strokes, curves, and intersecting lines. The apparent freedom of many calligraphic compositions conceals the skill with which the thick and thin strokes have been ordered.

"Kate and David Lambeth" by John Stevens
This beautiful example of flourished Copperplate Capitals demonstrates the importance of planning complex design flourishes without compromising legibility. The middle section is written in a larger x-height to add emphasis to the names of the bride and groom. The flourishes have a similar construction, which brings cohesion and harmony to the piece.

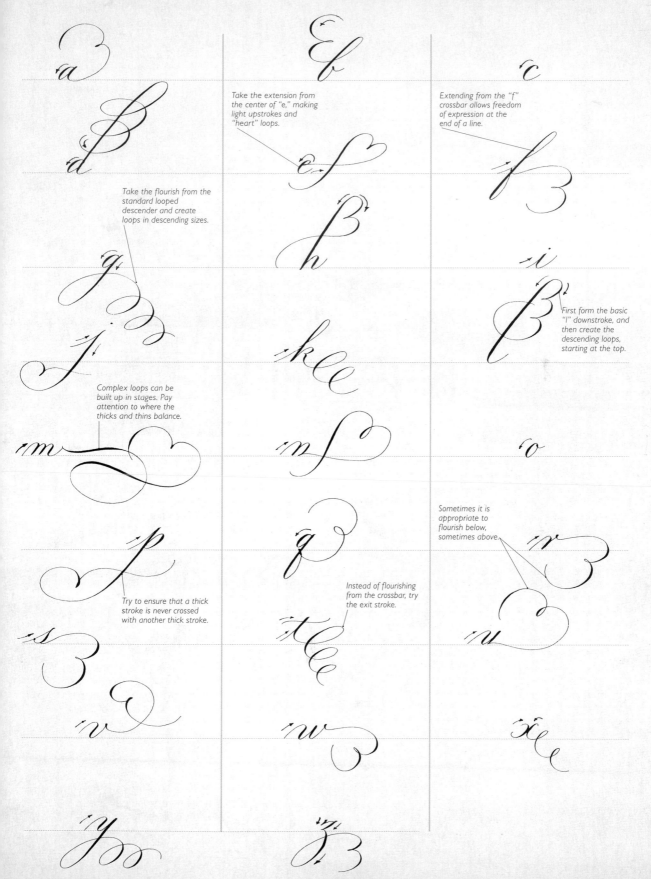

Take the extension from the center of "e," making light upstrokes and "heart" loops.

Extending from the "f" crossbar allows freedom of expression at the end of a line.

Take the flourish from the standard looped descender and create loops in descending sizes.

First form the basic "l" downstroke, and then create the descending loops, starting at the top.

Complex loops can be built up in stages. Pay attention to where the thicks and thins balance.

Sometimes it is appropriate to flourish below, sometimes above.

Try to ensure that a thick stroke is never crossed with another thick stroke.

Instead of flourishing from the crossbar, try the exit stroke.

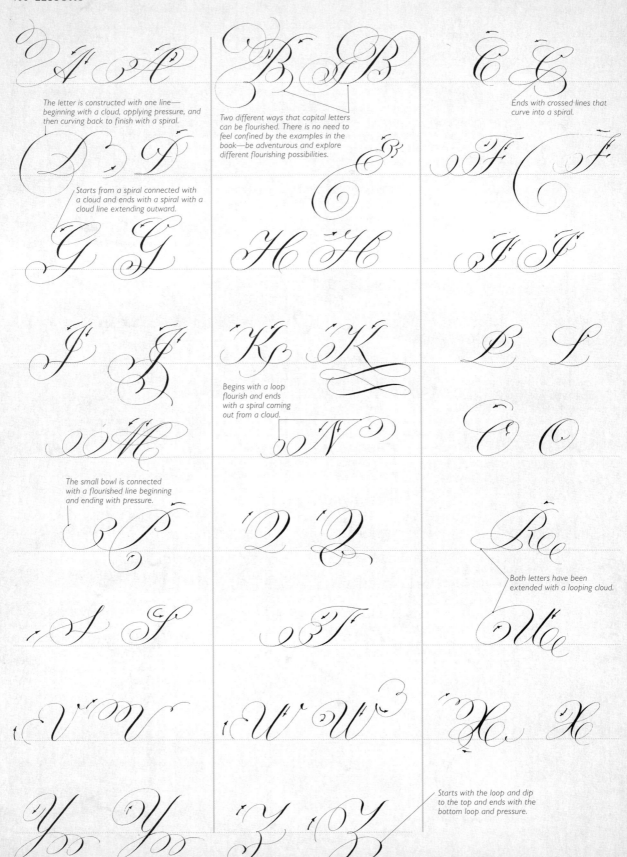

The letter is constructed with one line—beginning with a cloud, applying pressure, and then curving back to finish with a spiral.

Two different ways that capital letters can be flourished. There is no need to feel confined by the examples in the book—be adventurous and explore different flourishing possibilities.

Ends with crossed lines that curve into a spiral.

Starts from a spiral connected with a cloud and ends with a spiral with a cloud line extending outward.

Begins with a loop flourish and ends with a spiral coming out from a cloud.

The small bowl is connected with a flourished line beginning and ending with pressure.

Both letters have been extended with a looping cloud.

Starts with the loop and dip to the top and ends with the bottom loop and pressure.

KEY FLOURISHES

When making flourishes it is important to look at the space around the letter to see if the flourish will impinge on the lines above or below it. In calligraphy, as with so much other visual design, balance is key to creating beautiful effects. The illustration shows the four main types of flourish. They can be used singly or in combination with each other.

1 2 3 4

1. The line can be done from left to right or right to left.

2. Spirals can be made in any direction. Remember to apply pressure on the downstroke only.

3. All three are clouds forming either a line or a loop. The cloud is a flexible flourish, as it can go in any direction and is often looped.

4. This flourish is more limited in its applicaton. If you do decide to use it, use it sparingly.

JOINING LETTERS

There are fewer flourishes on the right-hand side of a capital letter so that other letters or words can be joined to it. The space between the letters should be roughly equal to the space inside letters; space between words should be equal to the size of one letter (e.g., "O"). Practice words that begin with different capital letters to familiarize yourself with how they fit together. Writing out names is excellent practice. Remember that complete words are not written in Copperplate capitals.

Alpha *Beta*

The crossbar of "t" provides an opportunity to flourish boldly as a balance to the elaborate "B."

The left-pointing flourishes of "A" are counterbalanced by the forward-flowing "l," "h," and "p."

Chi *Delta* *Eureka*

Keeping the flourishes of the "C" to the left leaves room for a flourish on "h" also.

Wildly decorative "D" has all its flourishing to the left to accommodate following letters.

Theta *Upsilon* *Vox*

The "T" is a looping cloud line, kept to the left so the next ascender can be elaborate too.

The descender of the "x" has been extended into a spiral flourish, finishing with pressure.

The "r" has been extended into a spiral created with pressure on all downstrokes.

The "X" is curved to allow space for the other letters to join it.

Wasser *Xeros* *Ye* *Zeta*

1
2
3
4
5
6
7
8
9
10
11
12
13
14
15
16
17
18
19
20
21
22
23
24

SPENCERIAN:
Minuscules

Spencerian was based on the idea that writing should flow from the free movement of the arm and hand. In appearance, Spencerian is lighter and more graceful than other cursive forms of handwriting, particularly Copperplate. The lowercase letters are delicate, and shading is often applied to just the third or fourth letter in a word. Like Copperplate, Spencerian is usually written using a flexible nib and an oblique penholder.

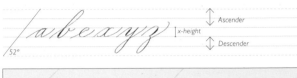

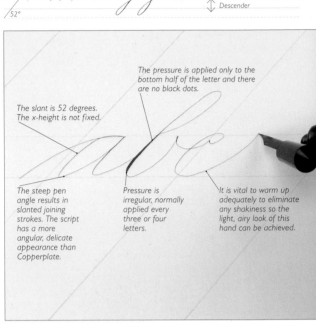

The pressure is applied only to the bottom half of the letter and there are no black dots.

The slant is 52 degrees. The x-height is not fixed.

The steep pen angle results in slanted joining strokes. The script has a more angular, delicate appearance than Copperplate.

Pressure is irregular, normally applied every three or four letters.

It is vital to warm up adequately to eliminate any shakiness so the light, airy look of this hand can be achieved.

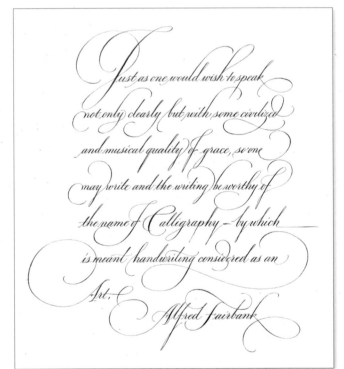

"Handwriting considered as an art" by John Stevens
This modern Spencerian script has a Copperplate "feel," as all letters are the same thickness, rather than having pressure applied on the third stroke, which is typical of Spencerian scripts. The small x-height contrasts with the extended descenders and ascenders to create a flowing handwriting.

ABOUT THE LETTERING

As in Britain, the Industrial Revolution had a profound effect on nineteenth-century America. Changes to commerce, production, and the growth of business created an unprecedented need for written communication. British machinery, processes, and styles of handwriting (as well as steel-nibbed pens) were imported to the former colony. Everyday handwriting or "formal penmanship" was considered vital to gain employment and prestige in the new industrialized America, and a number of handwriting artists emerged, most notably Platt Rogers Spencer, who established many successful writing academies and developed the Spencerian Handwriting System. Spencer took advantage of new lithographic printing methods to publish and distribute his writing system in copybook form throughout the United States.

Push up from the bottom left to the top of the letter, sweep down without pressure, release, and push back up to form the oval shape. Lead out with a hairline stroke.

a

b b

c

To exaggerate the lead-out stroke, push back up and finish with a small loop and a filled-in dot.

d

e

f f

g

h h

i

j j

k k k

l

m

n

o

Lead in from the bottom left, pushing up to the top of the letter. Sweep down with pressure to form the descender. Release and push back up the stalk, branching at the halfway point of the x-height to form a loop. Sweep down without pressure, release, and lead out.

p

q q q

r

s

t

u

Make a lead-in stroke and sweep down without pressure. Release and push up to the top of the letter to form the bowl. Sweep down without pressure, release, make a bowl, and push up to the top of the letter. Lead out with a hairline stroke.

v

w

x

SEE ALSO

Spencerian: Majuscules, pages 106–109

y y

z z

FAMILY GROUPS

Practice the letters in their family groups writing the letterforms without any pressure. Try different nibs to work out which will make the thinnest line. All Spencerian letters have thin entry and exit strokes.

i u v w y

1 *n m r x h p*

2 *a d g q*

3 *o c e*

4 *b f j k z l r s*

1. Letters contain straight lines.

2. Letters containing straight and curved lines.

3. Oval-shaped letterforms.

4. Letters with combinations of different shapes and lines.

BASIC STROKES AND PRESSURE

Practice the letterforms using a very light pressure to create thin, hairline strokes. Gradually experiment with pressure on the second or third stroke of a word. As you become more skilled, try to work out where to put the pressure in to create the most harmonious effect. You may need to apply pressure two or even three times in one word.

1 *l u*

2 *u u m*

i i

x x

2 *a a*

1. These strokes are the building blocks of the script—the diagonal lines, two flattened curves, and a loop. The loop is made from the diagonal lines and one curve; avoid making it too big.

2. These examples show how pressure can be applied at different points within a letter.

Warm-up exercises

It is vital to warm up before beginning to write so that your hand becomes accustomed to making the movements of the script. Neglecting to warm up will result in jagged, uneven letterforms. Think of the warm-up as part of the whole writing experience that prepares your mind and hands for the task to follow.

Make diagonal lines.

Practice making this simple shape, like the letter "u," repeated and joined together.

Try zigzags. The upward stroke should be longer; the downward stroke shorter.

Practice joining different letters together.

HOMEWORK

1. Make several lines of pen patterns, as in your warm-up exercises.

2. Repeat the patterns, applying pressure to every third downstroke.

3. Write a word such as "minimum," applying pressure differently each time you repeat it.

a b c d e f g h i j k l m n o p q r s t u v w x y z

JOINING LETTERS AND WORDS

Experiment with different ways of joining words together. Pay attention to the space around the letter as well as the space inside the letter when making joins. Practicing simple joins will help you progress more quickly to learning the flourished Spencerian letterforms.

Keep a light touch and be aware of the shapes made by the loops.

Keep the final circle open enough to cross other loops without creating tight knots.

Practice the heavy downstroke contrasted with a hairline downstroke.

hilaris *lento*

Develop rhythmic, even writing, here with pressure on every third letter.

mille *natura*

opera *thymum* *quantum*

Pressure is not always applied to the first part of the letter.

Note that the pressure is applied to just one stroke, not the whole letter.

LETTER VARIATIONS

As well as applying pressure at different points within a word, you can vary the pressure within the letterforms themselves (in the letter "q," for example). As a general rule, if a letterform has a long line, it looks better if the pressure is applied to the lower part (see "l") to keep it from becoming top heavy. It is important to consider what comes before and after the stroke so that your letterforms harmonize with the rest of the text.

1

2

3

4

1. As well as choosing where to apply pressure, there are options for the entry and exit strokes.

2. The "f" provides weight and loop opportunities for variation.

3. Try varying the pressure at the bottom of "i," and try different joining loops.

4. For "z," try varying the loops at beginning and end.

a b c d e f g h i j k l m n o p q r s t u v w x y z

1
2
3
4
5
6
7
8
9
10
11
12
13
14
15
16
17
18
19
20
21
22
23
24

SPENCERIAN:
Majuscules

Spencerian majuscules developed from their Copperplate counterparts. As there are fewer pressure strokes the letterforms appear lighter and more elegant. There is no x-height for the majuscules; they are adapted to fit the proportions of the rest of the text. The shape of the letter should be balanced: if flourishes are added to the upper letter, then they should be applied to the lower letter, too.

ABOUT THE LETTERING

During the nineteenth century, handwriting was seen as a social accomplishment as well as a function of commerce. Many instructional books were published complete with practice drills and illustrations of how the arm, hand, and pen should be held. Some contain illustrations of elaborate ornamental lettering or illustrations of animals, particularly birds, constructed of flourishes. These may seem strange to the modern eye, but they reflect the era's attitude to handwriting as an "art." In fact, many

handwriting artists were also great showmen, attracting crowds to public demonstrations of their skill. The majuscules were particularly favored for their flourishes, often to the point of compromising legibility.

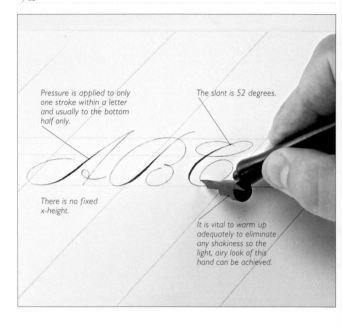

52°

Pressure is applied to only one stroke within a letter and usually to the bottom half only.

The slant is 52 degrees.

There is no fixed x-height.

It is vital to warm up adequately to eliminate any shakiness so the light, airy look of this hand can be achieved.

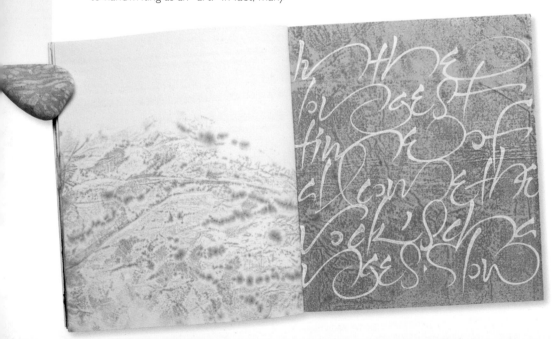

Calligraphy book by Susie Leiper
The words here are from the poem "Rock" by Kathleen Raine. The brush-written text is applied with Japanese ink stick, Chinese indigo, and white gouache on Chinese xuan paper, which was then sewn together to create a book. The use of brush for both image and text creates a harmony similar to that achieved in Chinese landscape painting.

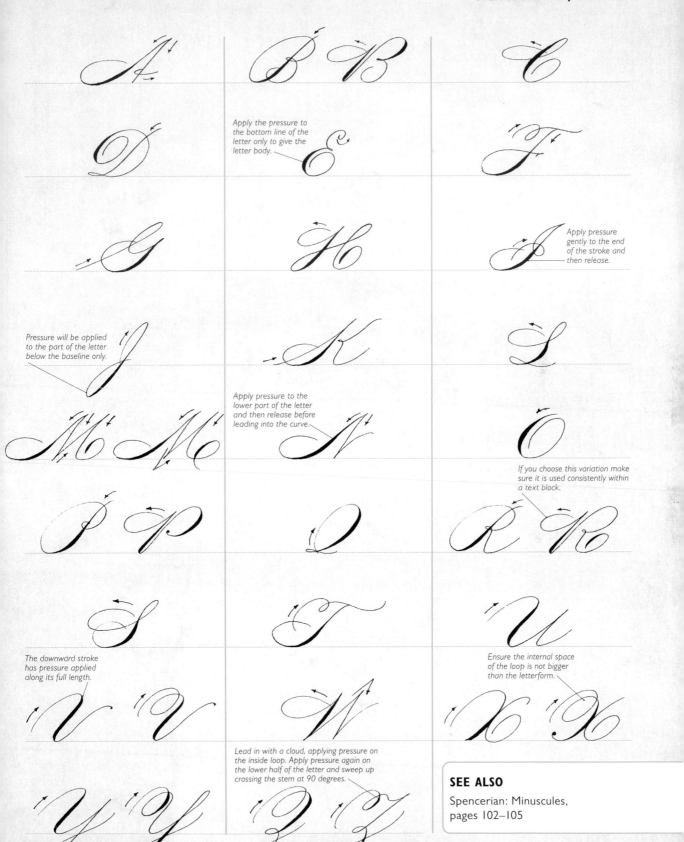

Apply the pressure to the bottom line of the letter only to give the letter body.

Apply pressure gently to the end of the stroke and then release.

Pressure will be applied to the part of the letter below the baseline only.

Apply pressure to the lower part of the letter and then release before leading into the curve.

If you choose this variation make sure it is used consistently within a text block.

The downward stroke has pressure applied along its full length.

Ensure the internal space of the loop is not bigger than the letterform.

Lead in with a cloud, applying pressure on the inside loop. Apply pressure again on the lower half of the letter and sweep up crossing the stem at 90 degrees.

SEE ALSO

Spencerian: Minuscules, pages 102–105

FAMILY GROUPS

The letters can be divided into family groups in many different ways. In this example, the alphabet has been organized into four different letterform shapes to simplify practice sessions. The best way to learn the script is to practice and study similar groups together.

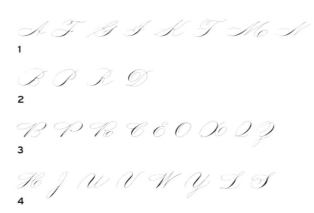

1. Pressure is applied to the lower half of the diagonal line only in these bottom-heavy letterforms.

2. Letters constructed primarily of both diagonal lines and loops.

3. Letters related to an oval.

4. Diagonal strokes have pressure applied along the length of the stroke.

BASIC STROKES AND PRESSURE

The key to success with this hand is understanding how pressure affects the shape of the letterforms. Everybody applies different amounts of pressure when writing. The following exercises will help you find the right pressure for your own writing and will teach you to apply it consistently.

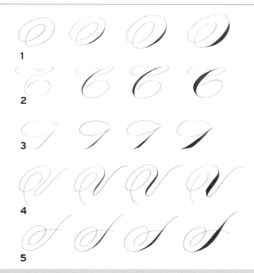

1. Clockwise curves: pressure is applied to the right-hand side of the letterform.

2. Counterclockwise curves: pressure is applied to the left-hand side of the letterform.

3. Heavy pressure lines: the pressure is gradually applied through the length of the stroke.

4. Pressure and release: most pressure is applied in the middle.

5. Counterclockwise pressure stroke: pressure is applied on the final stroke of the letter.

Warm-up exercises

It is best to do these warm-up exercises as often as possible to familiarize yourself with the script. Ideally, you'll want to produce a few pages of these exercises before going on to write the hand.

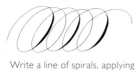

Write a line of spirals, applying pressure every second curve.

Write the shapes, applying pressure on the downstroke.

Apply pressure on the downward part of the stroke.

Using a pencil write a letterform. Keep writing over the original letterform as many times as you like. This exercise will help fix the shape of the letter in your mind.

HOMEWORK

1. Make a series of warm-up spirals and letter shapes in groups, applying pressure on every third downstroke.

2. Make fresh patterns by alternating two majuscules that contrast in shape.

3. Try again with a set of three majuscules.

abcdefghijklmnopqrstuvwxyz

JOINING LETTERS AND WORDS

All letters are joined with hairline upstrokes. Remember to maintain a slow, even rhythm. The space between the letters should be roughly equal to the space inside letters; space between words should be equal to the size of one letter (e.g., "o"). Begin with words that join together easily. Repeat lines of the same words, ensuring that even pressure, rhythm, and spacing is maintained. Note that the capital letters do not have to join the main body of text; sometimes it can be effective to have a small gap, especially after a flourished capital. However, it is important to lead in to the first letter with a hairline upstroke.

Amo

The lowercase and capital are connected. Pressure is applied at the beginning of the "A" and the counterclockwise stroke at the end of the "o."

Barba

Canto

Dives

Ego

Fieus

Galea

In "Hoora" the weighted line is on the far left surrounded by flourishes. The steep angle of the "H" allows the "o" to be spaced quite close without compromising the design or legibility.

Hoora

Pala

Quae

Rarus

Sal

The hairline lead-in strokes of the lowercase letters suggest that the letterforms are connected to the capital without actually joining them.

Tres

A generous amount of space has been used between the capital "T" and the "r" to balance the shape of the word. Closer spacing can be used, but the "T" and "r" should not be joined.

Urbs

Vox

Wasser

Yonder

If the capital has a line which curves back, like the descender of the "y," the lower case letter can be joined with a single stroke.

Xylophone

Longer words look best when most of the lowercase letters are joined. However, you should not force the joins or they will look obvious and spoil the rhythm of the word.

Carpe Diem Tempus fugit

Note the "D" in "Carpe Diem" is flourished on the left-hand side—the pressured downstroke balances with the inside space of the "D." The gap before the "i" prevents the letter from appearing too cramped. The hairline lead-in to "i" is an important visual link to the majuscule.

All the letterforms are joined. The exit stroke of the "t" has been extended to suggest a crossbar, rather than using a crossed line. Crossed lines can look cramped in Spencerian script.

abcdefghijklmnopqrstuvwxyz

1
2
3
4
5
6
7
8
9
10
11
12
13
14
15
16
17
18
19
20
21
22
23
24

FLOURISHED SPENCERIAN:
Minuscules and majuscules

Flourishes should appear to be a natural extension of the letterforms to match the mood of a piece of writing. Spencerian does not have filled-in dots and has pressure on only the third or fourth letter. It should appear lighter and more delicate than Copperplate.

ABOUT THE LETTERING

Spencerian script was popular during the nineteenth century when flourished and decorative handwriting was at the peak of popularity. Although flourished historical documents appear spontaneous and free-flowing they would have needed a great deal of care and planning. The amount of interlinear space required would need to be ascertained in advance to keep the flourishes from colliding with each other. Furthermore, certain combinations of flourishes would need to be carefully practiced to give the appearance of spontaneity. The script lends itself to elaborate extra ornamentation, such as flourishing descenders on the bottom line or extending flourishes into decorative borders. A light touch is essential throughout.

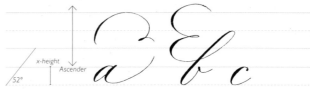

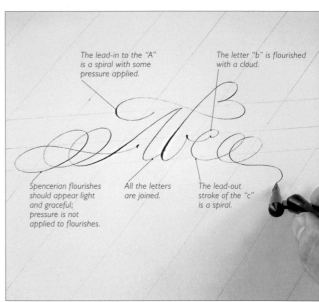

The lead-in to the "A" is a spiral with some pressure applied.

The letter "b" is flourished with a cloud.

Spencerian flourishes should appear light and graceful; pressure is not applied to flourishes.

All the letters are joined.

The lead-out stroke of the "c" is a spiral.

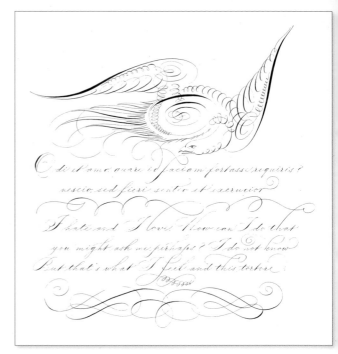

Decorative bird by Veiko Kespersaks
This contemporary example was written using the oblique penholder. These flamboyant illustrations were popular in the nineteenth century to promote different writing manuals. It is a good idea to "play" with different flourishes and doodles to explore the possibilities of the flexible pen.

Two different flourishes, each with pressure applied to the lower part of the letterform. The ascender has been extended with simple crossing loops. Any letter that has an ascender can use this variation.

Make sure the "c" is formed with a small cloud inside to differentiate it from an "e."

Pressure should be applied to the lower part of the letterform only.

Extending the final upstroke provides scope for generous flourishes.

To ensure legibility make sure that any flourishes you add don't look like letterforms.

Extending above the line in a generous loop assumes plenty of interline space.

Exit and entry strokes can be extended to make flourishes.

This flourish can be applied to any letterform that has a descender and occurs at the end of a line.

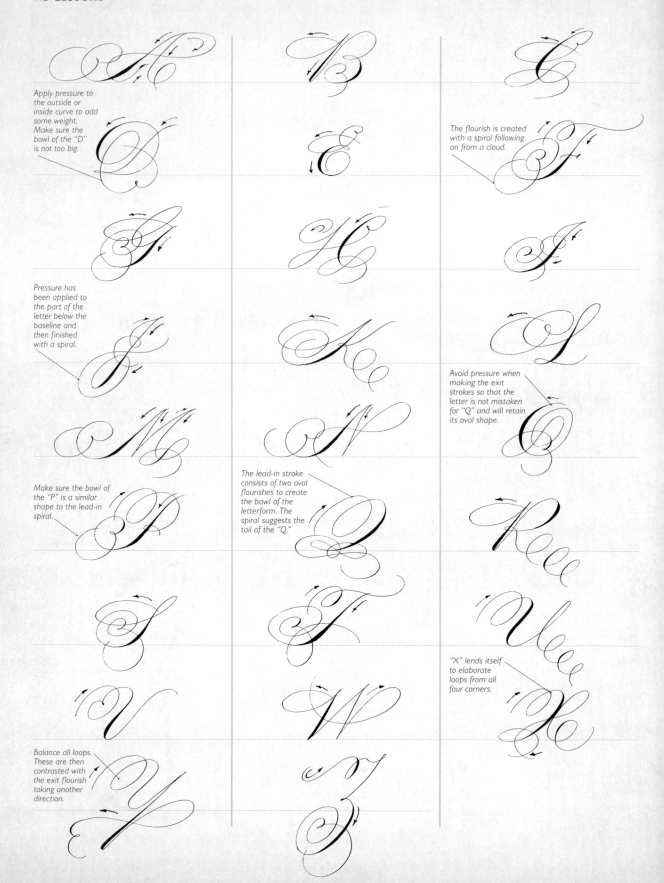

Apply pressure to the outside or inside curve to add some weight. Make sure the bowl of the "D" is not too big.

The flourish is created with a spiral following on from a cloud.

Pressure has been applied to the part of the letter below the baseline and then finished with a spiral.

Avoid pressure when making the exit strokes so that the letter is not mistaken for "Q" and will retain its oval shape.

Make sure the bowl of the "P" is a similar shape to the lead-in spiral.

The lead-in stroke consists of two oval flourishes to create the bowl of the letterform. The spiral suggests the tail of the "Q."

"X" lends itself to elaborate loops from all four corners.

Balance all loops. These are then contrasted with the exit flourish taking another direction.

FLOURISHES

The following flourishes can be used in isolation or in combination. If combining many flourishes, ensure that the result retains a visual relationship with the word and is clearly attached rather than floating in space. In Spencerian hand the flourishes should not have pressure applied so that they do not overpower the words.

1. Flourished straight line.

2. Spiral inward, exit from spiral.

3. Cloud: Use pressure only rarely with cloud lines. The cloud can also be used like a spiral.

4. Knot: Only apply pressure once inside the knot.

JOINING LETTERS AND WORDS

The right-hand side of a letter is always less flourished so that it can easily be joined with the following letters. Flourishes can originate from the beginning or ending of lines, or where two lines connect on the top line. Flourishes should never be added to the parts of letters that connect on the bottom line, for example in "N," "M," or "V."

Agora

The flourished line ends between the "A" lines, terminating with light pressure, instead of a crossbar.

Beta

Chi

Delta

Pressure must be only on letters, not on flourishes; otherwise the flourish will take over the letterform ("D" is an exception).

Ethos

The word does not have to be written like this; pressure could be placed on either the "h" or the "o."

Keep the loop tight and the pressure on the main stroke.

Vox

Wasser

In a single word, balancing the looped flourish on the "w" with loops from "r" adds decorative interest.

Xi

Yo

Zeta

The "Y" ends with a flourished spiral, as there is no letter following it. The "X" is followed by "i" so it has only a small looped flourish.

ILLUMINATION: Design choices

Illumination, whether it complements or contrasts with the text, should harmonize with the chosen style of lettering. Decorations rarely work well when they have been added to the text without careful consideration.

To determine which decorations work best, you will first need to analyze your text and extract the key characteristics of your lettering. If your calligraphy is fine and rounded (for example, Copperplate) it is important that the decorations and miniatures you use in your illumination design are also fine and rounded. For pointed, dense, Gothic styles the illumination will need to reflect this too. Analysis of Gothic and Classic

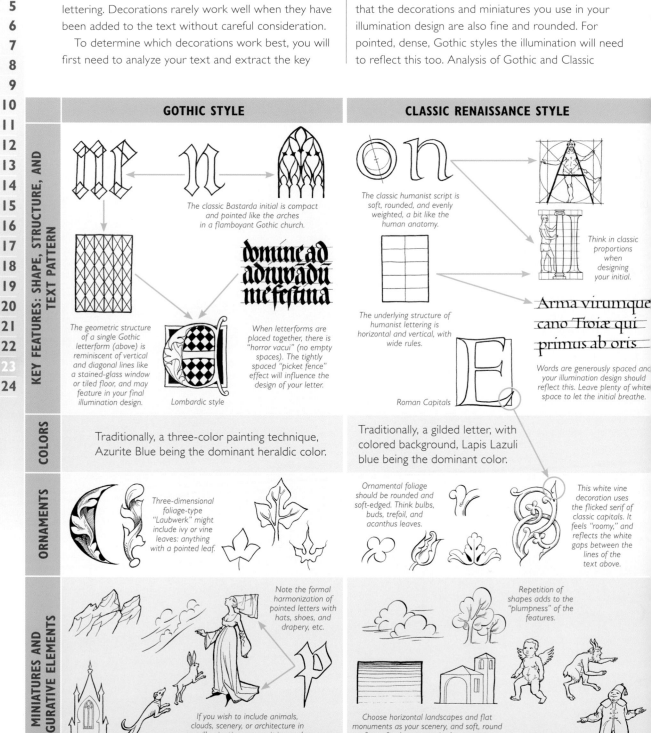

GOTHIC STYLE

KEY FEATURES: SHAPE, STRUCTURE, AND TEXT PATTERN

The classic Bastarda initial is compact and pointed like the arches in a flamboyant Gothic church.

The geometric structure of a single Gothic letterform (above) is reminiscent of vertical and diagonal lines like a stained-glass window or tiled floor, and may feature in your final illumination design.

When letterforms are placed together, there is "horror vacui" (no empty spaces). The tightly spaced "picket fence" effect will influence the design of your letter.

Lombardic style

COLORS

Traditionally, a three-color painting technique, Azurite Blue being the dominant heraldic color.

ORNAMENTS

Three-dimensional foliage-type "Laubwerk" might include ivy or vine leaves: anything with a pointed leaf.

MINIATURES AND FIGURATIVE ELEMENTS

Note the formal harmonization of pointed letters with hats, shoes, and drapery, etc.

If you wish to include animals, clouds, scenery, or architecture in your illumination, ensure it is angular and that it is consistent with the pen angle of the lettering.

CLASSIC RENAISSANCE STYLE

The classic humanist script is soft, rounded, and evenly weighted, a bit like the human anatomy.

Think in classic proportions when designing your initial.

The underlying structure of humanist lettering is horizontal and vertical, with wide rules.

Arma virumque cano Troiæ qui primus ab oris

Words are generously spaced and your illumination design should reflect this. Leave plenty of white space to let the initial breathe.

Roman Capitals

Traditionally, a gilded letter, with colored background, Lapis Lazuli blue being the dominant color.

Ornamental foliage should be rounded and soft-edged. Think bulbs, buds, trefoil, and acanthus leaves.

This white vine decoration uses the flicked serif of classic capitals. It feels "roomy," and reflects the white gaps between the lines of the text above.

Repetition of shapes adds to the "plumpness" of the features.

Choose horizontal landscapes and flat monuments as your scenery, and soft, round forms for the aspects in that scenery.

lettering (that is, the shape, texture, and pattern of the letterforms) suggests certain ideas for decoration. Historical illuminations can also be adapted and incorporated into your own designs.

If you're writing freehand and want to create your own illumination style, begin by analyzing your own handwriting.

Look at the overall impact: does it suggest formality or does it appear to be a more relaxed style? Are the shapes linear or curvaceous? Some examples are shown underneath, which you can adapt to suit your own handwriting or calligraphy style.

MODERN DROP OR "AMOEBA" STYLE

Use a simple yin-yang as a starting point.

First think about the construction of the key shapes in the yin-yang.

Work with this construction to build new shapes of your own design. Experiment with repetition.

Begin to build the shapes into letters...

...and whole words

...merge shape and letters together, thinking all the while about spacing. What are the key features of the script now? Are they different from when you were working with one letter only?

MODERN "LINEAR" STYLE

Vector Two vectors Curve

Once again, begin your analysis of the letterforms by understanding their structures. Are they made of one or two vectors? Are these vectors linear or curved?

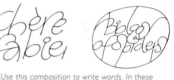

Create a free composition that uses all the basic strokes you have identified.

Use this composition to write words. In these examples, the ascenders of the second line butt up against the letterforms on the first line, creating a "spiderweb" effect.

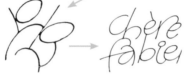

Experiment: See where else this structure might lead you.

Flat opaque painting with watercolor, or acrylic in pastel tones. Neon colors, metallic colors—even graffiti-style gildings might work.

The drop construction extracted from the yin-yang creates fun decorative wheels...

...or stylized plants.

Any kind of coloring is possible, but search for contrasts (light/dark; warm/cold, etc.).

Because the letterforms create such great shapes already, you might want to leave it at that; if you require more, combine the basic strokes to create repetitive patterns.

Figures, landscapes, and animals should be in keeping with the amorphous form.

 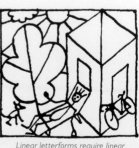

Linear letterforms require linear miniatures, almost cartoonlike in appearance.

Designing an initial

Copying letters from historical sources is a useful way to learn illumination, but eventually you will want to incorporate their design features into your own work. By close examination of illuminated initials and understanding their construction, you will be able to adapt them for more contemporary applications. Begin by making a basic pencil drawing of the initial. Make sure the letter is the appropriate size for the text that will accompany it. When the drawing is complete, experiment with color and gold as outlined opposite.

1 Draw a square big enough for the letterform to fit inside. The size of the letter should relate to the text that follows it and any other illuminated letters in the text.

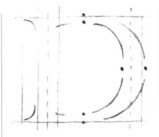

2 Mark the square with orientation points before you draw the letter. These do not have to be exact, they are guidelines for your drawing.

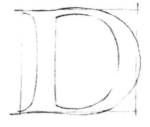

3 Draw the outline of the letter freehand. Before you proceed to the next steps double-check it is the correct size for your text.

4 Mark the main positions for the decoration. Any design elements (flowers, leaves, etc.) will need to be evenly distributed. The elements can touch each other and overlap, if desired.

5 Define the outline of the decorations. The thickness of the plant stems should be equal to the narrowest parts of the letter.

6 Define the decorative elements using pen and ink. Begin with the flowers, as they are the top layer of the design. You can use metal nibs or pointed quill pens and diluted watercolor, oak gall ink, or waterproof ink.

Finished drawing

HUMANISTIC WHITE VINE STEM INITIAL

In this "classic" style, the letter is gilded, not the background or ornaments. The vine stem is left the color of the parchment paper, which reflects the white gaps between the lines of the text. It should not be painted with white, but can be lightly shadowed. "Yellow" in these diagrams stands for "gold."

"GOTHIC-STYLE" INITIAL

In this variation, the background field of the initial is gilded with raised gold leaf. In this style, all surfaces are covered with paint in order to harmonize with the design of the calligraphy. The colors should be strong and pure.

1 Use synthetic or old brushes for the gilding and the first layers of paint. The raised gold technique is best (see pages 120–121).

2 Fill the background fields with gouache paint. The traditional Italian coloring is Lapis Lazuli for the outer fields, and Copper Green and Brazil Wood Lake for the remaining fields. Try to distribute colors like on a checkerboard.

1 Gild the background with gesso and gold leaf.

2 Paint the initial with Azurite Blue instead of Lapis Lazuli, if you can.

3 The following steps must be done with good-quality fine brushes. The background fields are refined by adding light dots (Chinese White on Lapis Lazuli, Naples Yellow on Copper Green and Brazil Wood Lake). Make the dots in geometrical groups (for instance, triangles) to prevent them from looking like snow.

4 Add shadow to the vine stems with diluted Terra di Siena to give them some volume. Go around the gilded letterform with a fine black pen.

3 Paint the stems in Malachite Green and the petals in Minium Orange. If you like, add shadows to the stems and petals. Use Sap Green on Malachite Green and Carmine on the Minium Orange.

4 Use Chinese White (historically, white lead) to enhance the leaves on the blue surface and opaque light yellow (historically: lead tin yellow) on green and red. To finish, outline all main contours, especially those of the gildings, with Lamp Black and a fine brush.

Finished illumination
This style harmonizes with all kinds of "classic" calligraphy, such as Italic and Foundational. Write the first word or line in majuscules to help the eye find the beginning.

Finished illumination
This style harmonizes with all kinds of "Gothic" calligraphy, such as Textura, Rotunda, and Bastarda, but also with modernized pointed styles such as personalized design lettering.

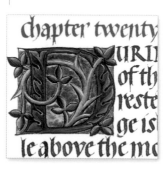

ILLUMINATION:
Basic techniques

Now that you have designed your initial, you will want to illuminate and decorate it. This lesson takes you step-by-step through the core techniques of laying gold leaf and coloring your letter.

TRANSFERRING YOUR DESIGN TO PAPER

When you have done all the hard work of refining the design and balancing the color of the decorated letter you have chosen to use from your main text, you need to transfer the drawing to the vellum or paper before you can start your finished piece. Using a carbon transfer method is the easiest and quickest way to transfer your design to paper, and it uses the minimum of materials.

TOOLS & EQUIPMENT

- Pen and ink
- Sheet of tracing paper
- Pencils 2B or 4B, 2H, HB
- Absorbent cotton
- Masking tape
- Good paper or vellum

ALTERNATIVE TRACING METHOD

Use a lightbox for transferring designs. If you don't have a lightbox, you can tape the drawing and paper to a window (so the daylight will reveal the design) and draw in the design.

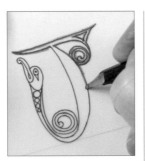

1 Draw the final design in ink on tracing paper. Turn the drawing over and, using either a 2B or a 4B pencil, go over the back of the drawing, just covering the lines.

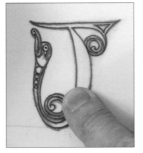

2 Remove any excess graphite by smoothing over the pencil marks with your finger or a small piece of absorbent cotton.

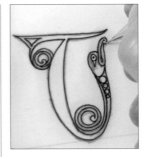

3 Place the drawing right side up in the correct position on good paper or vellum, and then tape it down lightly into place with masking tape. Use a sharp 2H pencil to transfer the drawing by tracing the lines.

4 Remove the tracing paper to reveal the drawing. If some parts are a little pale, where your carbon transfer was too thin, go over these lines with an HB pencil to fill in the gaps before the inking-in stage.

GILDING

Gilding has been used to enhance the pages of manuscripts for many centuries, either on large initials or as points of brilliance within decorative borders or line fillers. Gold can be beaten out into a very thin sheet, thinner than any other metal. It also has the property of sticking to itself, and every layer you put down increases the depth and brilliance of the shine.

Gold leaf comes in books of 25 leaves and should be at least 23¾ carat. Patent gold (known as transfer gold in the U.K.) is attached to a backing sheet, which makes it easier to handle. Transfer gold (known as loose-leaf gold in the U.K.) is not attached, but is supplied between sheets of soft tissue paper coated with jeweler's rouge. Both types of gold are available in single and double thickness. When applying gold to the gesso or other glues mentioned in this book, use a layer of single-thickness gold (of whatever type) first, followed by a double-thickness layer. After use, protect the books of gold by storing them between sheets of stout card.

FLAT GILDING USING GUM AMMONIAC

Gilding on paper or vellum requires some type of glue for the gold to adhere. Paper and vellum are pliable supports, so the glue used for gilding must be similarly flexible, so that the gold does not crack or flake off. Gum ammoniac has been used as a gilding medium for centuries and remains a favorite with calligraphers as a simple, reliable method for flat gilding. The gold finish is brighter than shell gold, but not as brilliant as gold on plaster gesso.

TOOLS & EQUIPMENT

- Gum ammoniac solution
- Plastic or glass rod
- Old small brush
- 140lb (300gsm) HP watercolor paper with predrawn letter
- Breathing tube
- Patent gold
- Glassine paper
- Dogtooth agate burnisher
- Large soft brush
- Piece of soft washed silk

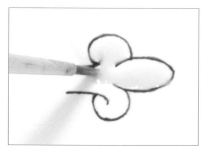

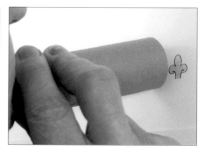

1 Have all your materials at hand, as you will need to work quickly to lay the gold after you have breathed on the gum to activate it. Before you start, stir the gum ammoniac solution slowly and thoroughly to incorporate all the gum from the bottom of the jar. This should avoid problems with bubbles, but allow it to settle a short while before use. Work on a flat surface so that the gum dries level. Using an old brush, lay a thin, even layer of the gum on the paper, working methodically across the area, wet into wet. Let dry for 30 minutes; then carefully add a second layer over the first and let dry completely for an hour or more.

2 With the paper on a smooth, hard surface, use a breathing tube or small rolled piece of paper to direct your breath onto the gum and breathe three times.

ALTERNATIVE FLAT GILDING METHOD

PVA glue or acrylic painting media can also be used (diluted 50/50 with distilled water) for flat gilding, like a modern version of gum ammoniac. The glue is colorless, so it helps to add a spot of red watercolor so that it can easily be seen when dry. The materials (substituting the PVA) and method are the same as for the gum ammoniac gilding described on this page.

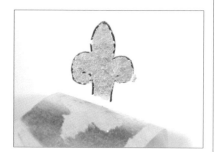

3 As soon as you have breathed on the gum, lay the patent gold face-down onto it, pressing down firmly (without twisting) with your fingers. If the gold does not stick, breathe on the gum again and reapply the gold. Peel off the backing sheet to reveal the gold stuck onto the gum. Repeat this step to cover the whole area completely.

4 Burnish the gold gently through a sheet of glassine. Repeat Step 3 to add a second layer of gold.

5 Let dry thoroughly for at least 30 minutes before removing any surplus gold with a large soft brush. Then give it another burnish through glassine before a final polish with soft silk.

RAISED GILDING AND BURNISHED GOLD

Raised gilding has changed little since medieval times. Layers of patent gold and transfer gold are applied to a firm base of plaster raised slightly from the writing surface. The gold can be burnished to a mirrorlike finish and its brilliance will light up your work, as it did the pages of early manuscripts. It is certainly not the easiest technique and is more time-consuming than flat gilding, but if it is done well, it will give the best results.

1 First you will need to lay the gesso. Have an outline of a letter or shape ready drawn. Work on a flat surface so the gesso settles evenly. Dampen the brush, then dry it again to expel all the air. Thin a little of the gesso with distilled water and apply it as a sealer or undercoat.

2 Flood in more gesso, wet into wet, until the whole shape is filled, making sure the surface is even and level (this applies particularly to larger areas). Let it dry out completely, at least overnight.

3 Gently scrape the gesso level with the scalpel, to even out any bumps (wear a dust mask). You do not need to press hard—let the weight of the scalpel do the work. Tip the paper slightly and gently brush the scrapings onto kitchen paper, which can be carefully folded up and thrown away.

4 Gently rub the surface with silk to reduce friction, and then burnish the gesso directly with either the agate or the psilomelanite burnisher. The shiny surface seems to take the gold more easily.

5 Pick up the patent gold in one hand, and then give six good breaths over the gesso using the breathing tube.

6 Press the gold gently onto the gesso surface, and then carefully peel off the backing sheet. Use the burnisher (without much pressure) through the glassine. Repeat until covered completely. Leave to settle for 30 minutes.

7 Burnish through glassine, using the point of the dogtooth burnisher to work around the edges.

8 Use tweezers to pick up a piece of transfer gold. In your other hand, hold the piece of silk. Because both hands are occupied, you cannot use the breathing tube. Breathe on the gesso, taking care not to let your mouth touch either gesso or paper. Lay the gold onto the gesso, pressing it into place with the silk. This will leave a slight impression of the weave on the surface.

9 Burnish through glassine to smooth out the silk marks and tuck the edges over.

10 Repeat Steps 6 and 7 for two complete layers (you will need fewer breaths for each subsequent layer). Allow the gesso to settle each time before burnishing. Burnish through glassine, using a pencil burnisher, to set the edges.

11 Remove any surplus gold with a soft brush and save the pieces in a film canister. They can be used for patching small areas of gesso. Leave to settle. (You can breathe onto the gesso and fold the surplus gold back over the raised shape and burnish.)

12 Burnish the gold directly with an agate or psilomelanite burnisher, using a circular motion and increasing pressure to produce a good shiny finish. Use the pencil burnisher carefully to polish the edges, taking care not to dent the gesso.

COLORING YOUR DESIGN AND USING MASKING FLUID

Gouache is generally the best all-around choice for beginners; it works equally well for both the painting and any accompanying calligraphy. Watercolor is used for transparent glazes. Whether you are using watercolor or gouache to color an illuminated piece, masking fluid can make your job easier. Where you need to lay background colors, but the letter or number has complex decorative motifs around it, it is much simpler to cover the entire intricate design first with masking fluid.

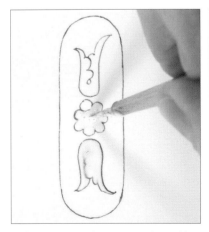

1 On a predrawn letter or number, with an old brush or one with synthetic bristles, apply masking fluid to all areas that need to be kept white, and then let dry.

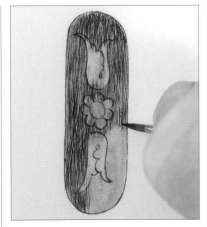

2 Paint the background colors freely over the whole area, using gouache or watercolor (shown).

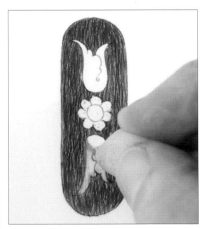

3 When all the painting has been completed and is thoroughly dry, remove the masking fluid by easing it off with a cut piece of soft plastic eraser, a pencil-type eraser, or a cotton swab. Take care not to spoil the color area.

THE PROJECTS

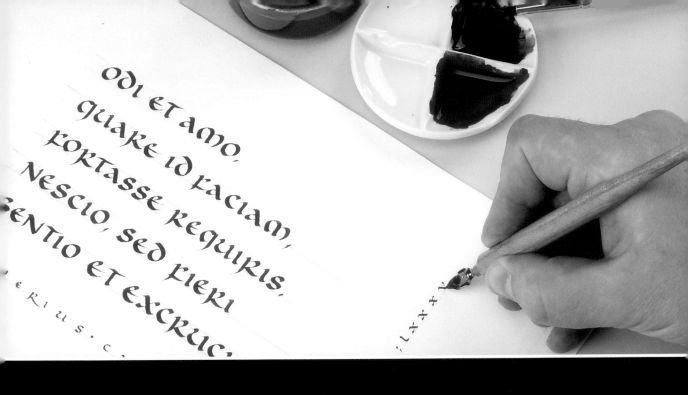

odi et amo,
quare id faciam,
fortasse requiris,
nescio, sed fieri
sentio et excruci

The best way to advance your calligraphic skills is to use them. The following chapter contains projects that will challenge your use of letterforms and design in a structured, practical way. Attempting the projects will improve your skills, as well as giving you the satisfaction of making something beautiful and useful.

CONCERTINA BOOK

Calligraphy and books go hand in hand, and knowing how to design and make a simple book is important for every calligrapher. Here, you will learn how to design, write, and bind a simple book; you can adapt this idea in many ways.

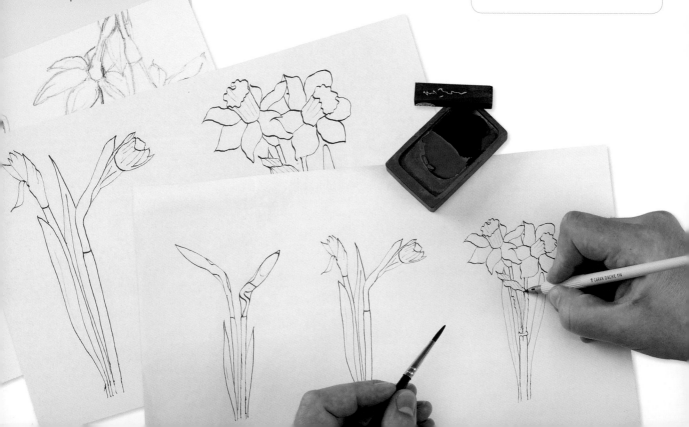

TOP TIPS

- Photocopy your drawings—a photocopy gives clearer lines to trace from.

- Try using a calligraphy nib for the illustration; this gives a line that has both thick and thin strokes.

- Working in black ink for the first stages of layout helps you to balance weights and spaces.

Much work goes into planning a project. You must make choices about script, color, and illustration to create important design elements. This project is a book, and how it functions as well as how it looks are things that you need to consider from the beginning.

ǀ TRACING YOUR DRAWINGS Trace your drawings onto layout paper with a hard pencil (here, daffodils are shown, but you could use any design you like). To reverse a drawing, turn the tracing over and trace the back of it. Go over the drawings with a narrow calligraphy nib and black ink. Use a paintbrush dipped in ink to charge the pen.

TOOLS & EQUIPMENT

- Pencils: one soft (2B or 3B) and one hard (HB or 2H)
- Layout paper
- Wide and narrow nibs
- Black and colored inks
- Glue stick
- Medium-thickness white paper
- Sharp knife
- Scissors
- Cutting mat
- Green and yellow paints
- Small brush
- Metal ruler
- Bone folder (or the blunt edge of a kitchen knife)
- Thick card
- Colored or decorative paper, for the cover of the book
- PVA glue and glue brush
- Baking parchment
- Wooden boards or heavy books, for pressing
- Two weights, such as full jelly jars

2 MAKING A ROUGH LAYOUT AND PASTE-UP
Write out your words on layout paper using a wide nib and black ink. Cut out the drawings and words, and move them around until you like the layout. Then paste them down with the glue stick. Decide where the folds for the pages will fall. You may need to experiment with different-sized words and drawings.

3 DECIDING ON THE SIZE OF THE BOOK Use the paste-up as a guide for copying your layout onto a piece of medium-thickness white paper, and then decide how big your book will be. Use the hard pencil to lightly mark where the margins and the page folds will be; then cut to size using a ruler and a sharp knife on a cutting mat. Place the tracings in position and rub with a soft pencil on the back of them to transfer the outlines to the paper. Leave a blank page at each end of the book.

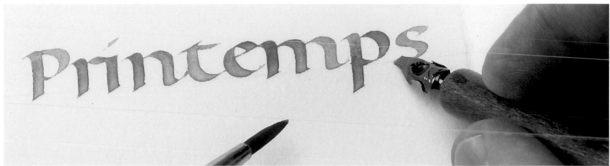

4 WRITING YOUR BOOK Rule the lines for the writing and then carefully write the words with the wide calligraphy nib. Here, different tones of green ink were fed onto the nib so that they mixed a little while writing.

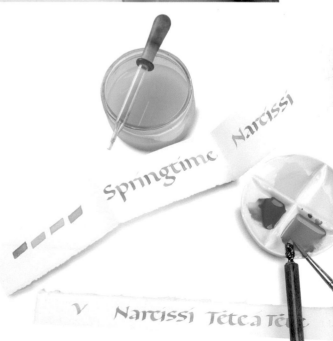

5 ADDING COLOR TO THE DRAWINGS
Go over the outlines of the tracings with colored paints and a small brush.

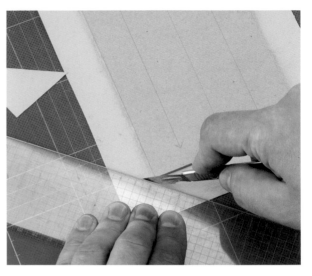

6 FOLDING THE PAGES With a bone folder, score the center line and crease into a valley fold. Check that the marks for the folds on either side will align with the center fold when the book is closed. Adjust if necessary. Score and make mountain folds. Check the next marks, score, and make valley folds. (This process will vary depending on how many pages your book has.) Trim off the ends.

7 MAKING THE COVER Cut two pieces of card just a little bigger all around than a page from your book. Also cut two pieces of cover paper 1in (2.5cm) bigger all around than the card. Keep the grain direction the same for both cover pieces. Apply glue to the cover paper, place the card in the center, and score all around it. Cut off the corners of the cover paper, as shown. Fold the edges of the paper up and over the card. Wrap a piece of baking parchment around the glued cover pieces and lay them between boards or on the table with a book on top. Use something heavy (such as full jelly jars) to weight them firmly and let the covers dry for a few hours.

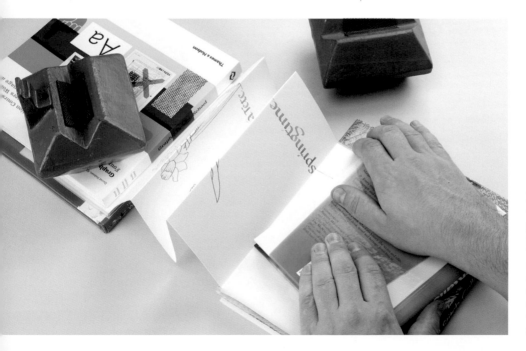

8 ATTACHING THE PAGES Tuck baking parchment between the last two pages of the book for protection, and glue the back of the very last page. Lay the glued page onto the inside of the back cover. Rub firmly to push out any air and let dry, weighted down with books and a heavy weight. Attach the first page to the front cover in the same way.

9 FINISHING Remove the weights, and your book is nearly finished. Check that the folds are smooth and straight, and go over them with the bone folder if you need to.

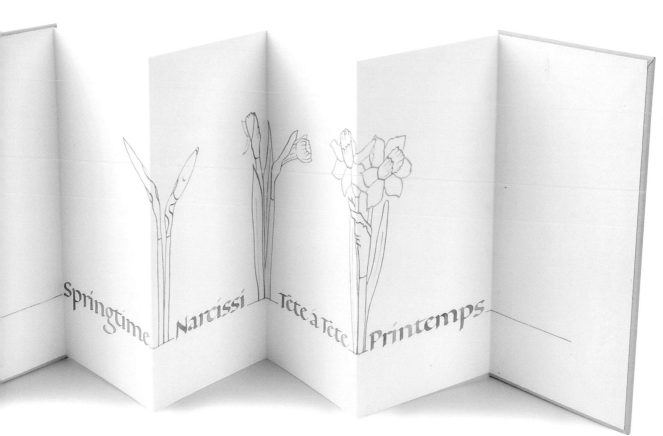

FINISHED PROJECT
Holding and looking at a handmade book is a special experience, and yours will give you much pleasure and a sense of achievement. You can use this method to make many different books for yourself or as gifts for other people.

EMBOSSED CERTIFICATE

Most certificates for qualifications or achievements are printed and embossed by machine (although the names may still be handwritten). Creating your own certificate gives you the opportunity to break out from the restrictions of traditional layout and make something that is really pertinent to the occasion.

TOP TIPS

- Use colors wisely—red helps to draw attention to the most important information or convey authority.

- Do take the time to cut and paste words onto your layout. This will ensure a more accurate result.

Embossing adds a really special touch and is an interesting alternative to using illustrations; however, you will need to balance it with the other design elements to make sure it does not detract from the text. If you are commissioned to make a certificate, the text will usually be supplied by the client.

I DESIGNING THE LAYOUT Using colored pencils on practice paper, make a rough draft of your certificate. Don't be afraid to try more than one design! Bold, minimal layouts are the most suitable, and two colors usually work best.

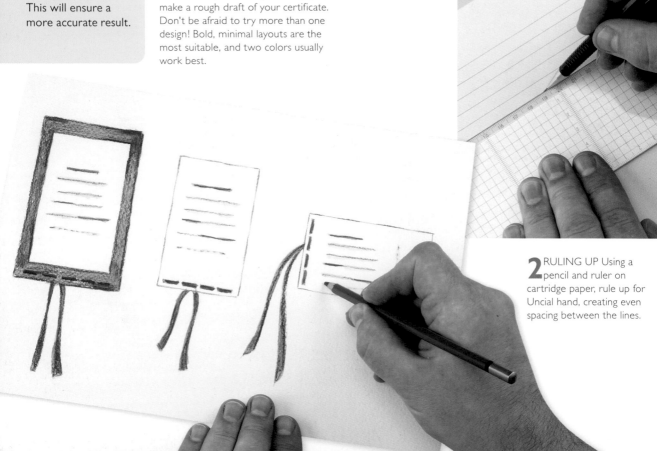

2 RULING UP Using a pencil and ruler on cartridge paper, rule up for Uncial hand, creating even spacing between the lines.

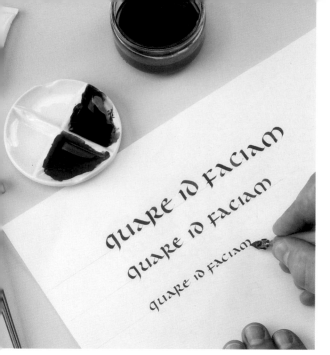

4 PERFECTING THE LAYOUT When you are satisfied with your layout, stick it to another sheet of paper using magic tape (which is easy to reposition if you then change your mind).

3 WRITING OUT THE TEXT Write out the text. Make some photocopies and use them to try out different arrangements of the text by cutting out words and moving them around.

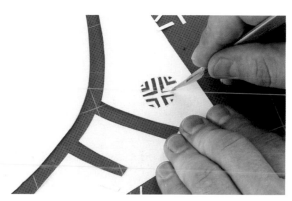

6 MAKING A STENCIL Using heavyweight paper cut out a border and decorative motif with a sharp knife. Place a cutting mat underneath your work to protect your blade and the surface you are cutting on. This cutout design will form the stencil for your embossing.

5 EXPERIMENTING Using your original layout from Step 4 as a guide, experiment with writing the text in different sizes and colors. Try out the different variations on your paste-up to see what works. It is important to actually cut out and place your words (rather than just guessing the result) so that you are clear about your design and have something to refer to when you come to write out the final version.

7 EMBOSSING Cover the stencil with good-quality paper and secure the edges with magic tape to make sure it does not slip. Using a bone folder, gently press the border and the motif until it begins to form a clear indentation on the paper.

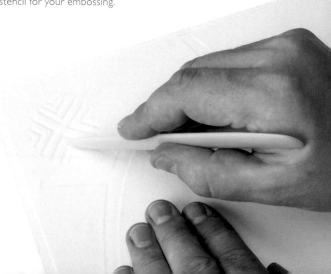

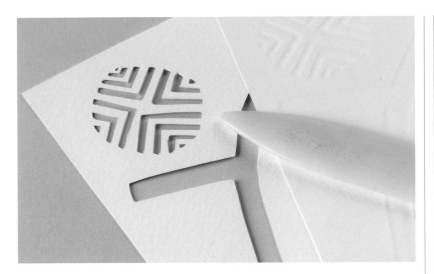

8 REMOVING THE STENCIL Remove the stencil from underneath the paper.

9 ADDING THE WRITING Write out the final design on the embossed paper and add the credits around the edges to form a border. (Usually writing that is smaller than the body of the text is most effective.)

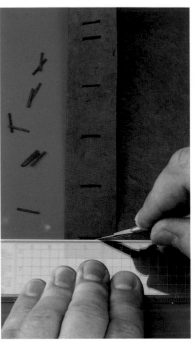

10 CUTTING THE TEMPLATE Lay the paper on the cutting mat, fold one edge, then measure and cut the slits as indicated in Step 11. The slits must be just wide enough to accommodate the thickness of two ribbons.

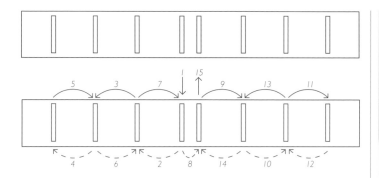

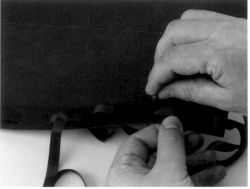

11 ADDING THE RIBBON This template shows you how to thread the ribbon; just follow the numbers. The template can be used for any size of paper. The two central slits are closer together so that the ribbon can be knotted if desired.

12 FINISHING Glue the paper onto the backing card and spread the ribbons through. It is a good idea to lightly glue the fold as well, so that it is more stable. Weave a ribbon in and out of the slits as shown. You may have to ease it through the slits using the bone folder.

THE FINISHED PROJECT
The red backing card and the ribbons work as a protective wrap, so you can roll up the finished scroll and tie the ribbons into a decorative knot.

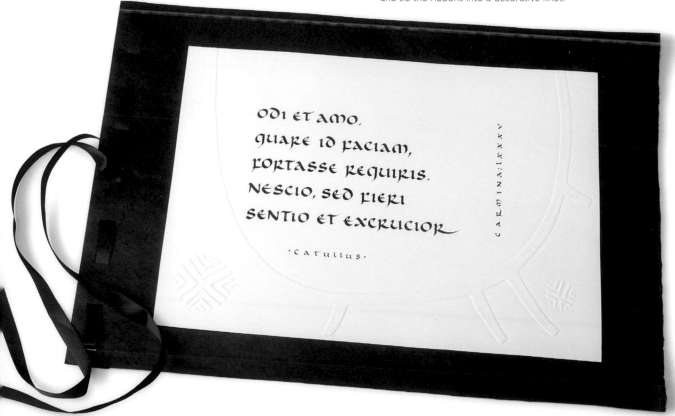

SONNET

Italic is one of the calligrapher's most useful and versatile scripts. This project uses a simple Flourished Italic and explores a number of layout possibilities, as well as an easy method of producing a colored background that will enhance your basic repertoire of calligraphic skills.

TOOLS & EQUIPMENT

- Selection of nibs
- Ink
- Pencil
- Ruler
- Sharp knife
- Metal-edged ruler
- Cutting mat
- Tabloid layout paper
- Glue stick
- Strips of colored card or thick paper
- Good-quality paper for the final piece
- Magic Tape
- Soft eraser
- Soft pastels
- Absorbent cotton or tissue
- Fixative or hairspray

TOP TIPS

- Ensure you shake surplus ink out of the nib after filling. It may be useful to write the first letter after refilling on a spare scrap of paper taped at the edge of the writing board, to remove any surplus ink before you resume writing.

- If strokes are not sharp, the ink may be too thick. Tip a small amount of ink into the ink bottle lid and add a few drops of water.

Interpreting poetry and prose using calligraphy offers wide scope for design and use of color. After reading the text, the first planning stage is to decide what style and size of script would be suitable. Practicing the alphabet is a good first step before writing out the text, cutting it up to make layouts, writing a final version, and finally adding a background.

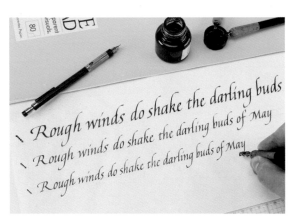

1 CHOOSING YOUR NIB First choose the nib size for writing out your text. To do this, rule up at a letter-body height of five nibwidths of different nib sizes on layout or cartridge paper and write out the longest line of text. There is no need to rule extra lines for ascenders/descenders; judge them by eye.

2 WRITING THE TEXT Rule up pencil lines on your paper, using five nibwidths letter-body height and ten nibwidths for interlinear spaces. Write out the text with no attempt at layout at this stage. Write it several times, making any letterform improvements that are necessary. Don't forget to write the title and/or author credit. In this example, the author's name alone is used. Use a smaller scale of writing or a different script—usually capitals would be used.

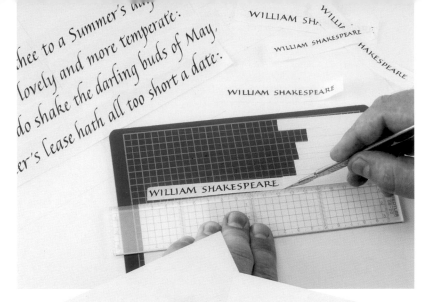

3 CUTTING OUT THE TEXT Using a sharp knife, cut out several written practices of the text, or photocopies, into lines, retaining the line lengths of the original text. Cut close to the ascenders and descenders. Arrange each version on a blank tabloid sheet of layout paper, to produce several horizontal layouts. Allow about two letter-body heights' interlinear space, to give clearance to ascenders/descenders, and a few inches of space at the top, bottom, and sides for margins. These will be assessed accurately later.

4 PASTING UP LAYOUTS On sheets of layout paper, rule lines for placing the text. Try arranging the text left and right, or centering it. Play with indents. Stick the text down using a glue stick and see which layout you prefer.

5 ASSESSING THE MARGINS Assess the surrounding margins by placing four strips of colored card or thick paper around each layout. For a horizontal layout, the top margin should be slightly less than the bottom, and the side margins need to be similar to the top or slightly greater still—to stress the horizontal format of the work.

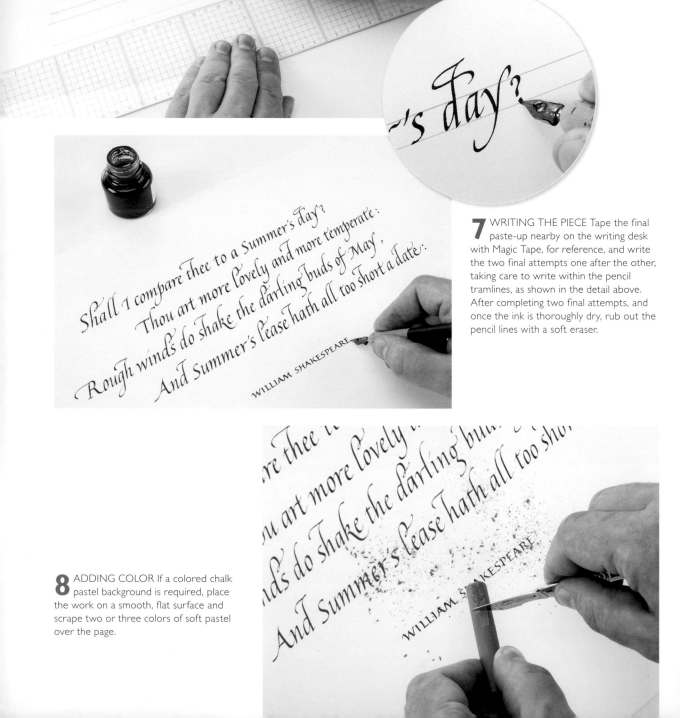

6 RULING UP Rule up two sheets of the selected paper for two attempts at the final piece. Unless you are using a layout aligned to a left margin, mark the line beginnings with a pencil dot, measuring from the paste-up design. Also rule up for one or two lines of writing on a third sheet of the same paper for warm-up practice before writing the final piece.

7 WRITING THE PIECE Tape the final paste-up nearby on the writing desk with Magic Tape, for reference, and write the two final attempts one after the other, taking care to write within the pencil tramlines, as shown in the detail above. After completing two final attempts, and once the ink is thoroughly dry, rub out the pencil lines with a soft eraser.

8 ADDING COLOR If a colored chalk pastel background is required, place the work on a smooth, flat surface and scrape two or three colors of soft pastel over the page.

9 BLENDING AND FIXING Rub in the pastel thoroughly with absorbent cotton or a soft tissue to achieve a subtle, blended effect, or dab and lightly rub it in for a "cloud" effect, as shown. If it is too pale, just add and rub in more scraped pastel. To test your color scheme, make some small-scale color trials on blank paper, or over photocopies of the work. You can fix the pastel by spraying it with fixative or hairspray.

THE FINISHED PROJECT
The asymmetrical layout of the finished piece gives a natural-looking movement to the text, and the interlinear space allows ascenders and descenders sufficient room. The generous space surrounding the text contributes to an overall harmonious appearance. The pastel has been dabbed on delicately, giving a cloudlike effect.

Shall I compare thee to a Summer's day?
Thou art more lovely and more temperate:
Rough winds do shake the darling buds of May,
And Summer's lease hath all too short a date:

WILLIAM SHAKESPEARE

EMBOSSED PANEL

Embossing is the art of shaping letters and patterns so that they are raised above the surface of the surrounding paper, casting subtle shadows that seem to "whisper" a message.

TOOLS & EQUIPMENT

- Dip pen and a range of nibs
- Black ink
- Cartridge paper
- Tracing paper
- Magic Tape
- Hard pencil (2H)
- Thin card for a template (cereal box thickness is ideal)
- Sharp knife
- Cutting mat
- Good-quality 250–300gsm paper for embossing (soft surface best)
- Bone folder
- Tracing paper
- Glue stick
- Lightbox
- Embossing tools
- Watercolors or colored pencils

TOP TIPS

- For clean cutting, make small cross cuts to avoid tufts being left if cut pieces are pulled out after cutting.
- Run the embossing tool into and over corners to ensure sharp, not rounded, results.

Combined with gentle, quiet color and textural additions, the effect of embossing can be stunning. Keep it simple for the best results. Plan your design using pen and ink, at the size you feel comfortable working with—you can always enlarge your finished design to the required size. Make a paste-up, if necessary, to get the spacing working and create a balanced design.

DESIGNING Use a dip pen with a range of nibs to try out your lettering in black ink on cartridge paper. Experiment, cut, and paste until you are happy with your design.

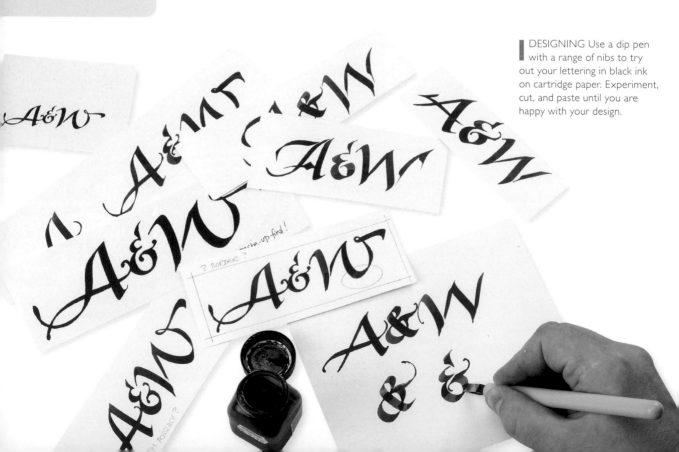

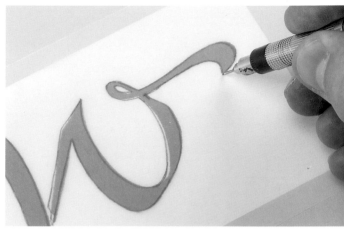

2 FINALIZING THE DESIGN Once you are happy with your design, produce a clean, finished version of it.

3 TRACING Tape tracing paper over your design with Magic Tape and trace it accurately, using a 2H pencil. On really narrow areas, such as the flourishes, thicken the shape slightly, to allow for the loss of width that occurs during embossing.

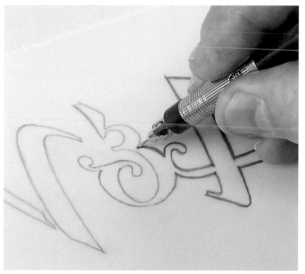

5 PREPARING TO TRANSFER Secure the tracing paper onto the template paper, right side up.

6 TRANSFERRING Draw over the design to transfer the image to your template paper.

4 RETRACING Remove the tracing paper, turn it over, and draw over the design on the back to lay down a deposit of carbon for the transfer process onto the template paper.

7 CUTTING OUT THE SHAPES Working on a cutting mat, with a sharp knife with a new blade, carefully cut around all the letter shapes. Hold your knife comfortably as if it were a pencil, not allowing it to lean to the left or right, as an angled cut would be detrimental to the result.

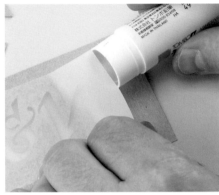

Keep the letter counters.

8 KEEPING ALL THE PIECES On completion, keep all the cut pieces, including the letter counters—these are most important.

9 BACKING THE TEMPLATE Back the template to keep parts that are vital to the reading of letters in place, such as the counters. Stick a sheet of tracing paper over the front of the whole surface with a glue stick, ensuring that no glue gets on the edges of the template. Turn the template over, so reversed letters are facing you, and glue the saved pieces into their correct positions.

10 PLACING THE PAPER ON THE TEMPLATE With your paper at the ready, place your template with the reverse side facing up. Cover the template with your paper and attach it along one side with Magic Tape—you need to be able to lift the paper to check the embossing without it moving. Run a fingernail around the areas to be embossed so you can see where to work.

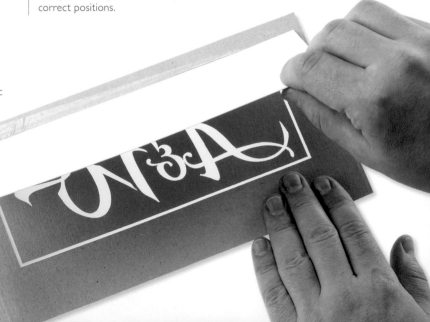

II PREPARING TO EMBOSS Position the paper and the template on a lightbox.

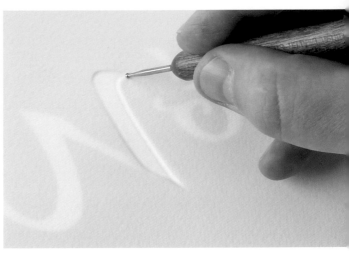

I2 EMBOSSING Using a larger-ended embossing tool, run the ball around the perimeter of the cut shapes. When the shapes are established, run around several times, pushing firmly against the template edge only. If you can't feel the cut edge, you're not where you should be! Run the tool into and over the corners to ensure crisp points. Next, use a smaller embossing tool to fine-tune the result. You need to run around only the perimeters of all the letter shapes. Finally, emboss the border if there is one.

TOP TIPS

■ Change blades frequently—a ragged cut will show when embossing.

■ Avoid adding color too close to the embossed edge or you will render the embossing completely invisible.

■ The key to good embossing is a crisply cut template, so do practice cutting smoothly to avoid disappointment.

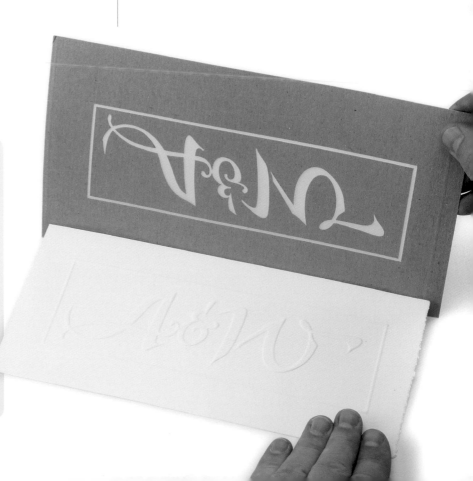

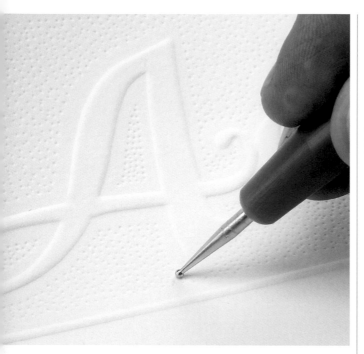

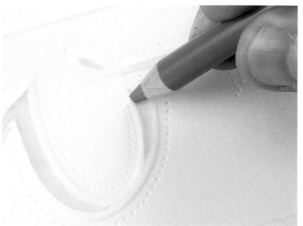

14 ADDING COLOR If you wish, you can add a very pale wash of watercolor or colored pencil. Whatever you choose, do stay well clear of the embossed edge or definition will be lost, as the "shadow" will disappear. Many a good embossed work has been ruined by too strong a color overwhelming the delicacy of the embossing—a good rule is "less is more."

13 ADDING INDENTATIONS Avoid removing the paper from the template until you have checked that you have a crisp, satisfactory result. Next, turn over to the right side to add extra indented decoration with a small embossing tool. (The indentations must be worked onto the right side or they simply won't show.) Stay well clear of the embossed edges.

15 ALTERNATIVE DECORATION Instead of coloring the embossed letters, you could color between the letters, as shown here.

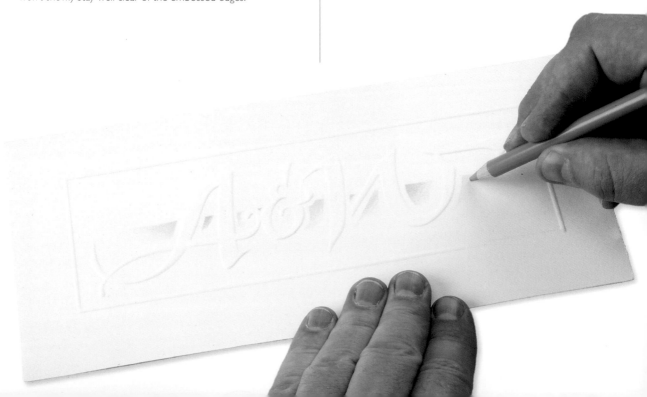

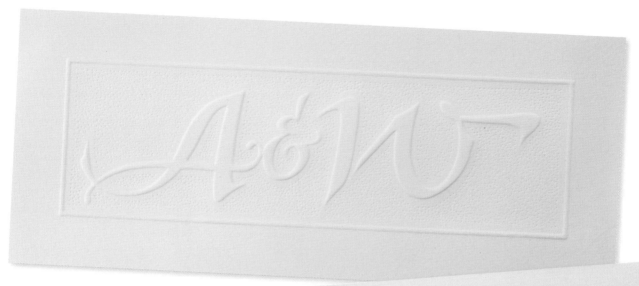

THE FINISHED PROJECT
Shown here are three quite
different designs from the same
template, achieved simply by
combining the results with color
and texture, or texture alone,
allowing the "whispered" letters
to be clearly read. Each panel
could easily be adapted to a
letterhead, a greeting card, or
other suitable applications.

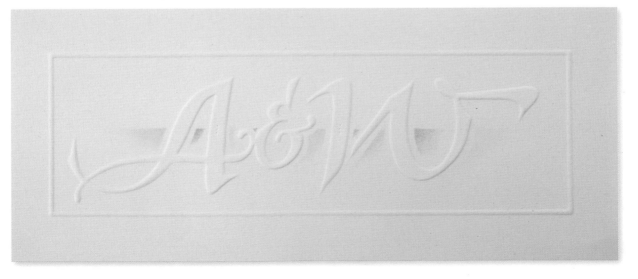

BOOKMARK

Show off your skills in Flourished Italic with this simple bookmark idea. Choose words that have several ascenders and descenders to play with, and make it decorative by coloring the counters and mounting on colored card.

TOOLS & EQUIPMENT

- Practice paper
- Dip pen with 3mm-wide nib
- Colored pencils
- Colored inks
- Cartridge paper
- Pencil and ruler
- Craft knife
- Metal ruler
- Cutting mat
- Dark-colored card
- Glue stick

TOP TIPS

- Writing upside-down works well provided there are both ascenders and descenders to balance the layout; if there aren't, then consider using capitals, as these have no extensions.

- The colors work on the design shown here because they are all secondary colors—green, orange, and violet—blue is made more dominant for the others to "sparkle" against.

A bookmark can be as simple or as decorative as you choose. For this design, the flourishing is what makes it, and you may need some practice to get the balance right. Pen patterns are also worth a try for added ornamentation. Incorporating pen patterns offers the chance to repeat the words, or offset them. Be careful not to overwhelm the lettering. Once you've decided on the main coloring, explore bright combinations of colors to support it, using a range of colored pencils. In this demonstration, the final design uses a single diamond pen pattern, but if your words are shorter, a longer pattern could be inserted.

EXPERIMENTING Experiment with how the flourishes will work together on practice paper. Try out different layouts to enhance the flourishes. Try adding patterns and shading with colored pencils.

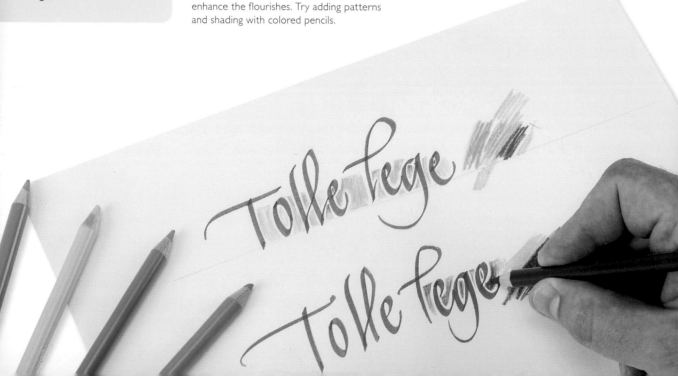

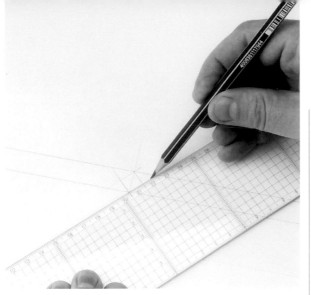

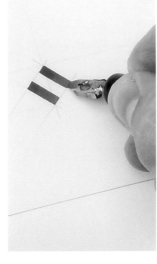

2 MARKING GUIDELINES On a strip of cartridge paper, rule guidelines across its length with a pencil, spaced five nib-widths apart. Mark the center and rule a small diamond shape, as shown.

3 MAKING THE DIAMOND Mix up your ink (olive green is used here) and make two full-width lines along the diamond's opposite edges; turn the paper around and repeat for the other sides to complete the diamond.

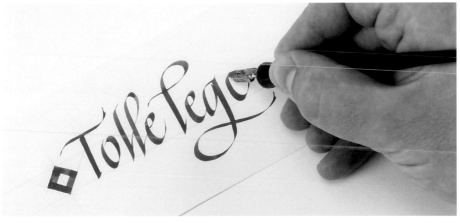

4 STARTING TO WRITE To the right of the diamond, write the first two words, with generous flourishing on the ascenders and descenders.

5 COMPLETING THE WRITING Turn the paper around and complete the writing, again working outward from the center.

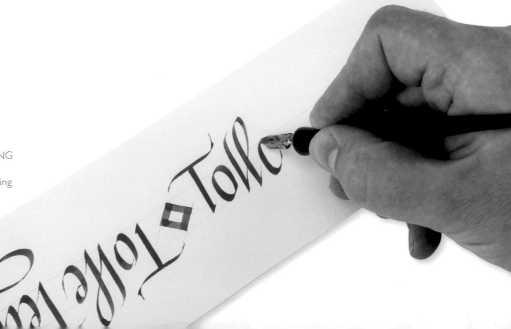

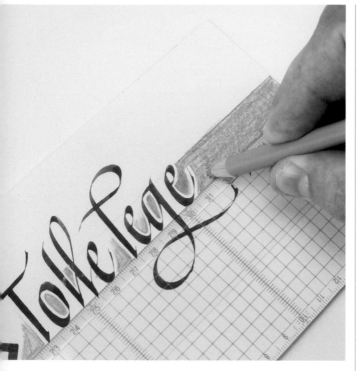

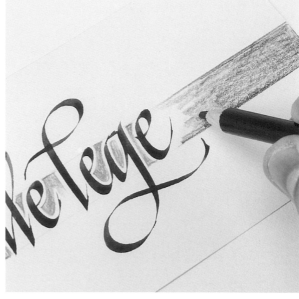

6 ADDING COLOR Using a ruler to prevent you from running over the edges, color in one end of the guidelines using colored pencil, going almost up to the letters but leaving a narrow white strip around them. Continue coloring random parts inside and around the letters.

7 ADDING A CONTRASTING COLOR Starting from the other end, use a different color and repeat the process, working your way across all the counter spaces and leaving narrow white gaps along all the edges of the letters.

8 BLENDING Use a third color and keep adding and blending it until you have an overall balanced, colorful effect.

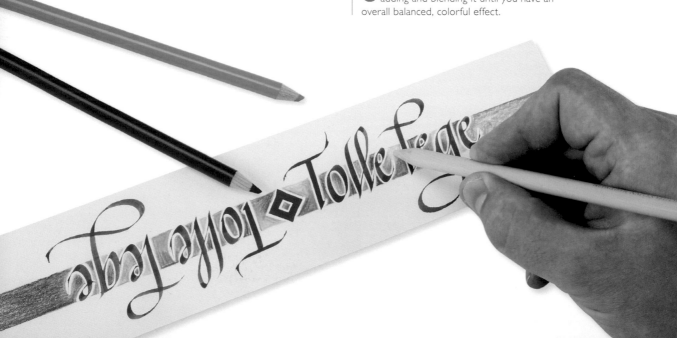

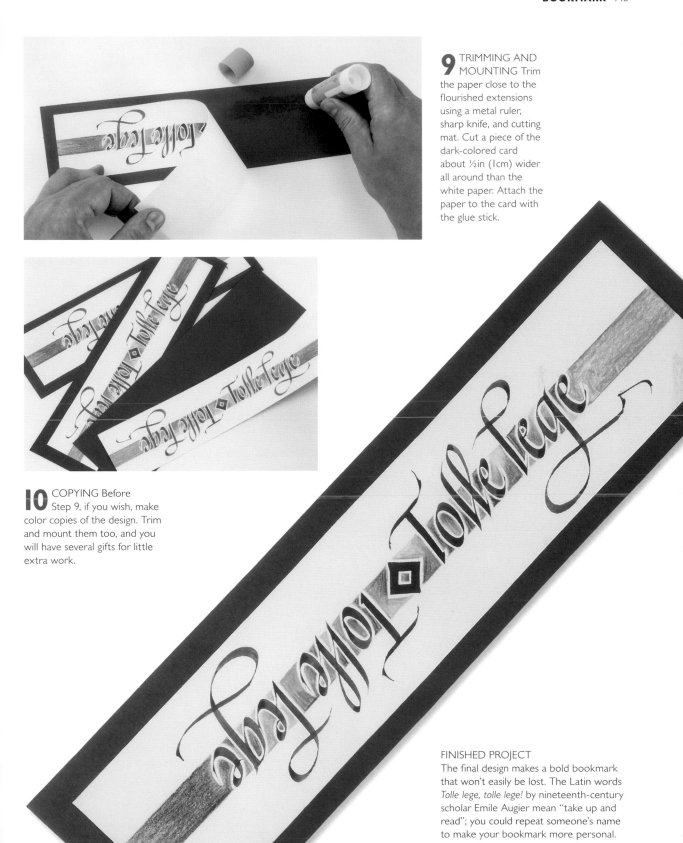

9 TRIMMING AND MOUNTING Trim the paper close to the flourished extensions using a metal ruler, sharp knife, and cutting mat. Cut a piece of the dark-colored card about ½in (1cm) wider all around than the white paper. Attach the paper to the card with the glue stick.

10 COPYING Before Step 9, if you wish, make color copies of the design. Trim and mount them too, and you will have several gifts for little extra work.

FINISHED PROJECT
The final design makes a bold bookmark that won't easily be lost. The Latin words *Tolle lege, tolle lege!* by nineteenth-century scholar Emile Augier mean "take up and read"; you could repeat someone's name to make your bookmark more personal.

WEDDING INVITATION

Creating an invitation is a perfect opportunity to apply your design and layout skills to a short piece of Copperplate text. Making decisions about words, decoration, color, and paper is fundamental to any finished piece and will help you progress to longer or more complicated projects.

Wedding invitations are usually quite formal, but do try to find some element of the design to which you can add your own individual touch. In the following example the calligrapher has chosen blue and gold rather than the traditional "champagne and roses" color scheme. Color choices must reflect the overall color scheme of the wedding; these often reflect the flowers, the seasons, or the color of the wedding dress.

TOOLS & EQUIPMENT

- Practice paper
- Pencil
- Copperplate pen
- Ink
- Glue stick
- Paper for the final invitation
- Colored card
- Colored inks
- Ruler
- Tracing paper
- Scissors/sharp knife
- Cutting mat
- Bone folder

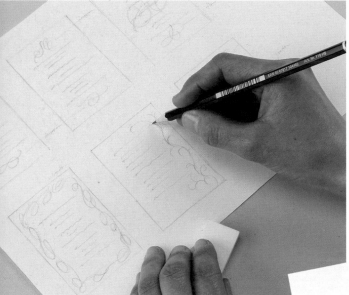

1 MAKING THUMBNAILS Begin by making thumbnail sketches of the whole piece on practice paper, in pencil. Experiment with different page orientations (landscape or portrait) and how the text should appear on the finished piece—centered, aligned left or right, and so on.

2 PLANNING THE WRITING Write the text out at different sizes—decide which elements of the invitation are more important and need to be bigger and which are less important. Or you could decide to write everything the same size.

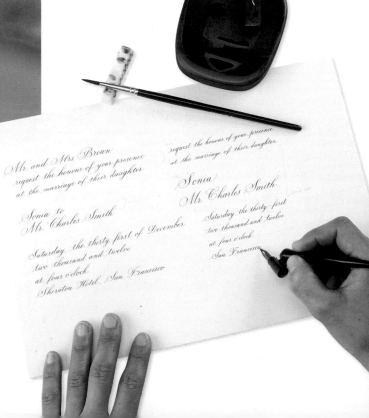

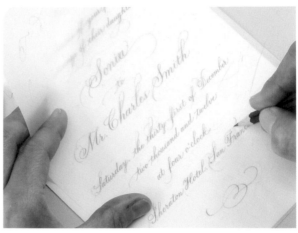

3 PASTING UP Cut out the text and paste it to a fresh piece of paper using a glue stick. It is possible to reposition the pasted text while the glue is still "tacky."

4 ADDING FLOURISHES Experiment with different flourishes. If you have a clear idea of what you are trying to achieve, then add the flourishes directly to the paste-up. If you would like to experiment with different designs, overlay a piece of transparent paper over the top and work on that. When you are satisfied, write the flourishes on the paste-up.

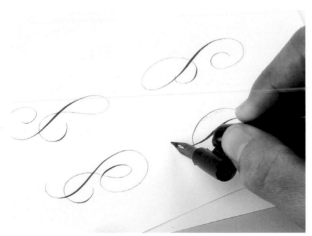

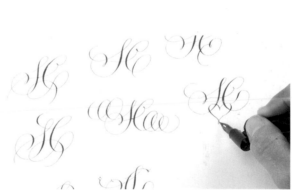

5 ADDING DECORATIONS Try out different decorations. Look at the flourished capitals you have used and try to incorporate some of the features of them into your design. Using a pencil, produce some thumbnails of your design and attempt to re-create them with pen. You may find that it is too difficult to translate some of your pencil strokes into pen and that you need to adapt the design accordingly. The design should comfortably occupy the available space and must seem an integral part of the piece rather than something added as an afterthought.

6 INTERLINKED LETTERS Choose two capital letters (usually the initials of the first names of the bride and groom) and work out different ways of connecting them. Using a pencil, explore the different possibilities, relating your flourishes to the rest of the invitation. Think of your design as a monogram that will "seal" the invitation. When you are satisfied with your thumbnails, begin translating them into pen and ink. Again, you might discover that some things do not work as well in ink and may need to be adapted.

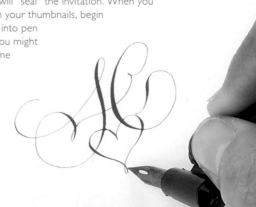

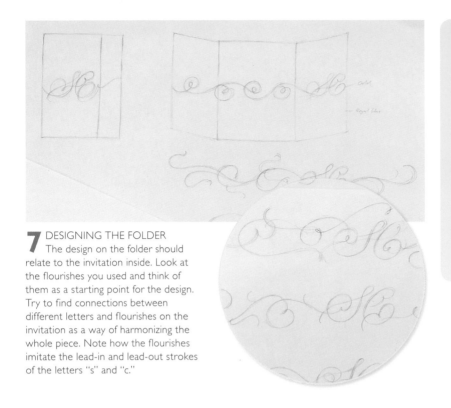

7 DESIGNING THE FOLDER
The design on the folder should relate to the invitation inside. Look at the flourishes you used and think of them as a starting point for the design. Try to find connections between different letters and flourishes on the invitation as a way of harmonizing the whole piece. Note how the flourishes imitate the lead-in and lead-out strokes of the letters "s" and "c."

8 VISUALIZING THE FINISHED PIECE
Consider how each of your designs will look when written on the card. The easiest way to visualize this is to produce the same design in different colored inks and on different colored papers for a direct comparison.

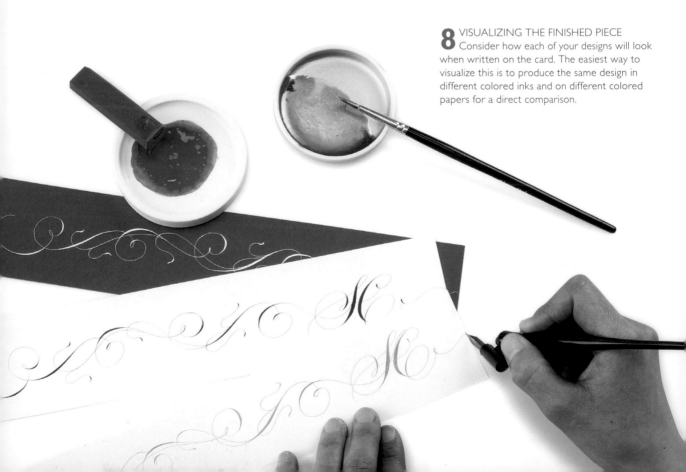

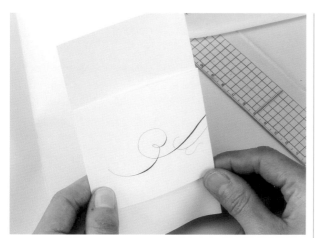

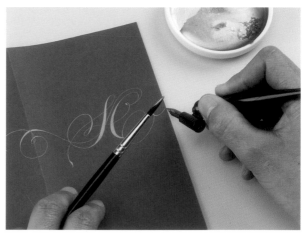

9 PLACING THE COVER DESIGN You will need to see how your design can be transferred to the cover of the folder. Placing it on a line just above halfway produces good results, but you should try placing it lower or higher to see what works best. Finally, ensure that your design sits comfortably along the entire width of the cover. It may be necessary to add or remove some elements to ensure an accurate fit. Make sure the folder can accommodate the invitation, with enough room for the two flaps on either side.

10 WORKING ON THE FINAL PIECE When you have made decisions about all the different design elements, begin work on the final piece. Although this may seem like a lengthy and daunting process, take each element a step at a time and it will become easier. In this instance, the calligrapher chose a blue and gold color scheme for the final design.

THE FINISHED PROJECT
Score two lines with the pointed edge of a bone folder and gently fold in the two flaps, smoothing them flat with the edge of the bone folder. Apply a thin line of glue to the top of the folder and position the invitation, pressing down to keep it firmly in place. This is a unique piece of work that the bride, groom, and their guests will treasure for many years.

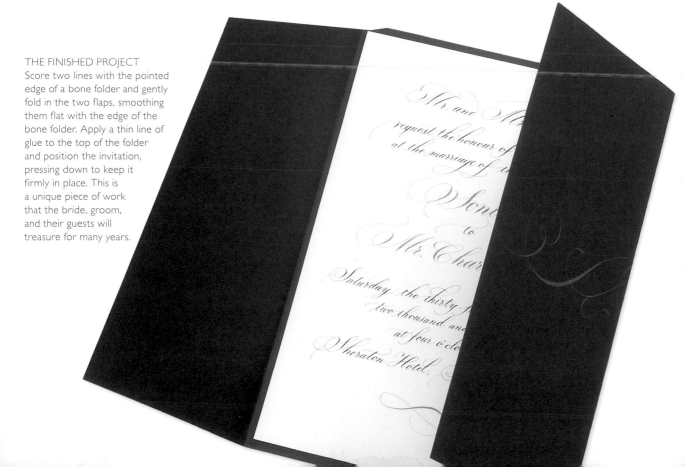

POEM

A poem makes a wonderful starting point for a very personal and expressive piece of calligraphy, combining literal meaning with imagery. Choose a poem that you like and that has meaning for you in some way. This project features an extract from "The Embankment" by T. E. Hulme.

The idea for the poem shown here was based on the image of a man sleeping out on a cold night, looking up at the stars. He has a fantasy of the cosmic "star-eaten blanket of the sky" condensed into a cloth that he could fold around himself—"and in comfort lie." When you are exploring a poem, many ideas may arise that can be explored as rough drafts. As the work progresses, other possibilities will suggest themselves—but do not let the design hijack your essential idea. As you continue to work, ask yourself: Is this a better idea, a further idea, or an entirely different idea? Be truthful!

TOOLS & EQUIPMENT

- Practice paper
- Pencil
- Pen and calligraphy nibs
- Selection of inks and watercolor paints
- Good-quality paper

TOP TIPS

- Keep all your early drafts. You might find, when you come to work up the final piece, that an earlier idea may be incorporated.

- Sometimes your first idea will be best... experiment, but try to retain your initial concept.

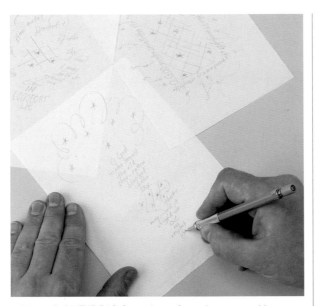

1 TRYING OUT IDEAS On a piece of practice paper, with a pencil, try out different design ideas. Here, one of the ideas that emerges is the image of the "star-eaten blanket" in the center, with the words folded around it.

2 DEVELOPING YOUR IDEA Once you are happy with one of your design ideas, try working it up using pen and ink, and watercolor paints. As you refine your design, consider how you will use color to enhance your work. Continue to refine your composition at the same time. See how the pieces above and on the right make a better shape on the page; the flourishes are beginning to play their part in creating the airy feel of the heavens.

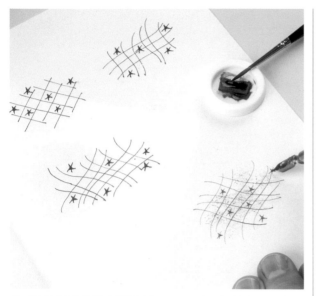

3 ATTENTION TO DETAIL Here, the artist decided to resolve the central image of the star-eaten blanket, which is a visual pun. The checkerboard of straight lines looked too stiff...

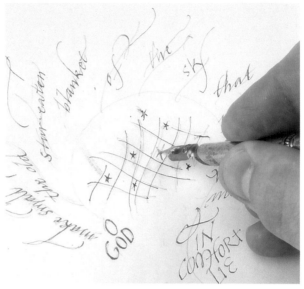

4 ...so wavy lines were tried, until finally achieving the appearance of a woven textile.

THE FINISHED PROJECT

In the working process, each piece develops its own identity—the rough draft can never be copied exactly. Here, the words were a little more generously written—making the design slightly wider. The ampersand anchors the poem. In terms of composition, it adds weight to the lower half of the design, balancing out the highly flourished top half. In terms of reading experience, it slows the reading pace and leads the eye to the poem's important conclusion.

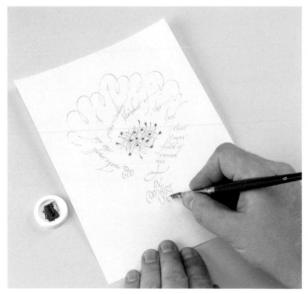

5 MAKING THE FINISHED PIECE Once you have decided on all the elements of your composition, put it all together in a finished piece of calligraphy.

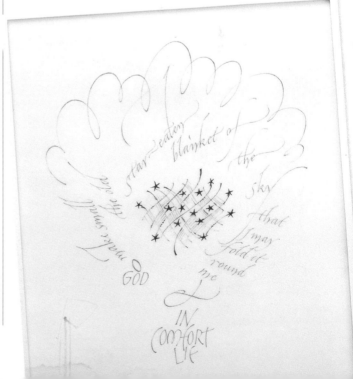

FAMILY TREE

The ease of researching information on the Internet means that more and more people are discovering information about their own family history. A family tree makes an ideal calligraphy project, for yourself or for a gift for another family member.

TOP TIPS

- Photocopy your drawing. The image gives clearer lines to trace from.
- Use a calligraphy nib. This gives a line that has thick and thin strokes, like the writing.

No two family trees are identical, and arranging all the data into one coherent document can be daunting. Some parts of the family may be better documented than others, and the availability of photographs or illustrations will have a strong influence on the finished look of your family tree. All parts of the tree need to be represented even if there is no visual information to support them.

There are many different ways of making family trees; this is a quite straightforward example. It is advisable to try some of the other projects before attempting the family tree, as this requires careful planning and consideration as well as calligraphic skill and is therefore best suited to more advanced calligraphers.

1 THUMBNAILING Assemble all the data and make a thumbnail sketch with a pencil of the structure of the tree.

2 DESIGNING THE LAYOUT Scan in any photographs or illustrations and explore how they might fit together with the text, using software such as Illustrator or InDesign. You might find that some photographs will need to be resized (or discarded) to fit the overall design.

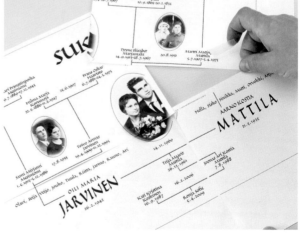

3 PRINTING OUT YOUR TREE Print out your design at the desired finished size. If you have only a tabloid printer, then you will need to print out your work in sections and stick them together with Magic Tape.

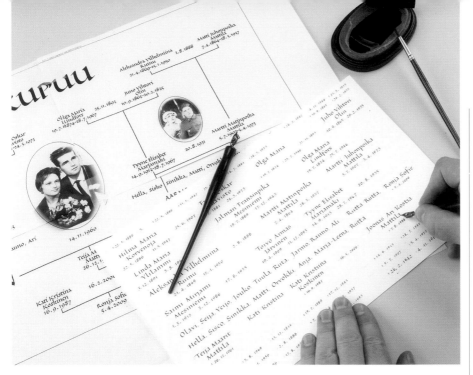

4 WRITING THE FIRST DRAFT Write out the first draft using black ink.

5 VARYING THE SIZES Try to write all the names and dates at the same size as on the printout; use a range of nibs.

6 DESIGNING HEADING WEIGHTS Explore different options for headings, changing the size and the color to see what works best. It is worthwhile spending some time on this exercise, as a logical structure for organizing the data will become apparent, though it may take some trial and error.

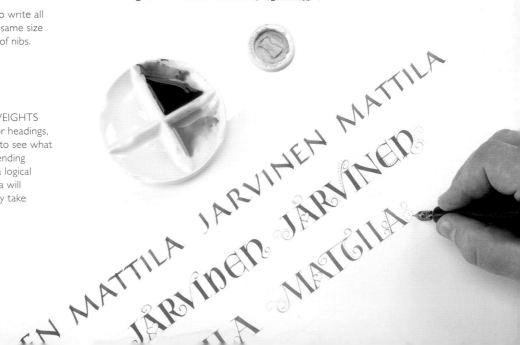

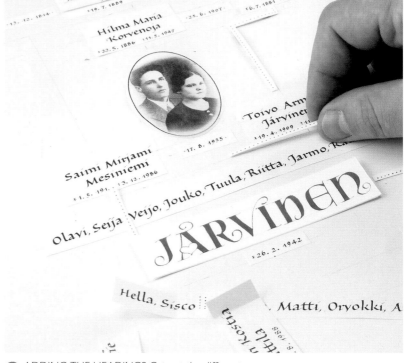

7 INDICATING MARRIAGES Two interlinked gold rings indicate a marriage. Add the date and location of the wedding, if known. Draw the circles for the rings using a pair of compasses and then go over the pencil line with gold ink.

8 ADDING THE HEADINGS Cut out the different headings with a sharp knife and lay them over the printout so you can see how they change the overall design.

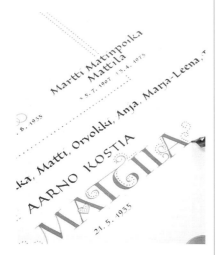

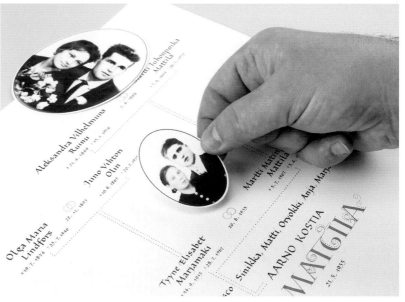

9 FINISHING THE TREE Write out the heading text and glue the pictures in place. Use dots to show connections, as ruled lines can look messy and are harder to judge accurately. In this example blue dots indicate male family members, green female.

10 PHOTOGRAPHS Print out the photographs using good-quality matte paper. It is important that the photographs are not glossy, as they will detract from the rest of the design.

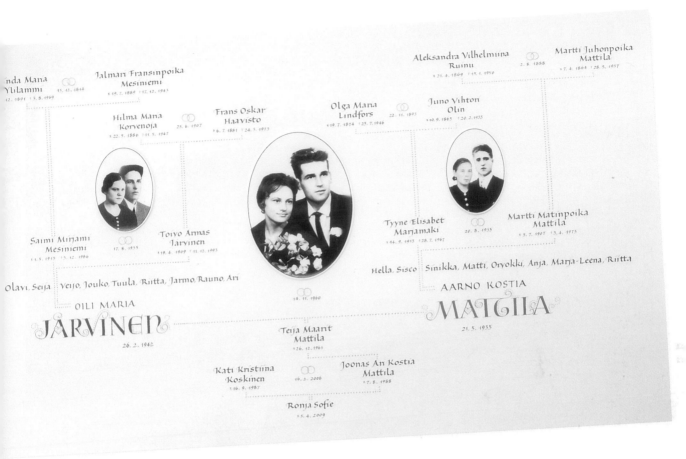

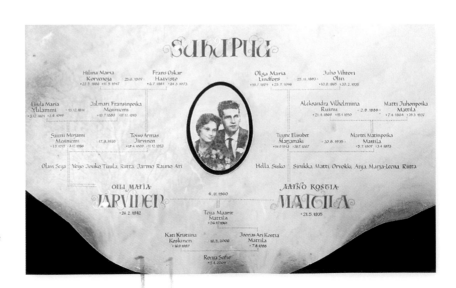

THE COMPLETED PROJECT
The family names have been placed underneath the pictures.

Variation
In this example, the tree was written on vellum parchment and the pictures of the grandparents were omitted. The edge of the parchment has been left deliberately ragged to suggest an antique effect.

NUMBERS AND PUNCTUATION

Numbers and punctuation must be treated the same as letterforms in terms of their construction and spacing. Options are given here for majuscule and minuscule letters.

NUMBERS

Arabic numerals were introduced to Europe in the Middle Ages, but the invention of the printing press in the fifteenth century helped them become accepted, and they quickly displaced their Roman predecessors. It is believed that the value of Arabic numerals is derived from how many angles they contain, but this is contested.

Numbers need to reflect the characteristics of the script that they are being used with. For example, if the script is compressed, rounded, or sharp, the numerals must be as well. The numerals should harmonize with the style of the script and match the rhythm, size, and spacing of the letterforms. Note that the letterforms

have different variations in different countries (such as the crossbar of the 7 used in France); they also have ascenders and descenders. Unlike their calligraphic forms, printed numerals are of uniform size and height (usually that of printed Roman Capitals).

NUMBERS FOR USE WITH ROUNDED LETTERFORMS

0 1 2 3 4 5 6 7 8 9

Upright numbers that harmonize with any rounded letterforms such as Foundational or Uncial. These numbers are for use with capital letterforms.

0 1 2 3 4 5 6 7 8 9

Lowercase numbers for use with rounded letterforms.

NUMBERS FOR USE WITH ITALIC LETTERFORMS

0 1 2 3 4 5 6 7 8 9

Sloped numbers for use with Italic minuscules.

0 1 2 3 4 5 6 7 8 9

Sloped numbers for use with Italic capitals.

NUMBERS FOR USE WITH SCRIPTS WRITTEN WITH THE COPPERPLATE PEN

1 2 3 4 5 6 7 8 9 0

Pointed-pen numbers for use with Copperplate script. If you are writing Spencerian script, it is not necessary to add the pressure stroke to each number.

1 2 3 4 5 6 7 8 9 0

Pointed-pen numbers for use with Copperplate or Spencerian minuscules.

PUNCTUATION MARKS

Punctuation marks help the reader to make sense of a page of text by indicating how words should sound when spoken aloud. As Roman Capitals have been adopted by so many different countries and languages, it is necessary to add sound marks or diacritics to differentiate the various pronunciations. Diacritics need careful placing so that they are not so close that they overpower the letterform and not so far away that their relationship to it becomes unclear. This is especially important in languages such as Latvian or Finnish, which use many diacritics. Diacritics and punctuation marks should flow naturally from even and balanced spacing. If the spacing is correct and easy to read, then the punctuation will be too.

Most punctuation marks are made by small pulling movements of the pen. Even with a pointed nib it is usually unnecessary to push a stroke.

The ampersand originates from the Latin word "et," its form becoming more abstracted over time. It is rarely used in blocks of text but is common in names and titles, especially of registered businesses. If you are intending to address invitations or envelopes, the ampersand will be especially important. Like other symbols it must harmonize with the rest of the text and reflect the characteristics of the script you are using. See the examples below.

PUNCTUATION FOR USE WITH ROUNDED AND ITALIC LETTERFORMS

There are two different options for ampersands.

Ensure that the marks are centered above the script.

The structure of the ampersand is similar to the numeral "8," with two circles on top of each other. Complete the top circle first, then the lower part of the letterform.

PUNCTUATION FOR USE WITH SCRIPTS WRITTEN WITH THE COPPERPLATE PEN

Æ

This symbol originated from Latin when the "e" was placed above the "a" to indicate a different sound. As the sound was interpreted by different languages, it was gradually replaced with dots and other diacritics, although it is a letter in its own right in contemporary Danish, Norwegian, and Icelandic.

Æ
For use with upright or rounded scripts.

Æ
For use with Italic scripts.

Æ
For use with Copperplate or Spencerian scripts.

INDEX

CREDITS

Quarto would like to thank the following artists for kindly supplying images for inclusion in this book:

■ Rosella Garavaglia p.90
■ Veiko Kespersaks p.62, 70, 74, 82, 86, 110
■ Merja Koivumiemi p.58
■ Susie Leiper p.106
■ Tara Luhta p.36
■ Mary Noble p.97b
■ Jan Pickett·p.40
■ Timo Pontinen p.78
■ Klaus-Peter Schäffel p.114–117
■ John Stevens p.102
■ Maureen Sullivan p.54
■ Dave Wood p.97t

With special thanks to the following calligraphers for their projects:

■ Gaynor Goffe p.132–135
■ Emiko Hashiguchi p.146–149
■ Ann Hechle p.150–151
■ Sue Hufton p.124–127
■ Veiko Kespersaks p.152–155
■ Mary Noble p.142–145
■ Jan Pickett p.136–141
■ Kaia Tamminen p.128–131